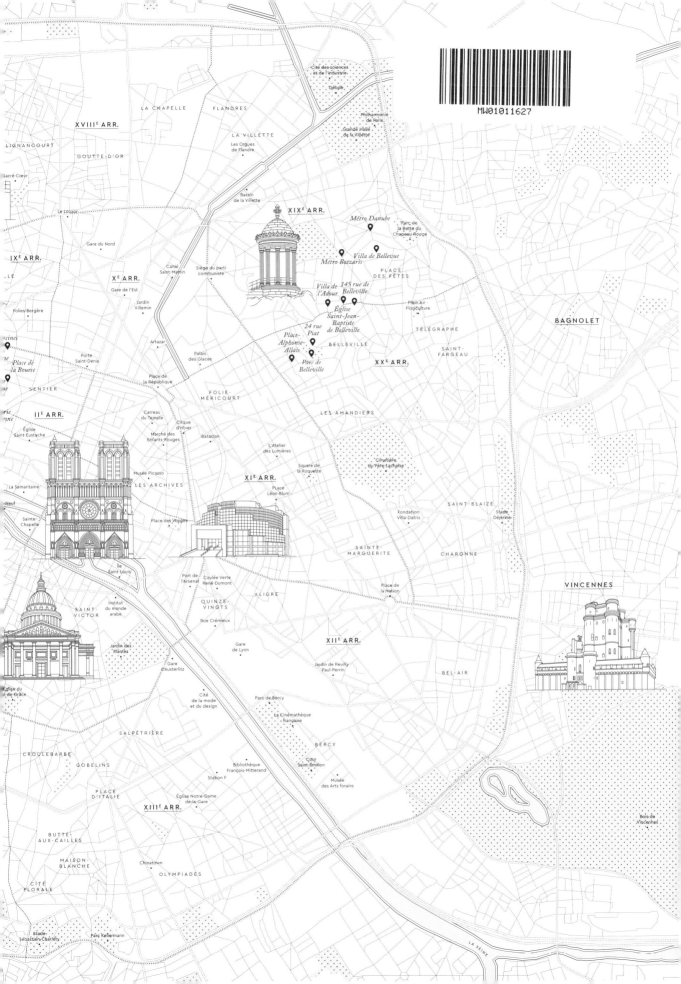

XVIIIᴱ ARR.

LA CHAPELLE FLANDRES

LIGNANCOURT

GOUTTE-D'OR

LA VILLETTE

Cité des sciences
et de l'industrie

Géode

Philharmonie
de Paris

Grande Halle
de la Villette

Les Orgues
de Flandre

Sacré-Cœur

Le Louxor

Gare du Nord

Bassin
de la Villette

XIXᴱ ARR.

Métro Danube

Parc de
la Butte du
Chapeau Rouge

IXᴱ ARR.

Canal
Saint-Martin

Siège du parti
communiste

Villa de Bellevue

Métro Botzaris

PLACE
DES FÊTES

Xᴱ ARR.

Gare de l'Est

Jardin
Villemin

Villa de
l'Adour

145 rue de
Belleville

Plein Air
Floriculture

Folies-Bergère

Église
Saint-Jean-
Baptiste
de Belleville

TÉLÉGRAPHE

BAGNOLET

Artazar

24 rue
Piat

Place-
Alphonse-
Allais

BELLEVILLE

SAINT-
FARGEAU

cines

Porte
Saint-Denis

Palais
des Glaces

Parc de
Belleville

XXᴱ ARR.

Place de
la Bourse

Place de
la République

SENTIER

FOLIE-
MÉRICOURT

LES AMANDIERS

IIᴱ ARR.

Carreau
du Temple

Clique
d'Hiver

Bataclan

L'Atelier
des Lumières

Église
Saint-Eustache

Marché des
Enfants-Rouges

Musée Picasso

Square de
la Roquette

Cimetière
du Père-Lachaise

La Samaritaine

LES ARCHIVES

XIᴱ ARR.

SAINT-BLAIZE

Stade
Déjerine

Neuf

Place des Vosges

PLace
Léon-Blum

Sainte-
Chapelle

Fondation
Villa-Datris

Île
Saint-Louis

SAINTE-
MARGUERITE

CHARONNE

Port de
l'Arsenal

Coulée Verte
René-Dumont

SAINT-
VICTOR

Institut
du monde
arabe

QUINZE-
VINGTS

ALIGRE

Place de
la Nation

VINCENNES

Rue Crémieux

Jardin des
Plantes

Gare
d'Austerlitz

Gare
de Lyon

XIIᴱ ARR.

BEL-AIR

Jardin de Reuilly
Paul-Perrin

Église du
l-de-Grâce

SALPÊTRIÈRE

Cité
de la mode
et du design

Parc de Bercy

La Cinémathèque
française

CROULEBARBE

GOBELINS

BERCY

Cour
Saint-Émilion

PLACE
D'ITALIE

Bibliothèque
François-Mitterrand

Station F

Musée
des Arts forains

XIIIᴱ ARR.

Église Notre-Dame
de-la-Gare

BUTTE-
AUX-CAILLES

MAISON-
BLANCHE

Chinatown

CITÉ
FLORALE

OLYMPIADES

Bois de
Vincennes

Stade-
Sébastien-Charléty

Parc Kellermann

LA SEINE

ENCHANTING PARIS

✦ THE HEDONIST'S GUIDE ✦

ENCHANTING
PARIS

HÉLÈNE ROCCO | SOPHIA VAN DEN HOEK

HARPER
DESIGN

An Imprint of HarperCollinsPublishers

INTRODUCTION

CENTRAL PARIS

1ST TO 4TH ARRONDISSEMENTS

THE EASTERN LEFT BANK

5TH, 13TH, AND 14TH ARRONDISSEMENTS

THE WESTERN LEFT BANK

6TH, 7TH, AND 15TH ARRONDISSEMENTS

THE HIGH-END DISTRICTS

8TH AND 16TH ARRONDISSEMENTS

NORTHWEST PARIS

9TH, 17TH, AND 18TH ARRONDISSEMENTS

AROUND THE CANALS

10TH AND 19TH ARRONDISSEMENTS

EASTERN PARIS

11TH, 12TH, AND 20TH ARRONDISSEMENTS

GREATER PARIS

SEINE-SAINT-DENIS (93), VAL-DE-MARNE (94) AND HAUTS-DE-SEINE (92)

INTRODUCTION

Paris arouses our imaginations. Admired worldwide and the backdrop to many novels and hundreds of films, this city of dreams becomes a tangible experience when we take the time to explore its multifaceted character. Whether you observe Paris from the top of the butte of Montmartre or from the rooftops of one of its famous bistros, the capital is a constant source of discovery and astonishment. We can begin to comprehend it by absorbing the unique identities of its twenty arrondissements and three surrounding departments.

More than 2.1 million people live in the French capital, which spans 41 square miles (105 square kilometers). If we include the geographical "inner ring" (the Petite-Couronne) of the departments Seine-Saint-Denis, Val-de-Marne, and Hauts-de-Seine that surround the city, the population increases to 6.8 million, covering an area of about 294 square miles (762 square kilometers). With a density of 8,951 inhabitants per square kilometer, the metropolis of Grand Paris (Greater Paris) has a larger population than Berlin.

The Jacobin legacy made Paris the beating heart of French political and administrative life. The capital is also one of France's 101 administrative departments, where power has been centralized for thirteen centuries.

In the third century BC, the Romans were interested in what was then a Gallic village. They were attracted by its hills, rich soils, and river. The site's inhabitants were called the Parisii, and the site itself was referred to as Lutetia as early as 53 BC. The Romans conquered the area and transformed its topography; the city was established south of the river Seine (the area known today as the Left Bank) and gradually spread toward its banks. The name Parisius was first attested in the fourth century. It was not until the Norman invasions and the fires on the Left Bank in the ninth century that the marshy areas north of the Seine (the area known today as the Right Bank) were settled.

In the eleventh century, the entire city extended over ninety-nine acres (forty hectares) and was enclosed by a wall. Faced with a growing number of Christian faithful, Bishop Maurice de Sully decided to build a monumental sanctuary, Notre-Dame de Paris, completed in 1345. But Paris was soon struck by the Black Death, then suffered the Hundred Years' War and the English occupation—crises from which

the city needed time to recover. During Henry IV's reign from 1589 to 1610, the capital experienced an unprecedented boom, extending to 990 acres (400 hectares). The number of inhabitants surged to two hundred fifty thousand, and construction projects increased to improve the city.

The Parisian ramparts were destroyed starting in 1670 under the reign of Louis XIV, who would move his court to Versailles several years later. Soon, the City of Enlightenment opposed the Royal Court. The capital took on a more modern design, with its ring of boulevards and the multiplication of public buildings. But when economic growth came to an abrupt halt, the French Revolution broke out in 1789 and, over the next decade, many inhabitants lost everything and emigrated.

Following the coup d'état of 1799, General Napoleon Bonaparte I took over the country's leadership, determined to make Paris the capital of Europe. He initiated, among other projects, the creation of the Canal de l'Ourcq and the quays, as well as the numbering of houses. The number of inhabitants increased again, thanks primarily to immigration. Along with the opening of several railway lines, industrial development focused on luxury goods and cotton processing, which led to social disparities—and some districts within the city were hit by cholera.

The revolution of 1848 followed. Napoleon III (Louis-Napoleon Bonaparte), who had risen to power, responded to the revolution with a policy of major works led by the prefect of the Seine, Baron Georges-Eugène Haussmann. The capital was restructured with parks, a network for drinking water and wastewater, and intersecting streets and avenues, giving the capital a new face. In 1860, the ten peripheral villages—including La Villette, Belleville, and Charonne—were annexed to the city, making twenty arrondissements. The population then increased to 1.4 million inhabitants. Several emblematic monuments emerged during this period, including Sacré-Coeur basilica and the Eiffel Tower, whose controversial construction from 1887 to 1889 coincided with the Universal Exposition.

Gradually, Parisians began to leave the city center. The wealthiest settled in the west while the poorest were constrained to the outskirts and suburbs. On the occasion of the Universal Exposition of 1900, held in the capital, the underground train system (the *métropolitain*, or "metro") was inaugurated. It aimed to relieve congestion in the city's existing transportation networks.

At the turn of the twentieth century, the Belle Époque was an especially rich period both culturally and artistically. Theaters, cabarets, and cafés abounded while the Impressionist movement led to the emergence of Fauvism and Art Nouveau.

The Great War, however, marked a sudden halt to forty years of optimism. Paris was frequently bombed by planes and giant long-range guns, which caused casualties

and significant damage to the city. While the government settled in Bordeaux, the capital emptied, and war set in. The armistice of November 11, 1918, brought great joy to the city.

The exuberant decade of the Roaring Twenties followed next. The population of Paris increased again, reaching 4.8 million inhabitants in 1920. Paris was the city of all that was avant-garde. A wind of freedom blew through the capital, as represented by the burlesque choreography of dancer and singer Josephine Baker and the comfortable clothing imagined by Coco Chanel. The economic crisis of 1929, however, put an end to the party.

In 1940, only a few months after the start of the Second World War, the German army entered Paris, and the city became the capital of occupied France. The inhabitants' daily lives were centered around food supplies and the organization of the Resistance. As soon as the Allied forces landed in Normandy in June 1944, Parisians hoped for liberation; they even organized a demonstration on July 14 to show their determination. The city was finally liberated on August 25, even though Hitler had ordered its complete destruction.

In the mid-1950s, the Paris urban area had reached 6.5 million inhabitants, but the growth of the inner population slowed beginning in the 1960s, unlike the suburbs, whose populations were continually increasing. Thanks to the development of motorways and the RER train system, the urban area extended to the west and south. The shape of the peripheral quartiers (districts) changed gradually as buildings rose, while the city center was transformed in the 1970s thanks to the transfer of Les Halles (the Paris covered markets) to near Rungis and the construction of the Centre Georges-Pompidou and the roads along the riverbank. The *boulevard périphérique* ("ring road") was created during this decade.

Like New York and London, Paris enjoys an international reputation. After the brutal terrorist attacks of 2015 and the effects of the 2020 pandemic, the city has regained its place on the list of the world's most visited cities. The city's *art de vivre* can be taken in while walking its streets, avenues, and boulevards to experience its taste for fashion, unique architecture, museums, markets, and the habit of lingering on terraces over aperitifs. With nearly 16,000 restaurants, including 115 Michelin stars, Paris is a must-visit destination for lovers of food and drink.

The city regularly hosts major sporting events. Every summer, the finish line of the Tour de France takes place on the legendary avenue des Champs-Élysées, and the French Open is held in the spring in the 16th arrondissement. After welcoming the 1924 Summer Olympics, the French capital is preparing to host them again in 2024.

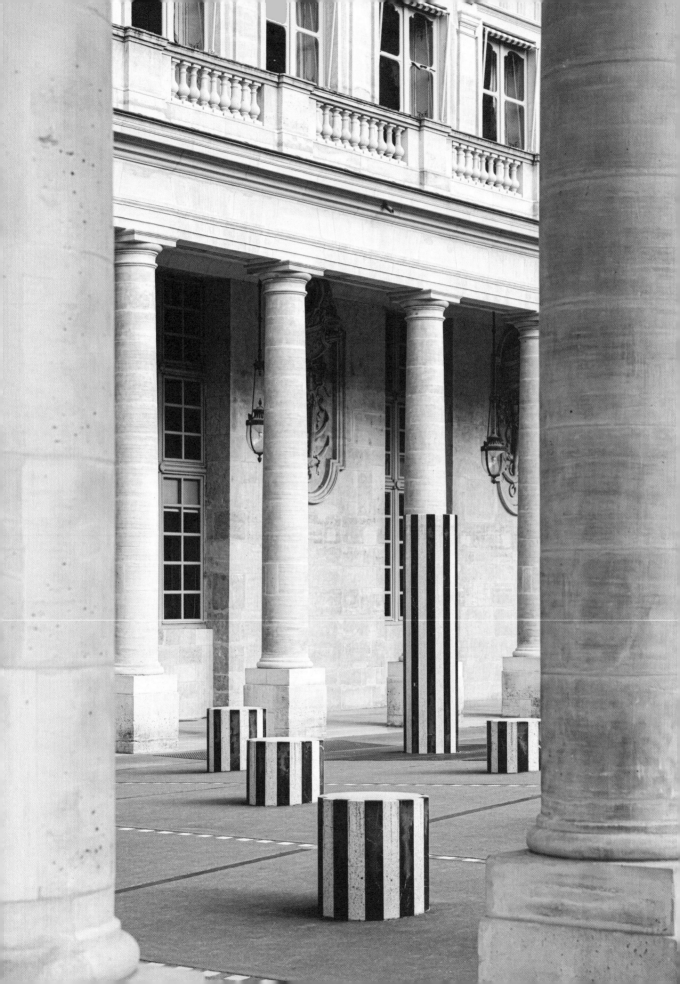

CENTRAL PARIS

Although the official geographical center of Paris is considered the tip of the Île de la Cité, the expression "the center of Paris" refers to the first four arrondissements where there are many must-see attractions, including the Louvre Museum, the Bourse de Commerce, Notre-Dame de Paris, and La Samaritaine.

The Gallo-Roman city of Lutetia was founded after the Roman conquest in 52 BC on what is now the Île de la Cité. After first spreading along the Left Bank of the Seine, Paris spread to the Right Bank during the Middle Ages. Over the following centuries, the city's central districts gradually developed into hubs of commercial activity. Even today, these districts are plentiful with shops, especially in Châtelet-Les Halles, and with offices, near the Opéra Garnier. Although few Parisians visit these areas at night, this corner of the capital is quite lively during the day.

The Tuileries Gardens is a lovely starting point for a stroll through the city's center. Designed by André Le Nôtre and filled with flower beds, the gardens embody a dreamy vision of Paris and represent the epicenter of the chic Louvre district, named after the museum and its famous pyramid. The Palais-Royal and the Comédie-Française, located just a few steps from the gardens, also make this area a popular tourist spot. Near are Place Vendôme and rue Saint-Honoré, headquarters of major jewelry brands and fashion houses. These areas attract tourists who appreciate luxury and fashion. Rue Sainte-Anne is a haven for lovers of Asian gastronomy.

Starting from Place de la Concorde, rue de Rivoli acts as a link between the 1st and 4th arrondissements, running beyond the Hôtel de Ville, the city's central administrative building. But to move from one arrondissement to another, it is more pleasant to stroll through Rives-de-Seine park, which runs along the river from the Pont-Neuf. Devoid of vehicle traffic, the park can be explored on foot, on skates, or by bike and allows you to discover the Île de la Cité and Île Saint-Louis from a new perspective. On sunny days, Parisians gather here with friends for an aperitif at sunset, when the lights of the boats and the view of the historical monuments offer an incredible panorama.

Among all the central districts, the Marais is probably the most popular. Nothing remains of the marshes from which this district earned its name. Cobblestoned streets and private urban mansions now make up the landscape here. Several cultural institutions are located in this area, such as the Musée National Picasso-Paris and the Musée Carnavalet, housed in majestic hewn-stone buildings dating from the seventeenth century. Be sure to take a break in the Marais for lunch, as the neighborhood is the perfect place to enjoy a falafel on the go. Otherwise, head to the popular Enfants-Rouges market, where you can taste dishes from all over the world—provided you arrive early to avoid the long lines.

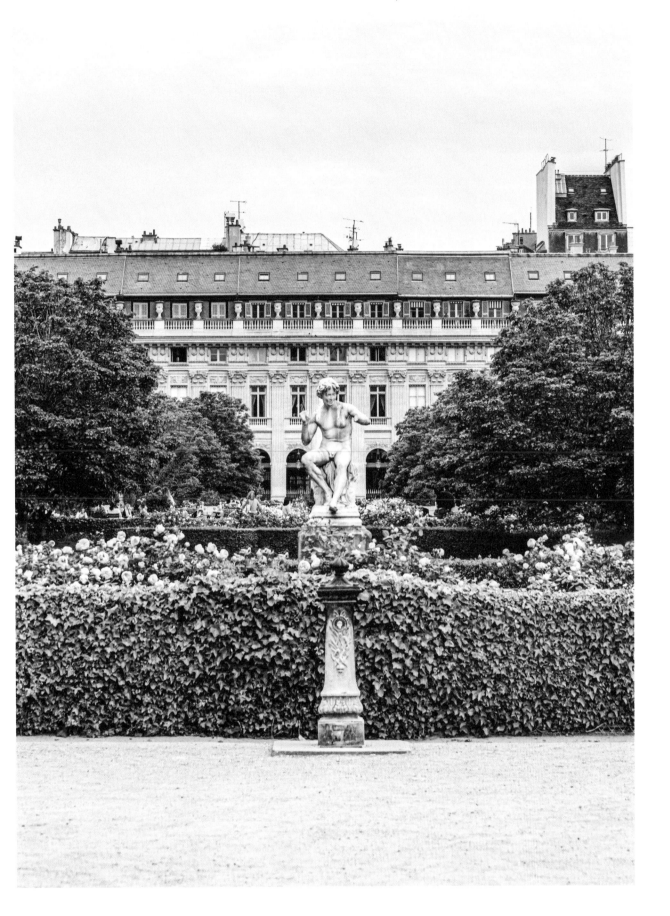

THE ESSENTIALS

01

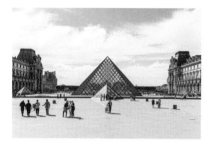

LOUVRE MUSEUM (1ST)

Formerly a royal palace, the Louvre now houses 150,000 works. The iconic glass pyramid has stood in its forecourt since 1989.

02

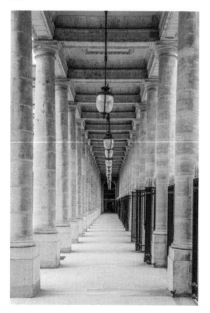

JARDIN DU PALAIS-ROYAL (1ST)

Built by Cardinal Richelieu in 1633, this palace and its garden attract Parisians who come here to take a break or to admire the striped columns by artist Daniel Buren.

03

QUEEN ELIZABETH II FLOWER MARKET (4TH)

Since the early nineteenth century, this picturesque market has offered all kinds of flowers, plants, and shrubs.

04

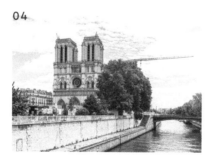

NOTRE-DAME DE PARIS (4TH)

Built between the twelfth and fourteenth centuries, this Gothic masterpiece today symbolizes Paris. After its destructive fire in 2019, it is being masterfully rebuilt.

05

MUSÉE DE L'ORANGERIE (1ST)

This structure once protected the garden's orange trees in winter in the heart of the Tuileries Gardens. Since 1927, it has housed the famous *Water Lilies* cycle by Claude Monet.

06

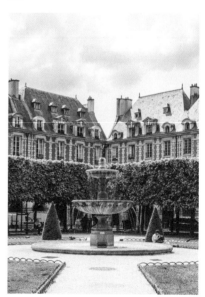

PLACE DES VOSGES (4TH)

With its arcades, red-brick facades, and small central park, this sixteenth-century square is one of the most emblematic spots in the capital.

07

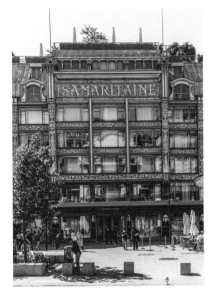

LA SAMARITAINE (1ST)

Founded in 1870, this famous Parisian department store was the first to display single prices. It was closed for fifteen years for renovations and reopened in 2021.

08

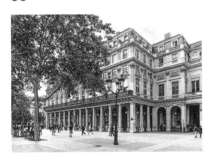

COMÉDIE-FRANÇAISE (1ST)

This theater company was founded in 1680 and has a permanent troupe of actors. The theater has performed some of the greatest plays of the classical repertoire in the Salle Richelieu of the Palais-Royal.

09

ENFANTS-ROUGES MARKET (3RD)

The city's oldest food market, dating to 1615, is in the Haut-Marais (Upper Marais). The market mingles stalls of fresh products with excellent restaurants.

10

EUROPEAN HOUSE OF PHOTOGRAPHY (4TH)

Nicknamed the MEP (Maison Européenne de la Photographie), this center is dedicated to photography. It exhibits the works of famous artists (Rheims, Sidibé, Parr, etc.) as well as new artists.

11

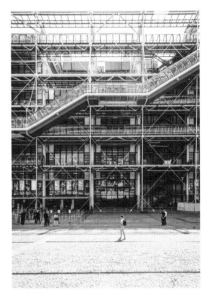

CENTRE GEORGES-POMPIDOU (4TH)

Behind its facade of blue and red tubes, this museum has housed one of the world's most important collections of modern and contemporary art since 1977.

12

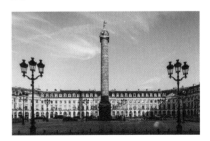

PLACE VENDÔME (1ST)

This square was built on the orders of King Louis XIV to embody the king's absolute power. It is adorned with a tall bronze column 141 feet (43 meters) tall, commissioned by Napoleon. The square today is the epicenter of French luxury.

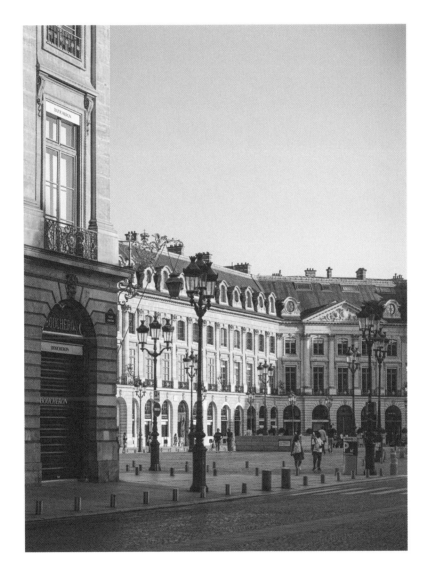

ABOVE

Place Vendôme mingles fine jewelry houses with luxury hotels.

LEFT

*Rue de Rivoli stretches for almost 2 miles (3 kilometers) along
the Tuileries Gardens, starting from Place de la Concorde to the
Saint-Paul district in the Marais.*

VISITING

CHÂTEAU VOLTAIRE

Located a stone's throw from the Louvre and the Opéra Garnier,
Château Voltaire is an intimate five-star hotel seemingly out of a
Wes Anderson film. The hotel is luxurious without being ostentatious,
and its uniqueness seduces.

On rue Gomboust in Paris's 1st arrondissement, an intriguing golden shell carved in stone above a door immediately catches the attention of passersby. This rococo ornament, surrounded with bunches of grapes and golden flowers, marks the entrance to a former brothel. The facades of its three buildings, erected in the seventeenth and eighteenth centuries, were later classified as historical monuments. Before the space was renovated as a hotel of timeless chic, the global apparel brand Zadig & Voltaire was headquartered here. The brand's founder, Thierry Gillier, orchestrated the building's incredible transformation.

For his first foray into the world of hospitality, Gillier turned to artistic director Franck Durand, who wished to work with architects Charlotte de Tonnac and Hugo Sauzay, heads of the Festen agency. They designed a cozy decor tinged with genuine elegance that pays tribute to the Parisian way of living.

At the entrance, the discreet check-in desk displays a rack of thirty-two tasseled keys, and the black-and-white floor tiles evoke the charm of English manors. The space, as a whole, offers an atmosphere of conviviality. Observant visitors will notice that the emblematic shell motif continues throughout. Other architectural marvels, trompe l'oeil, and secret staircases are hidden here and there. The hotel's taste for all things beautiful consists of Cubist paintings—including a work by Picasso—from Gillier's private collection.

On the ground floor, Brasserie l'Émil attracts the district's locals thanks to its inviting charm and menu accented with Mediterranean flavors. After a certain hour, head to the hotel's cocktail bar, La Coquille d'Or (the Golden Shell), which is hidden behind a secret door. With its thick floral carpet and black woodwork, the bar bears all the hallmarks of an exclusive address.

Equally mesmerizing but reserved only for Château Voltaire guests is the wellness area, situated below the ground floor and adorned with white stone. The spa's minimalist pool, sauna, and treatment cabins promise moments of relaxation. After a day of city strolling, it's time to retire to one of the comfortable rooms on one of the hotel's five floors. An insider's tip: ask for key number 32. It opens the doors of a 430-square-foot (40-square-meter) apartment. The view of the city's rooftops from the apartment's greenery-filled terrace is breathtaking. This is an ideal haunt for aesthetes at heart.

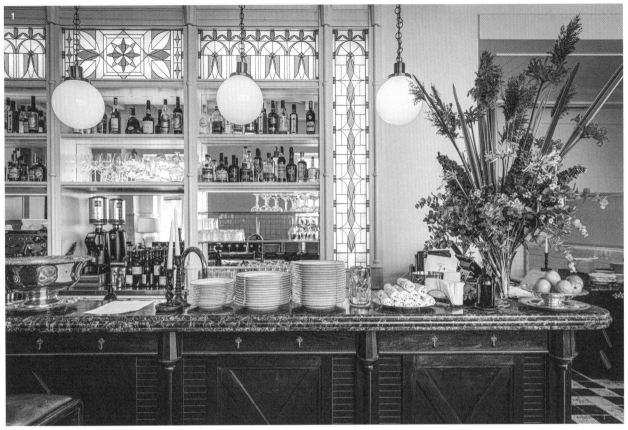

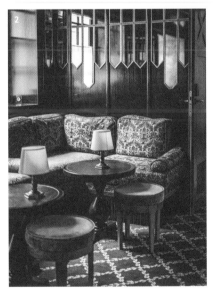

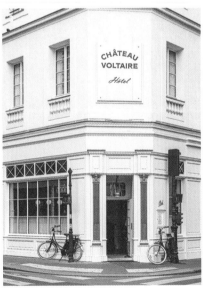

1. AND 4. BRASSERIE L'ÉMIL

The dishes of Brasserie l'Émil present many Mediterranean gastronomic surprises.

2. INTERIOR DECOR

Masters of design Charlotte de Tonnac and Hugo Sauzay of the Festen agency collaborated with artisans to craft an understated yet elegant decor.

3. A MODERN CHOICE

Rather than replicating eighteenth-century decor, Thierry Gilier imagined a contemporary five-star hotel punctuated with nods to the building's past.

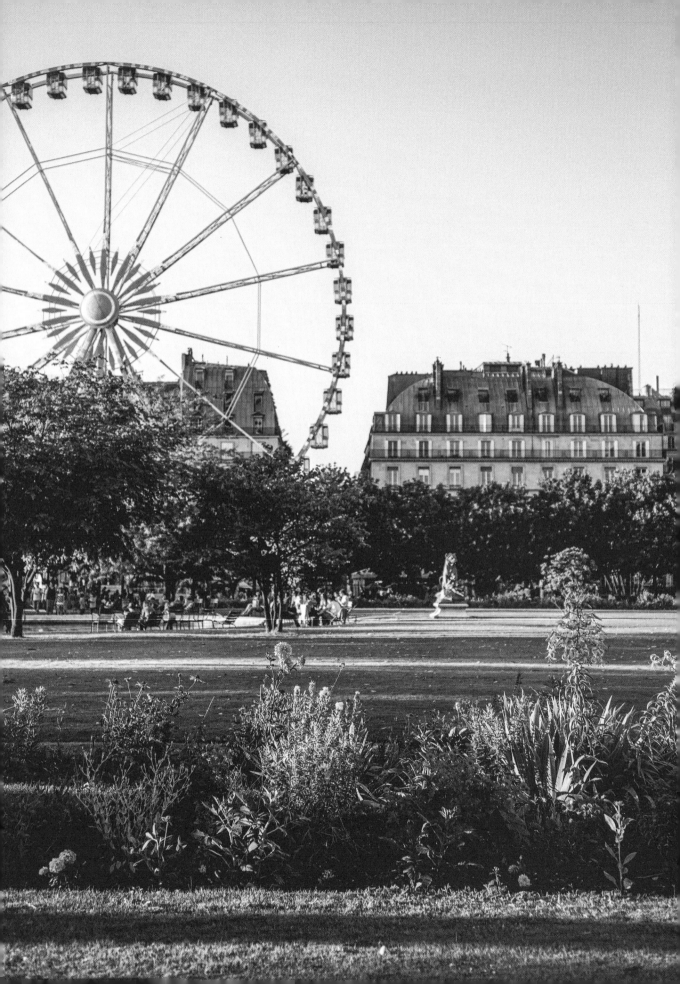

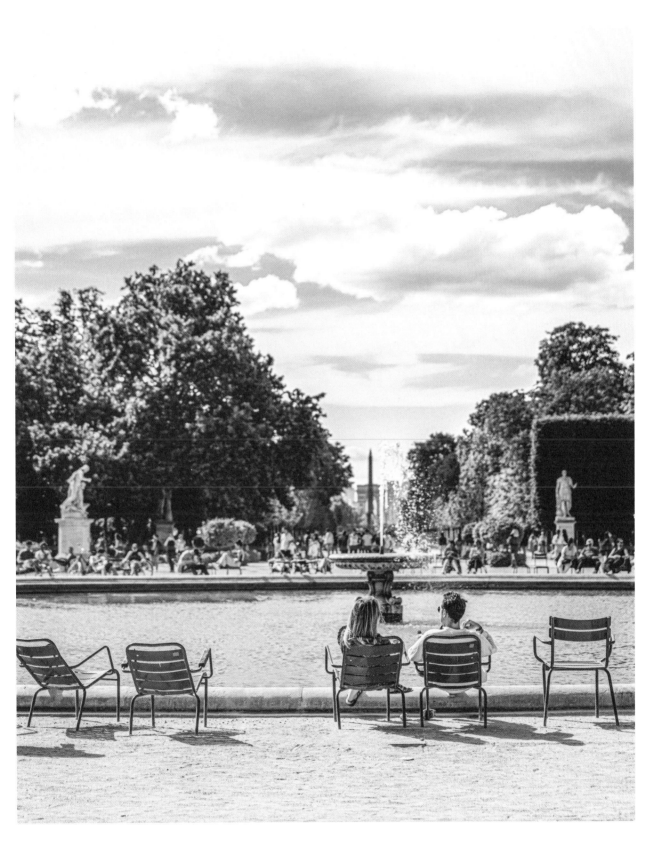

The Tuileries Gardens is a delightful place to spend sunny days.
Many Parisians relax here to read or sunbathe.

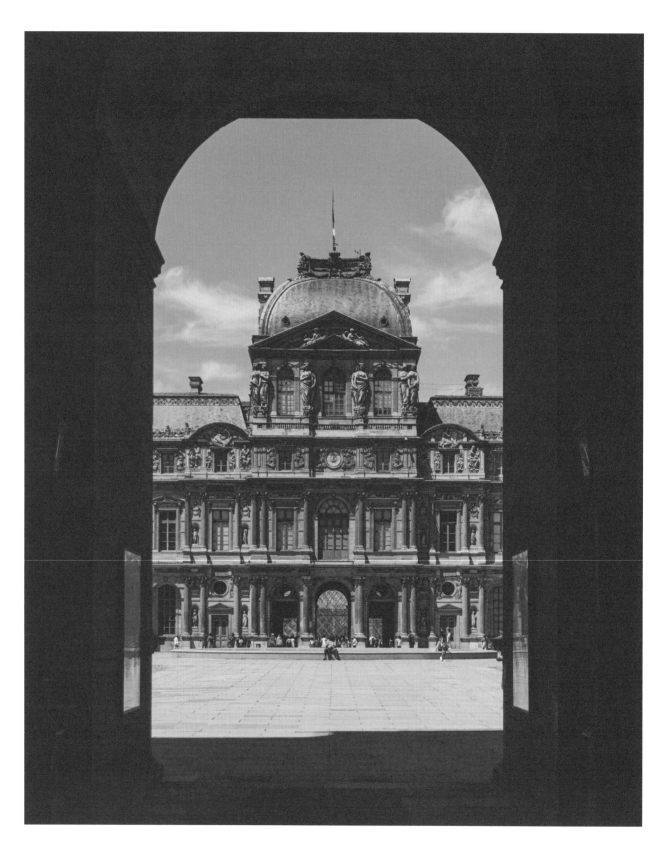

*During the Middle Ages, Philippe Auguste's fortified castle stood on
the current site of the Louvre Museum's Cour Carrée.*

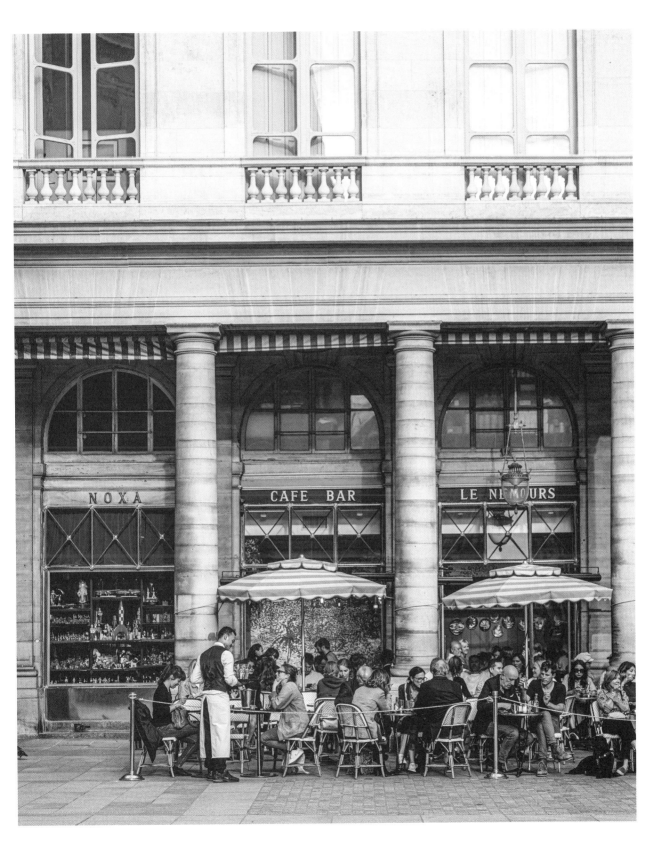

Around the Palais-Royal, there is no shortage of café terraces
to enjoy a drink or meal under the sun.

FOOD

RUE SAINTE-ANNE LE GOÛT DE L'ASIE

RUE SAINTE-ANNE

This street between the 1st and 2nd arrondissements is the temple of Japanese and Korean gastronomy.

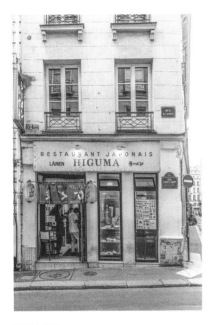

HIGUMA

Higuma is famous for its generous and inexpensive ramen made with pork or squid.

DOSANKO LARMEN

A bowl of fresh and comforting ramen entices diners in this tiny restaurant.

KUNITORAYA

On the menu at this delicious Japanese bistro are homemade udon, chicken karaage, and sea urchin sushi.

RESTAURANT KUNITORAYA

In addition to its eponymous bistro, Kunitoraya has an equally popular restaurant at 5, rue Villedo.

AKI

Curry beignets are available for purchase alongside dorayaki and other desserts at this Franco-Japanese bakery.

ACE OPÉRA

Plum paste, fresh tofu, and matcha tea are among the many products to discover in this famous Japanese-Korean food market.

SAPPORO

In addition to its ramen, this small canteen-restaurant offers curried rice, vegetable sobas, and gyozas at low prices.

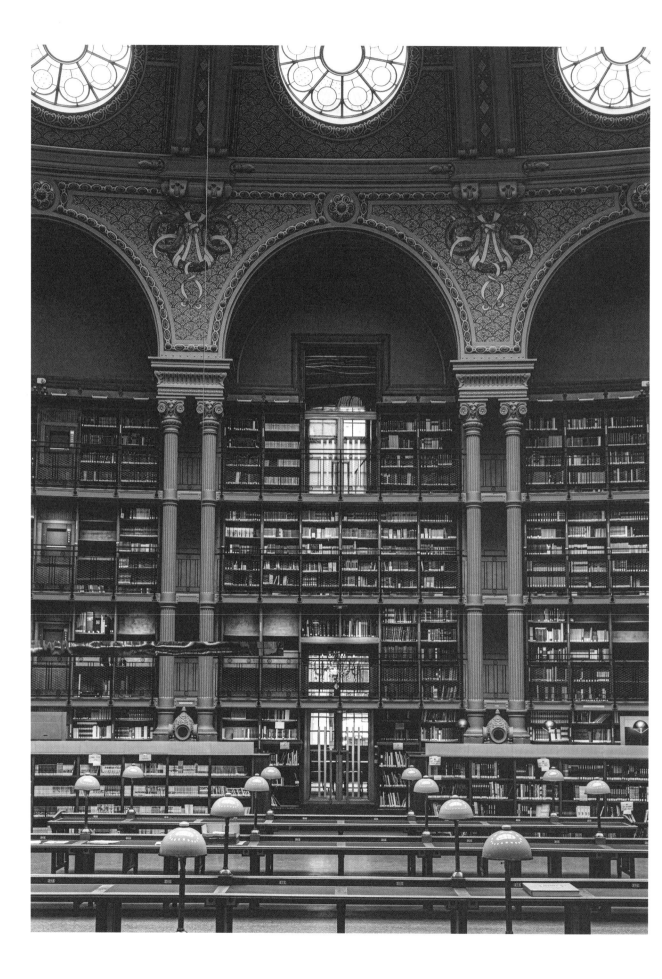

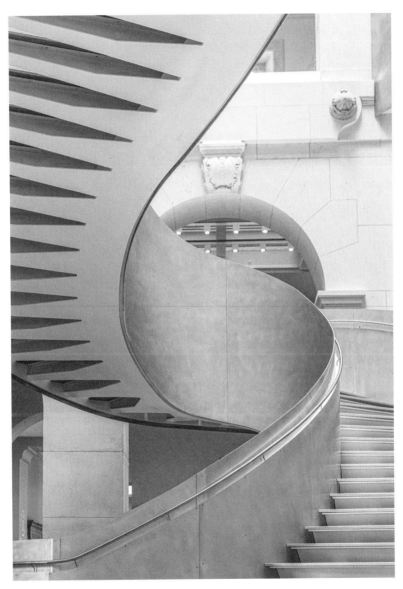

ABOVE

The revolving staircase of the great hall of the National Library
of France is composed of steel and varnished aluminum.

LEFT

The Richelieu–Louvois site is the historical birthplace of the National Library
of France. It has a vast oval room that houses 20,000 books.

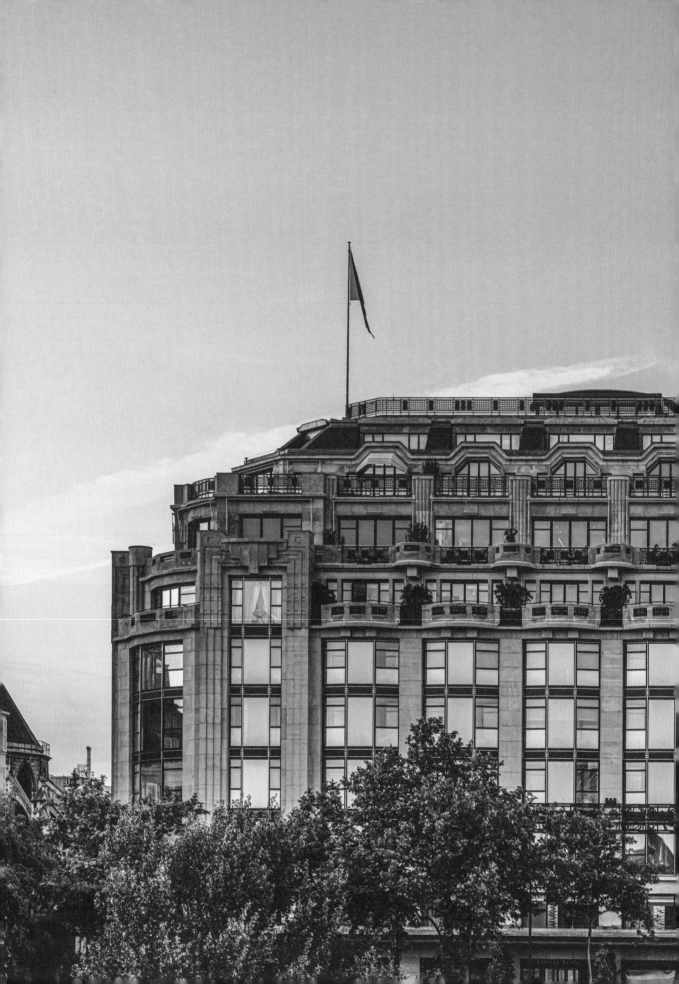

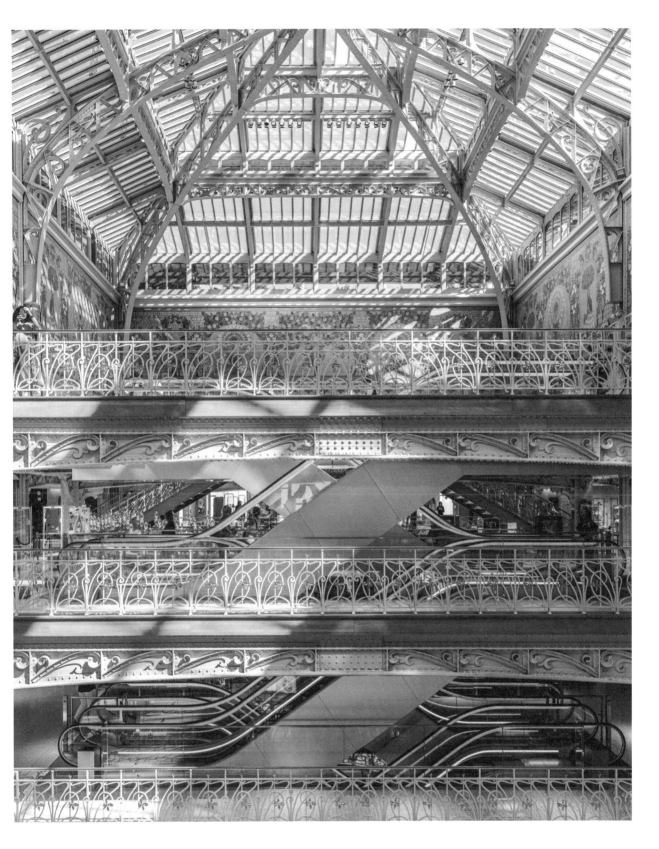

La Samaritaine's Art Deco facade by Henri Sauvage changes colors in the sunlight throughout the day on the side facing the Seine. The interior of the store's other building, facing the street side, represents Art Nouveau decor.

MAXIME FRÉDÉRIC

PASTRIES AT THE TOP

Next to the large department store La Samaritaine is the Cheval Blanc Paris hotel, housed in an Art Deco building facing the Seine. There, pastry chef Maxime Frédéric and his team create sweet dishes that visitors can savor in one of the hotel's four restaurants.

"When I was a child, my dream was to be a pastry chef in a palace," says Maxime Frédéric, seated at Le Tout-Paris, the hotel's French restaurant. This was a daunting goal for the chef, who grew up in Normandy near his grandparents' dairy farm. Raised on quality products and dedicated to watching chef Joël Robuchon's cooking shows, chef Maxime studied baking and pastry arts before learning the trade by working in a pastry shop until age twenty.

To fulfill his dream, chef Maxime moved to Paris and began his career at Le Meurice with chefs Camille Lesecq and Cédric Grolet. In 2016, he joined the kitchens of Hotel George V, where he advanced to the rank of executive pastry chef. His meteoric rise continued after meeting chef Arnaud Donckele. "It was a friendly love-at-first-sight that is reaffirmed every day!" Chef Arnaud offered him a position on the Cheval Blanc Paris team, still under construction at the time. Together, the two men sketched out the menus of the hotel's restaurants.

Once the hotel opened in the fall of 2021, chef Maxime organized a team of forty-eight pastry chefs. Together, they create pastries and many kinds of breads and desserts that can be enjoyed from breakfast to dinner. Each specialty is made with extreme precision, from the house-made yogurt of Le Tout-Paris to the *torta di rosa* (a flower-shaped pain au lait from which each petal is detached) of Langosteria, the Italian restaurant located on the top floor.

True to his heritage, the chef sources his products with care while respecting the seasons, and he maintains a very strong link with the farmers with whom he surrounds himself. He uses eggs and hazelnuts from his sister's farm in Normandy, milk from the Cotentin peninsula, and grains from an artisanal producer. With one foot in Paris and the other in Normandy, chef Maxime plans to soon have his own farm with his partner.

In the kitchen, the know-how of the team members from all over France is highlighted. The menu of Limbar, the restaurant located on the ground floor, attests to this. Teatime takes the form of a *Tour de France* of snacks. *Tarte au sucre* (a sugar pie) typical of the North, *douillon normand* (a baked pear or apple and various fillings wrapped in pastry) from Normandy, and *gâteau nantais* (a soft round cake moistened with rum and lemon) from Nantes, are all regional specialties chef Maxime likes to introduce to visiting gourmands. Finally, at Plénitude, the hotel's three-star gastronomic restaurant, he works with Arnaud Donckele, whose sauces take center stage in his dishes. One thing is sure: witnessing the enthusiasm that drives chef Maxime Frédéric proves he has found his calling at this top-level address.

From its tearoom to its restaurant on the top floor,
the Cheval Blanc offers a cozy ambiance.

EXCELLENCE IN KNOW-HOW

Maxime Frédéric makes his *Paris-Brest* with
hazelnuts harvested from his Normandy farm.

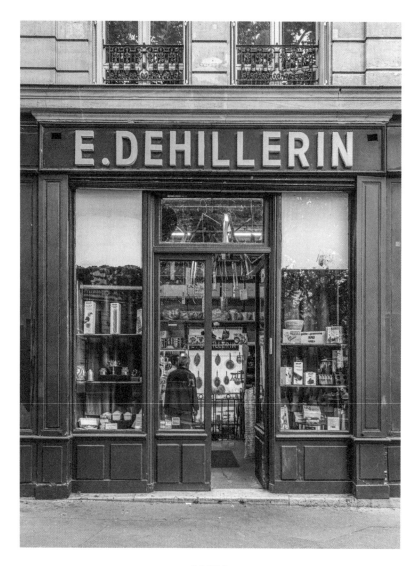

ABOVE

In the heart of the Les Halles district, the Church of Sainte-Eustache,
built in 1532, has a gothic facade.

RIGHT

Founded in 1820, E. Dehillerin sells kitchen equipment of all kinds.
This institution attracts chefs from all over the world.

UNDERSTANDING

THE ARCHITECTURE

OF PARIS

Parisian buildings bear witness to the richness of the city's architectural history. Although Haussmann-era buildings represent more than half of those in Paris, other periods, from modest to exuberant styles, have left their marks on the city's urban landscape.

Still visible today, the remains of the Lutetia arenas remind visitors that the city has existed since ancient times. Buildings such as the Romanesque bell tower of Saint-Germain-des-Prés or Notre-Dame de Paris have left traces of the different architectural styles from medieval times. However, most buildings that occupy the capital date from the end of the Revolution to today.

From 1800 to 1815, Paris's architecture represented a return to order. Empire-style buildings are imposing and without embellishments. A thin band along the facade delimits each floor, and pillars are embedded in the walls. Running balconies stretch along the first floor, and portals and windows are rounded. Rue de Rivoli, whose construction began in 1802, perfectly illustrates this style.

From 1820 to 1830, the Restoration style further stripped facades, as housing was constructed for the working classes. This style can be identified by a fifth floor and louvered shutters. Large housing estates emerged in the Saint-Georges and Saint-Vincent-de-Paul districts.

In the 1840s, the transition to the Louis-Philippe style prompted the gradual return of decorative finishes and wider sidewalks. Balconies lost depth, and facades were now identifiable by their architect. The famous Haussmann style arrived during the 1850s. Appointed by Napoleon III, prefect Baron Haussmann's mission was to modernize the former

Lutetia. Many buildings were demolished during this time to make a clean sweep of the past. Streets were widened, and large axis roads facilitated traffic flow, the sewer system was refurbished to clean up the city, and public gardens were created.

Haussmann ordered the construction of thirty-four thousand cut-stone buildings, reaching four to six floors. A door allowed entrance to the courtyard by horse-drawn carriage, the ground floor and the mezzanine were adorned with deep horizontal lines, and the second floor had a running balcony. From 1880, the Haussmann style became more understated, and urban planning standards were relaxed, leaving room for creativity. Thus, projecting windows were once again allowed.

At the beginning of the twentieth century, balconies became deeper, and buildings were often topped with domes—an inventiveness that announced the end of the Haussmann era and the beginning of Art Nouveau, embodied in Paris by architect Hector Guimard. The richness of ornamentation, omnipresence of floral-inspired curves, and use of wrought iron in doors are distinct characteristics of this style, which was also applied to the entrance of some metro stations decorated with an *édicule* (a cast-iron canopy). Over the course of the century, other materials such as brick, reinforced concrete, steel, and glass gradually replaced cut stone. The increasingly taller architectural achievements of the city invited pedestrians to look up toward the sky.

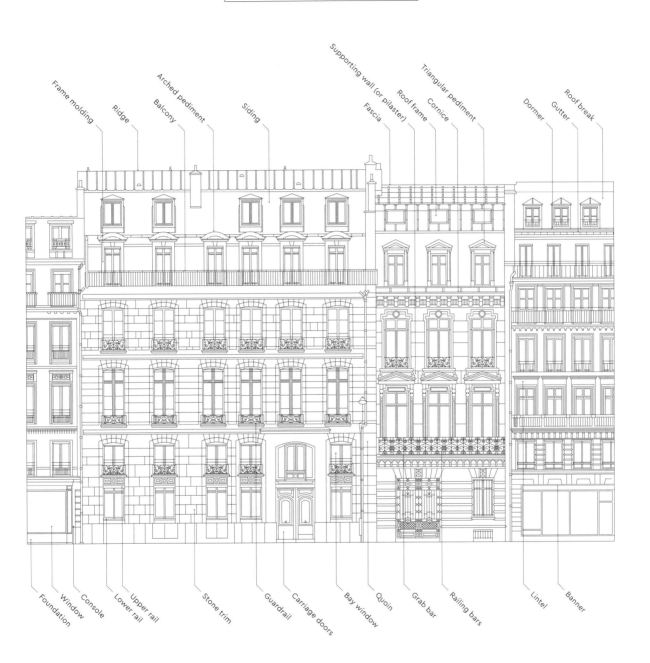

Frame molding • Ridge • Balcony • Arched pediment • Siding • Supporting wall (or pilaster) • Fascia • Roof frame • Cornice • Triangular pediment • Dormer • Gutter • Roof break

Foundation • Window • Console • Lower rail • Upper rail • Stone trim • Guardrail • Carriage doors • Bay window • Quoin • Grab bar • Railing bars • Lintel • Banner

A CITY OF MANY STYLES

The facades of Parisian buildings represent many architectural styles
(Restoration, Haussman-era, Art Nouveau, etc.). This eclecticism continues
to expand as new structures arise. Paris is joining the world's major capitals
in a race for impressive architectural achievement, as evidenced by
the new Tribunal de Paris court building.

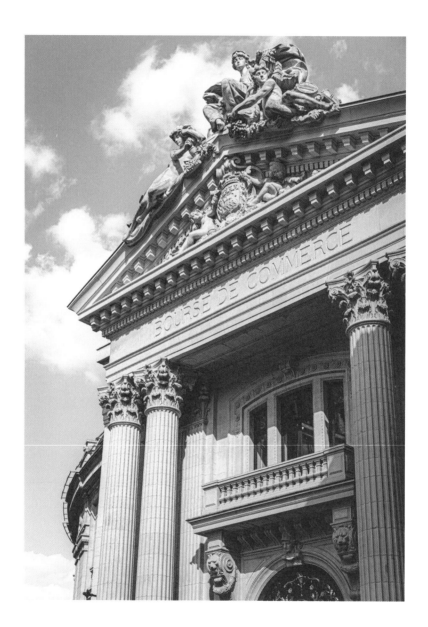

ABOVE

*In 2021, the former Bourse de Commerce was converted into a contemporary art museum
exhibiting the private collection of François Pinault.*

RIGHT

*The dome of the Bourse de Commerce is a masterpiece of metalwork.
Its glass roof floods the museum with light.*

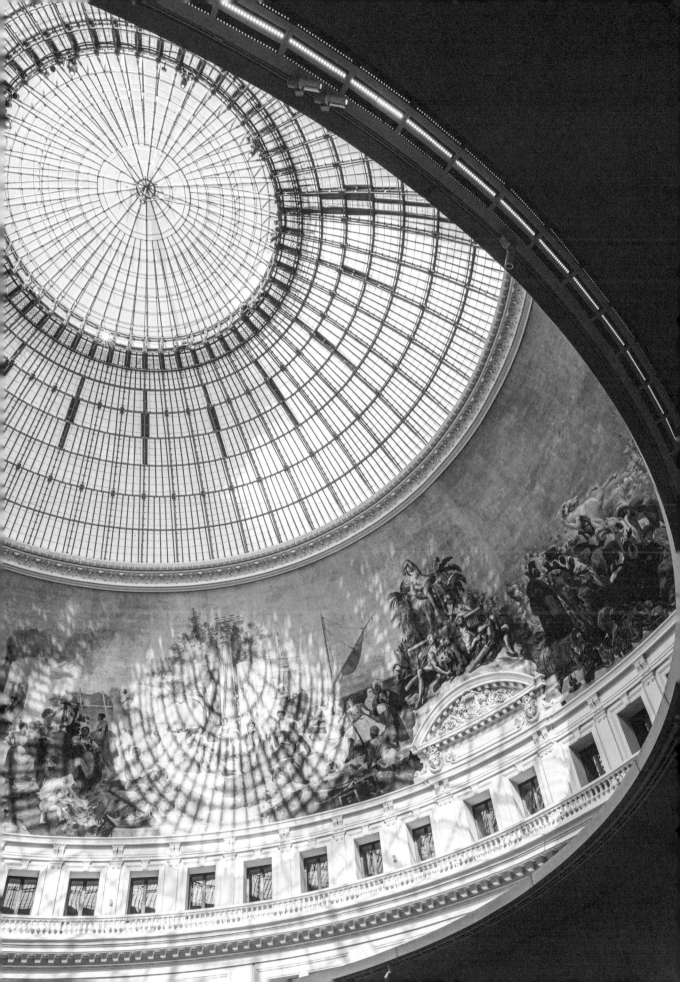

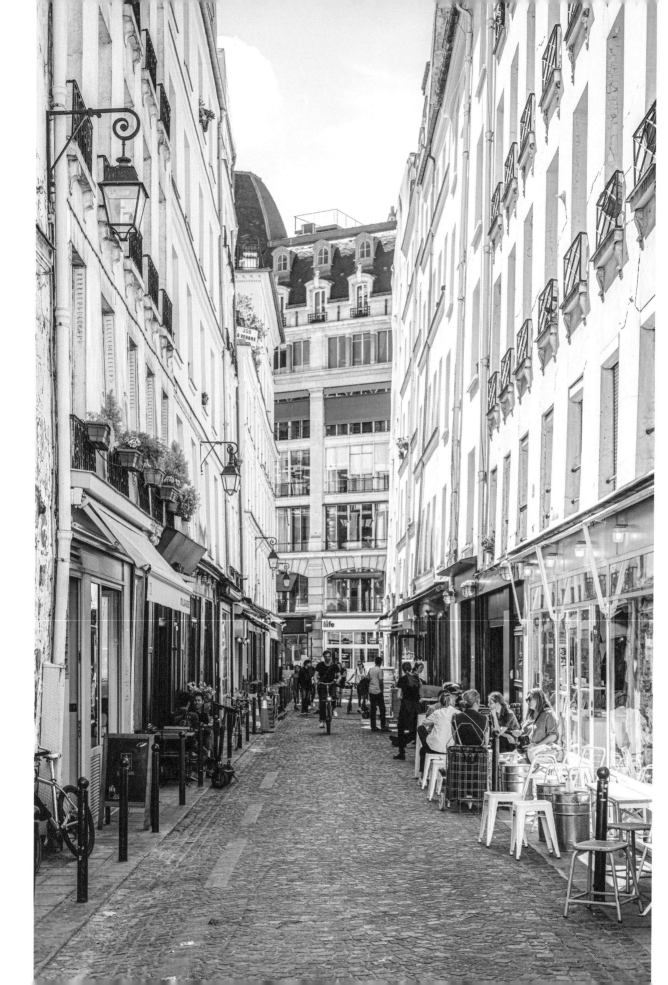

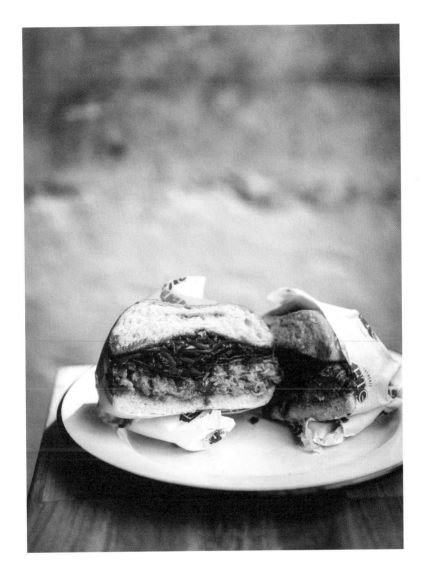

ABOVE

*The pulled pork sandwich by Michelin-starred chef Greg Marchand at FTG
on rue du Nil is a gastronomic icon.*

LEFT

*From grocers to fishmongers to cheese shops, the shops of Terroirs d'Avenir
are a dream destination for gourmets.*

P.40–41

*The Conciergerie was first a medieval palace, then a revolutionary court, and
the prison of Marie-Antoinette. Today, it is a UNESCO World Heritage Site.*

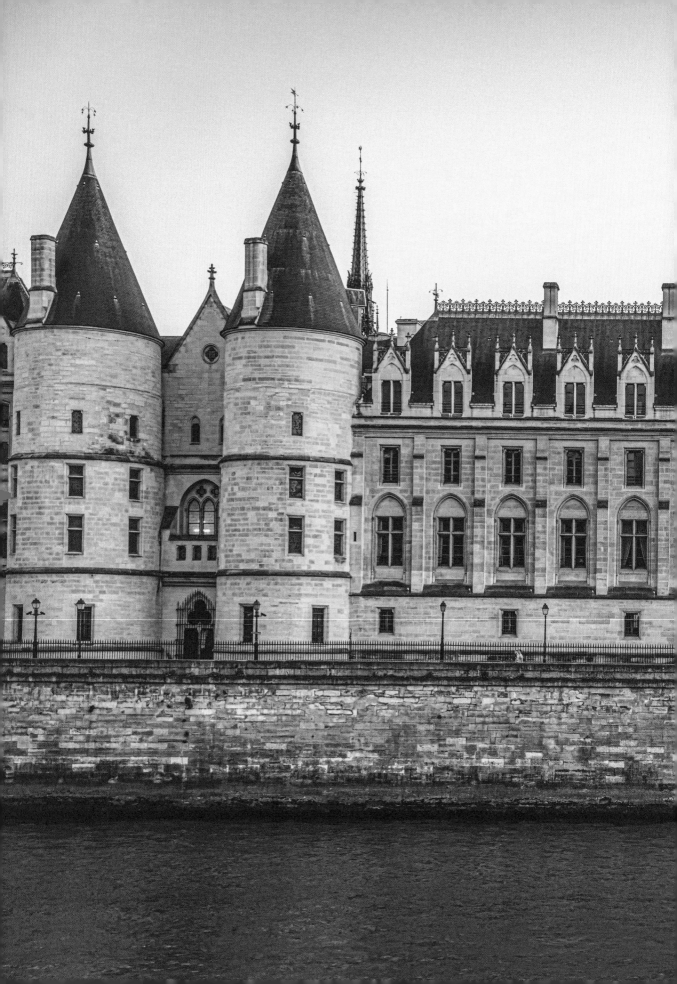

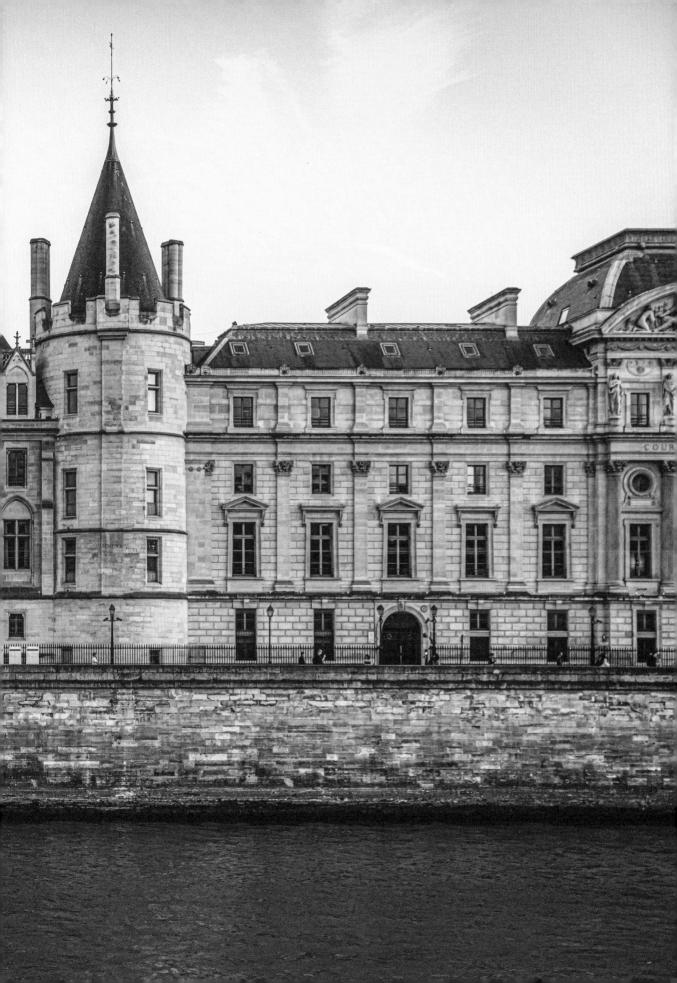

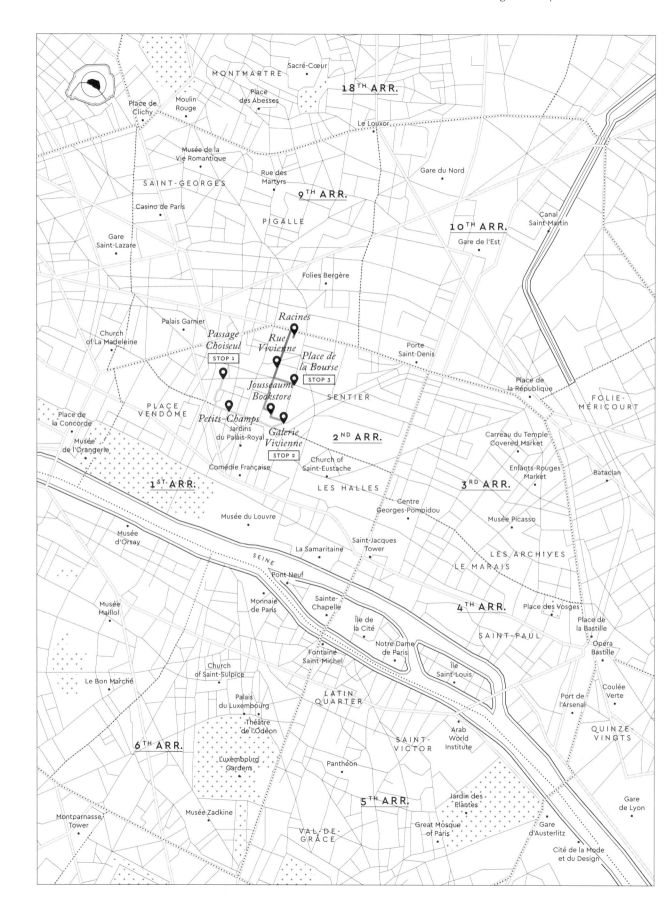

MONTMARTRE

Sacré-Cœur

18TH ARR.

Place de
Clichy

Moulin
Rouge

Place
des Abesses

Le Louxor

Musée de la
Vie Romantique

Gare du Nord

SAINT-GEORGES

Rue des
Martyrs

Casino de Paris

9TH ARR.

Canal
Saint-Martin

PIGALLE

10TH ARR.

Gare
Saint-Lazare

Gare de l'Est

Folies Bergère

Place de
la République

Palais Garnier

Racines

Church
of La Madeleine

*Passage
Choiseul*

*Rue
Vivienne*

STOP 1

Porte
Saint-Denis

FOLIE-
MÉRICOURT

*Place de
la Bourse*

STOP 3

*Jousseaume
Bookstore*

SENTIER

PLACE
VENDÔME

Place de
la Concorde

Petits-Champs

*Galerie
Vivienne*

Carreau du Temple
Covered Market

Musée
de l'Orangerie

Jardins
du Palais-Royal

STOP 2

2ND ARR.

Enfants-Rouges
Market

Bataclan

Comédie Française

Church of
Saint-Eustache

1ST ARR.

LES HALLES

3RD ARR.

Musée du Louvre

Musée Picasso

Centre
Georges-Pompidou

Musée
d'Orsay

SEINE

La Samaritaine

Saint-Jacques
Tower

LES ARCHIVES

LE MARAIS

Pont Neuf

Musée
Maillol

Monnaie
de Paris

Sainte-
Chapelle

4TH ARR.

Place des Vosges

Place de
la Bastille

Le Bon Marché

Church
of Saint-Sulpice

Île de
la Cité

SAINT-PAUL

Opéra
Bastille

Fontaine
Saint-Michel

Notre Dame
de Paris

Île
Saint-Louis

Port de
l'Arsenal

Coulée
Verte

Palais
du Luxembourg

LATIN
QUARTER

Théâtre
de l'Odéon

QUINZE-
VINGTS

6TH ARR.

Luxembourg
Gardens

Panthéon

SAINT-
VICTOR

Arab
World
Institute

Montparnasse
Tower

Musée Zadkine

5TH ARR.

Jardin des
Plantes

Gare
de Lyon

VAL-DE-
GRÂCE

Great Mosque
of Paris

Gare
d'Austerlitz

Cité de la Mode
et du Design

COVERED PASSAGEWAYS

Quintessentially Parisian, covered shopping arcades can be found across the capital
tucked between buildings, offering cozy escapes sheltered from the rain.
During the first half of the nineteenth century, these passages were so appealing
that their numbers grew to one hundred fifty throughout the capital. Although many
have since been demolished, several can still be found in the 2nd arrondissement.

STOP 1: PASSAGE CHOISEUL

This walk begins near the Palais Garnier at 23, rue Saint-Augustin. Built between 1825 and 1827, this covered passage is one of the longest in Paris, extending over 620 feet (190 meters) along the street from where it gets its name.

Simple in appearance, the glass-roofed Passage Choiseul consists of a long suite of arcades on pilasters and offers shops on the mezzanine and ground floor. The upper floor is reserved mainly for residential apartments. The theater has occupied a prominent place here since the opening of the Théâtre des Bouffes-Parisiens. Leaving rue des Petits-Champs, turn left and continue straight until you reach the intersection with rue de la Banque, then turn left again.

STOP 2: GALERIE VIVIENNE

One of this gallery's three entrances is at 5, rue de la Banque. Located just a stone's throw from the Palais-Royal, this chic gallery was built in 1823. The mosaic-paved floor with colorful patterns is dazzling. When the sun is at its peak, an incredible light reveals the details of the neoclassical decor. The half-moon windows adorned with cornucopias, caducei, and laurel wreaths symbolize the economic prosperity of the time.

Be sure to admire the rotunda topped with a glass dome. Once a popular location for festivals, this shopping street has regained its former glory following renovations and has been home to the Jousseaume bookstore since its opening.

STOP 3: PASSAGE DES PANORAMAS

Exit rue Vivienne and walk straight to the Place de la Bourse. The Brongniart Palace in the center of the square was built under the command of Napoleon I between 1808 and 1826. This neoclassical building, which displays rows of columns on each of its facades, is now an event center. Continue walking up rue Vivienne to number 38 and pass through the door to enter one of the oldest passages in Paris. When it opened in 1799, the Passage des Panoramas was well received thanks to its panoramas: painted frescoes exhibited in two rotundas built on the side of the Grands Boulevards. After the demolition of the frescoes in 1834, the arcade continued to attract crowds thanks to the charm of its old signs. Today, philatelists mingle with postcard and old-coin collectors. Be sure to plan a break while here, as this is where a good number of famous restaurants, such as the Italian bistro Racines, are located.

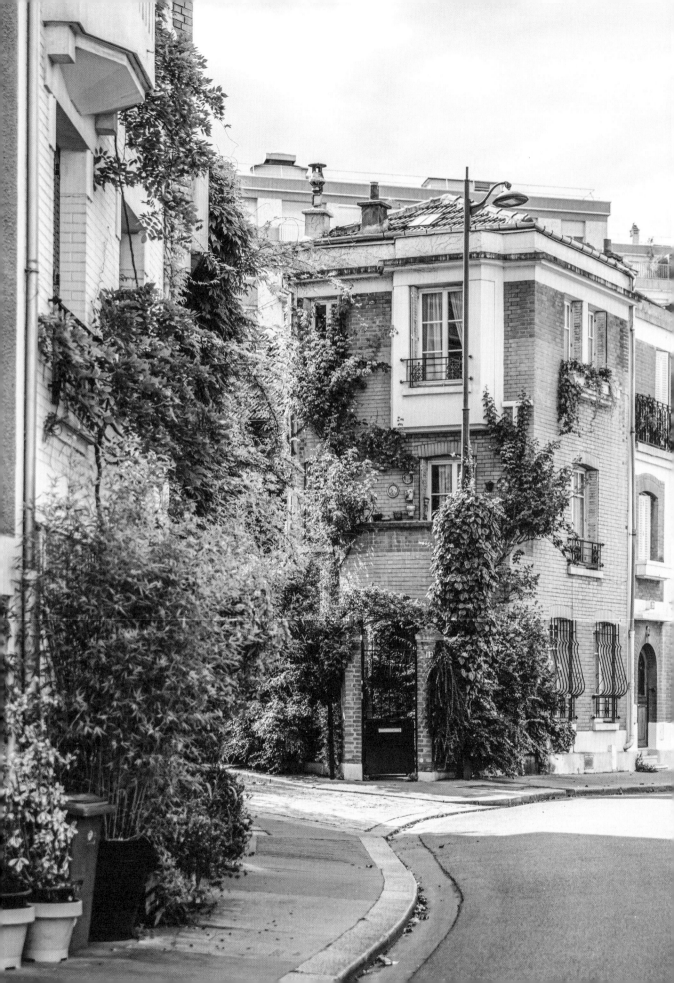

THE EASTERN LEFT BANK

From the famous Latin Quarter to the more secluded Parc de Montsouris,
the eastern arrondissements of the Left Bank, appreciated by artists
and intellectuals for centuries, reveal different facets of the capital.

Few traces of Lutetia remain today in Paris: the amphitheater and the Cluny baths, built during the first and second centuries, are the last vestiges of this era. Established on what is today the Île de la Cité and the slopes of the Left Bank (the 5th arrondissement), the Gallo-Roman city unfolded around a north-south axis that became rue Saint-Jacques. During the Middle Ages, the name "Latin Quarter" was adopted in reference to the students and teachers who, until the time of the Revolution, studied in Latin at the many colleges found here, including the Sorbonne.

A unique atmosphere permeates this district's narrow streets. This is where rue du Chat-qui-Pêche is located, one of the shortest streets in the city at barely sixty-six feet (twenty meters) long. Among its music stores and independent film cinemas, the Latin Quarter's cultural vibe has remained a constant to this day. To the east, around the Jardin des Plantes and its large greenhouses, families and people of all ages who seek a touch of greenery can be seen out for a stroll.

Beyond the Jardin des Plantes emerges the new district of the Bibliothèque Nationale de France (National Public Library of France). The atmosphere here is very different. Tall glass towers have replaced the former industrial lands and anchor the 13th arrondissement in the twenty-first century. Several other venues have sprung up in the area, including the Cité de la Mode et du Design (City of Fashion and Design) with its bright green exterior, and a gigantic hall dedicated to digital commerce.

To the south, the entrance to Chinatown is marked by a series of pagodas located on the esplanade of Les Olympiades. Among all the Asian restaurants and shops here, supermarket Tang Frères is undoubtedly the most well known. The fruits, pastas, and other delicacies along its aisles will instantly whet your appetite.

To go back in time, head to the Butte aux Cailles where there were once mills built along the Bièvre. At the end of the nineteenth century, this river was buried because its waters had become unhealthy. Only a few plaques fixed to the ground today recall its route. Due to the instability of its subsoil, this district has eluded major real estate development. You can still admire the Art Deco villas of the Cité Florale, a micro-district of houses with streets bearing the names of flowers, and the half-timbered houses of Petite-Alsace, an equally exotic set of dwellings.

The 14th arrondissement has long been a hangout for artists in Paris. The Fondation Cartier, the Institut Giacometti, and the theaters of rue de la Gaîté continue to promote creativity here. This vast district is divided into different villages, such as Plaisance, Pernety, and Montsouris, whose enormous park offers thirty-seven acres (fifteen hectares) of green space.

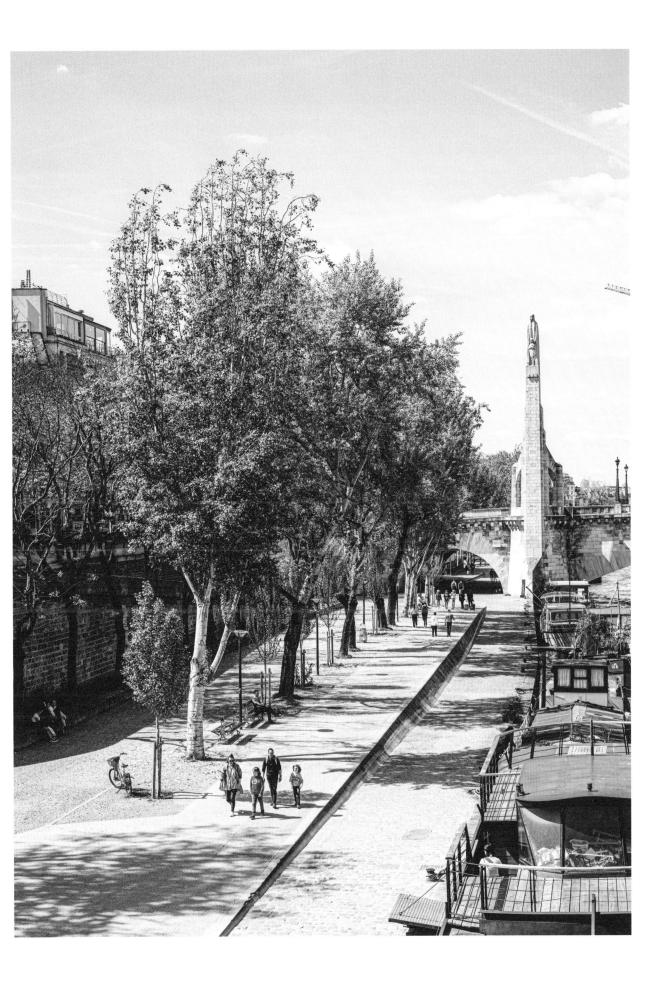

THE ESSENTIALS

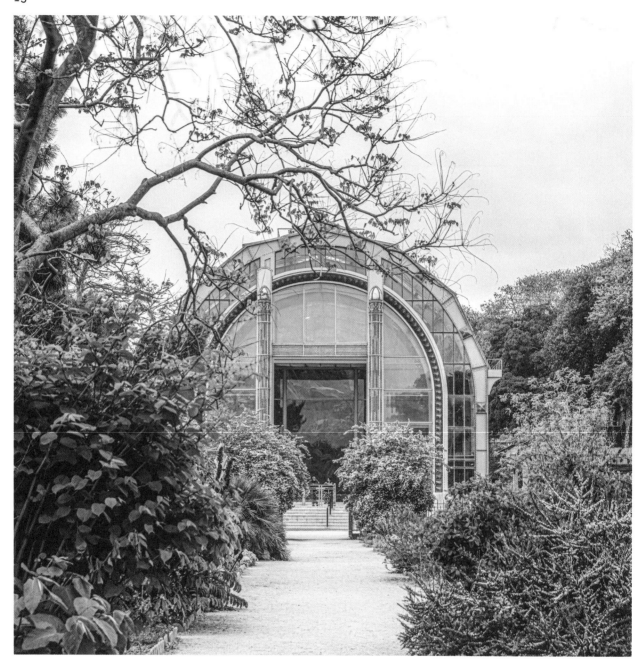

JARDIN DES PLANTES (5TH)

Situated on just over 6 acres (2½ hectares), this park welcomes thousands
of visitors each year who delight in discovering its large greenhouses,
specialized gardens, and menagerie.

14

CITÉ FLORALE (13TH)

This micro-district dating to the 1920s has maintained its charm and offers a small plot of green space within Paris.

15

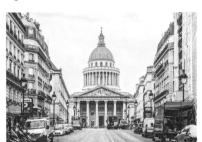

PANTHEON (5TH)

This church was transformed during the Revolution into a secular and Republican temple where the country's great personalities (including Émile Zola and Marie Curie) are interred.

16

CITÉ DE LA MODE ET DU DESIGN (13TH)

On the banks of the Seine, the industrial buildings of the Magasins Généraux were replaced in 2012 with this cultural venue that celebrates the avant-garde of fashion and design.

17

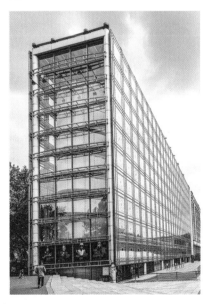

ARAB WORLD INSTITUTE (5TH)

This institute has promoted Arab culture in Paris since its opening in 1987. With a facade of "moucharabiehs," this remarkable building was designed by Jean Nouvel and Architecture-Studio.

18

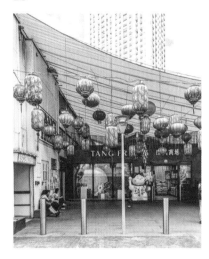

CHINATOWN (13TH)

Found at the cross points of avenue d'Ivry, avenue de Choisy, and boulevard Massena, the city's Chinatown is abundant with traditional Chinese restaurants and shops.

19

BUTTE AUX CAILLES (13TH)

With its half-timbered houses and cobblestoned streets, this district has retained its character over the centuries and is an inviting place to walk.

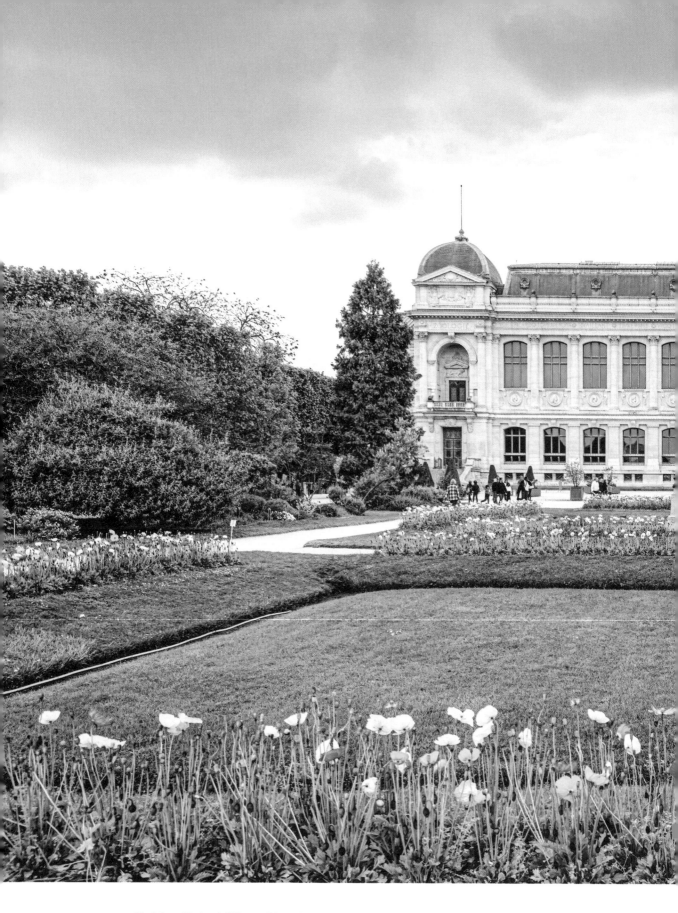

The Musée National d'Histoire Naturelle is within the Jardin des Plantes, a stone's throw from the Seine.

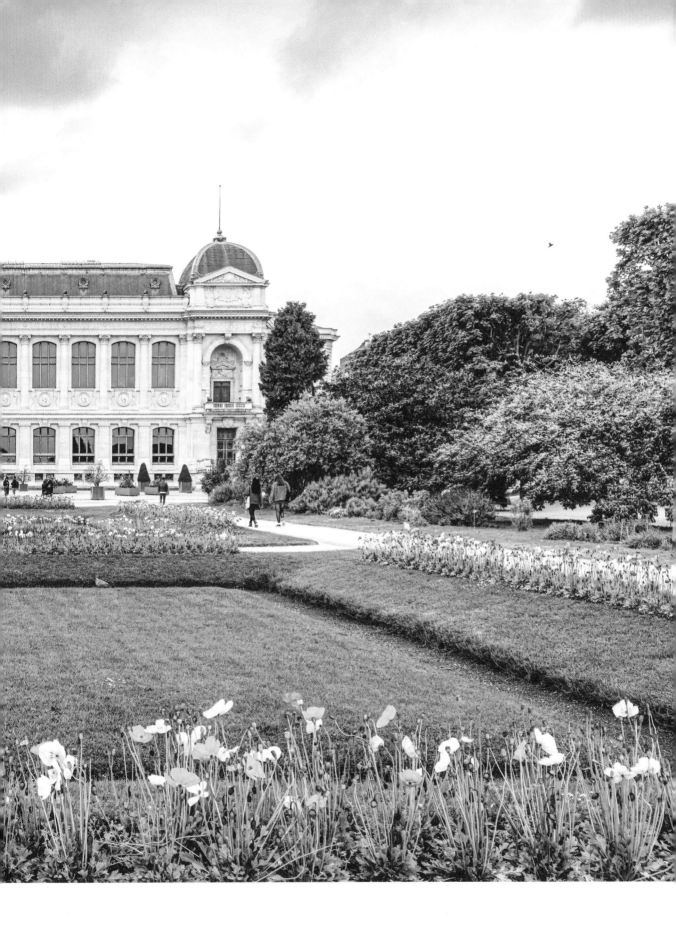

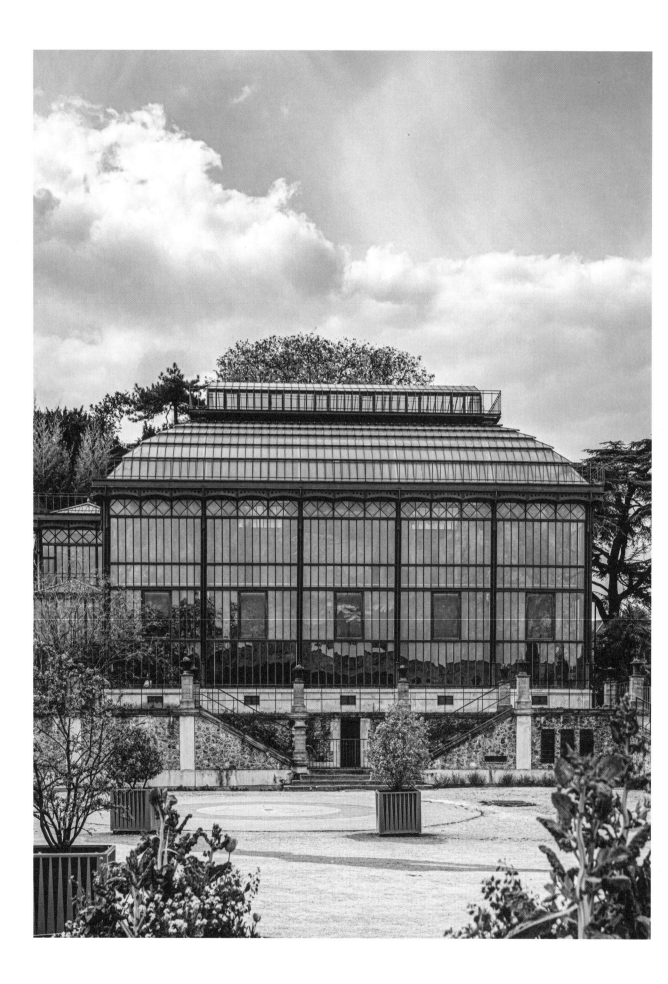

*The Jardin des Plantes has eleven gardens, including the Grandes Serres,
an iris and perennial garden, and even a maze.*

*The five greenhouses of the Jardin des Plantes present different natural
environments, from the maquis to the mangrove to a rainforest.*

HISTORY

THE NATIONAL MUSEUM OF NATURAL HISTORY

Since its founding in 1793, the Musée National d'Histoire Naturelle (National Museum of Natural History) has fascinated those curious about Earth and life. Visit its Jardin des Plantes (Garden of Plants) or observe reproductions of elephants in its Grande Galerie de l'Évolution (Gallery of Evolution) among its other sites in the 5th arrondissement dedicated to the pursuit of scientific excellence.

The story began when King Louis XIII ordered the creation of the Jardin Royal des Plantes Médicinales (Royal Garden of Medicinal Plants) in 1636. After five years of construction, the space opened free of charge to the public. Botany, chemistry, and anatomy were taught here—a sacrilege according to the Church, which considered that natural history should not be the subject of scientific research. This opposition, however, did not prevent the garden from gaining international notoriety during the following century.

The land soon occupied sixty-four acres (twenty-six hectares) nestled along the Seine, and more and more plants were brought back from travels and acclimatized to the conditions in Paris. *Coffea arabica* thus introduced the virtues of coffee to the French, and its exploitation began in the West Indies starting in 1721. The display of exotic animal species was also a result of expeditions to other points around the globe. In 1771, Pierre Sonnerat discovered the dodo on the road to the East Indies. The institution then set up a methodology for the collection and conservation of species.

After the French Revolution, the Musée National d'Histoire Naturelle was created, and it prospered during the first half of the nineteenth century. Its collections were enriched by ongoing scientific explorations. After the Second World War, the institution supported the fight against man's devastation and pollution of natural environments by co-creating l'Union Internationale pour la Conservation de la Nature (International Union for the Conservation of Nature), or UICN.

The museum remains committed to the advancement of science. In addition to their maritime missions in Corsica, which aim to sample algae and marine and land invertebrates, researchers also study signs of life on Mars!

Herbariums, meteorites, mollusks, microorganisms—with its sixty-eight million specimens, the building now houses one of the three largest collections of natural history objects in the world, exhibited in permanent galleries or temporary exhibitions as well as in greenhouses, the zoological park, and other sites, such as the Marinarium de Concarneau.

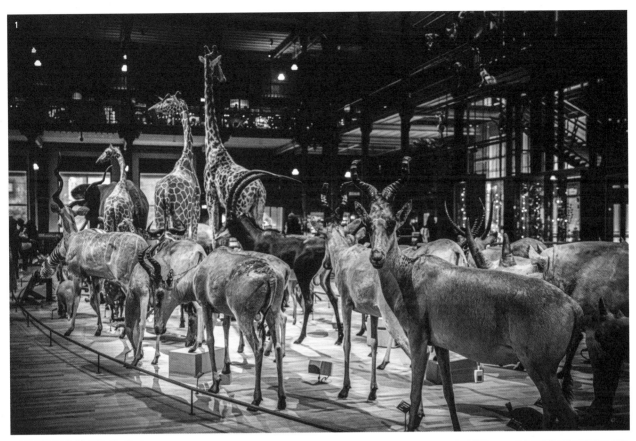

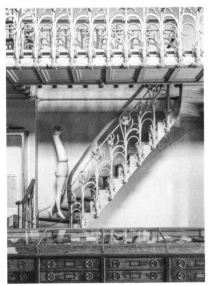

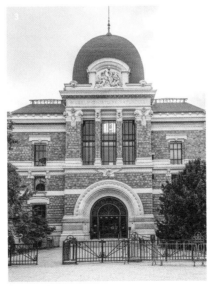

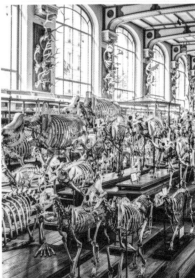

1. THE GRAND GALLERY

The Grande Galerie de l'Évolution presents some 7,000 species of animals and addresses man's impact on nature.

2. AND 3. AN ALL-NATURAL HISTORY

From paleontology to geology to mineralogy, each museum gallery has a specialty.

4. HISTORY IN BONES

Skeletons of a herd of large terrestrial and aquatic vertebrates are lined up in the gallery of comparative anatomy.

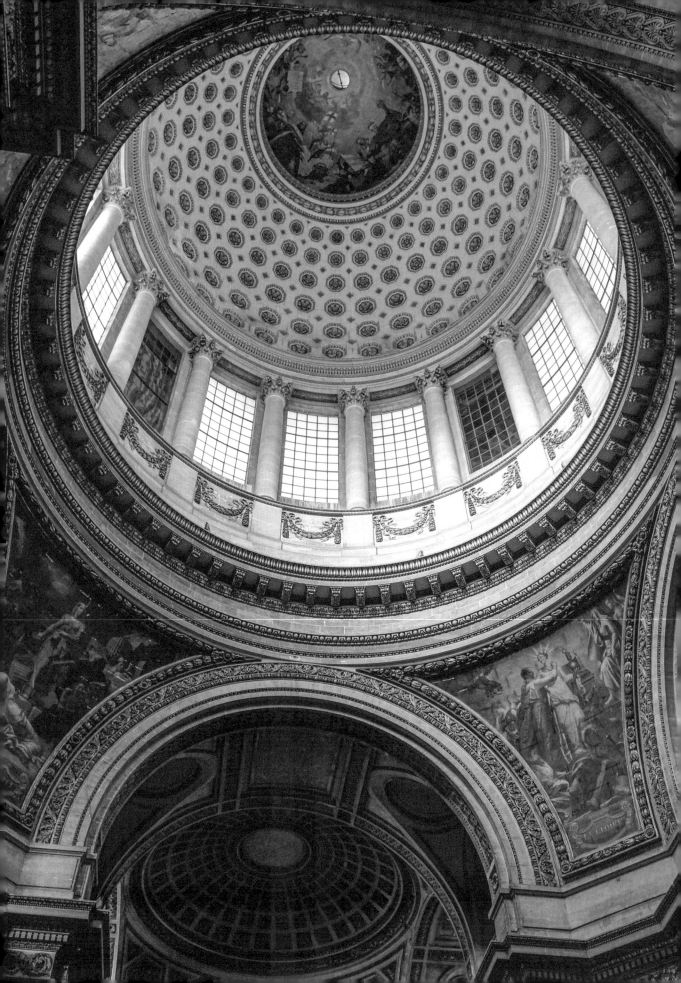

ABOVE

*On rue Galande, this half-timbered house bears
witness to the city's medieval past.*

LEFT

*In the heart of the Latin Quarter, the Pantheon's dome
rises to 272 feet (83 meters). The building is composed of
three interlocking structures including its dome.*

VISITING

GREAT MOSQUE OF PARIS

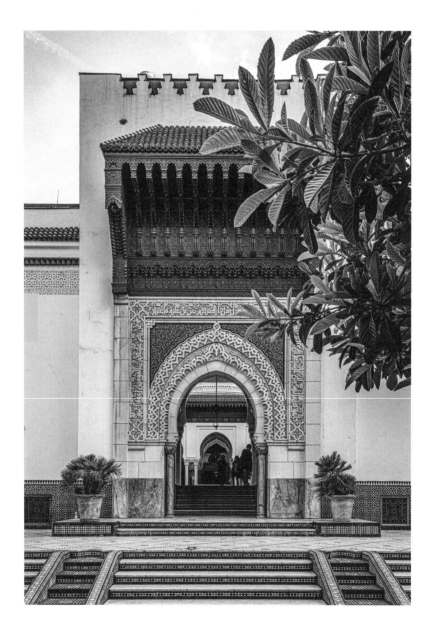

ISLAM IN PARIS

Located in the Latin Quarter, this religious structure was built between
1922 and 1926 to recognize the role of Muslims in the country.

MOROCCAN INFLUENCES

In a neo-Moorish style, the buildings and gardens are inspired by the mosques of Fez.

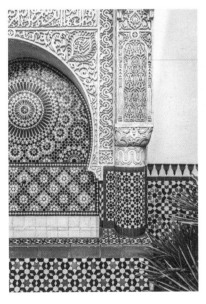

EXCELLENT CRAFTSMANSHIP

The various mosaics (called zelliges) that adorn the mosque are made of pieces of tile in geometric shapes.

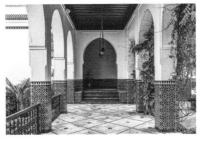

COLONNADES

The Andalusian garden is surrounded by galleries adorned by multicolored mosaics.

TEAROOM

The richly decorated patio houses a quaint tearoom to enjoy mint tea and pastries.

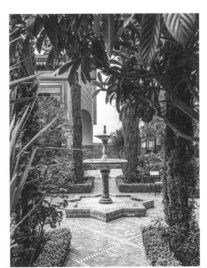

AN EXOTIC FEEL

The scent of cypresses, lemon trees, and pomegranate trees gives visitors the impression of being far from Paris.

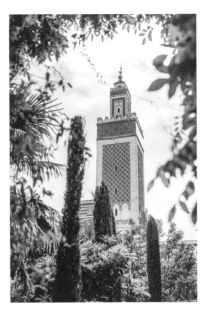

AT THE TOP

A minaret 108 feet (33 meters) high dominates the Great Mosque of Paris.

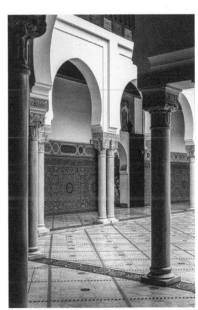

GRAND COURTYARD

The marble courtyard mixes different elements of Islamic decorative art, such as mosaics, ceramics, and stucco.

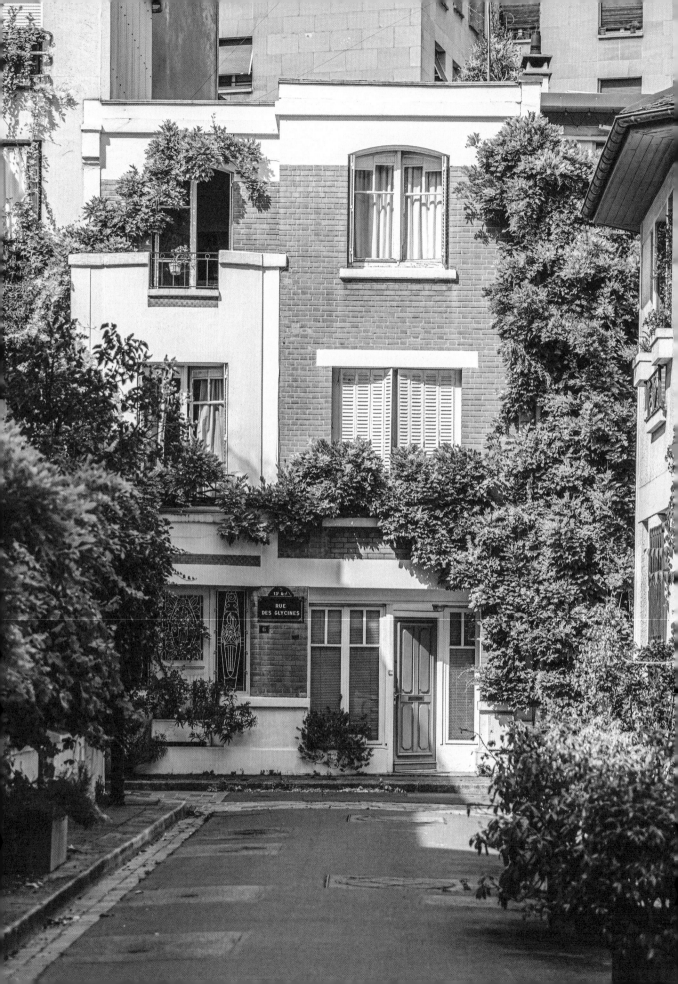

ABOVE

Street artist Julien Malland, nicknamed Seth Globepainter, depicts childhood in the frescoes he paints around the world.

LEFT

Five pathways make up the Cité Florale. Each has a flower-themed name, such as rue des Glycines (Wisteria Street).

UNDERSTANDING

THE CATACOMBS

In the Denfert-Rochereau district, the largest ossuary in the world
has been open to the public since 1809. Six million bones,
displaced when Parisian cemeteries were closed, rest in
these underground corridors.

This Parisian maze resulted from the closure of the Cimetière des Saints-Innocents (Holy Innocents' Cemetery) in 1785. After an accumulation of almost a thousand years of corpses and mass graves, this cemetery in the heart of the capital had become unsanitary, creating difficult conditions for residents.

The Conseil d'État decided to exhume the remains, part of which were from the old quarries of the Tombe-Issoire on the Montrouge plain. Removing the remains made it possible to eradicate what had become a hotbed for infections in the city's center. The capital, therefore, continued to store human remains from other parishes in these new catacombs. Until 1860, all the remains buried in the capital were transported to the catacombs, located sixty-six feet (twenty meters) underground.

This veritable underground labyrinth covering 118,000 square feet (11,000 square meters) is isolated from the rest of the old quarries thanks to masonry walls. Once the empty sections were filled in, it became possible to design the galleries while fortifying the structure. The bones were left loose in the galleries until a 2,620-foot (eight-hundred-meter) pathway was opened to the public, encouraging the administration to adopt a museum-style layout for the remains.

Inspector Héricart de Thury, in charge of the construction site, first drained the water to clean up the space then ensured the galleries and the quarry ceiling were secure. The arrangement of the bones was inspired by the aesthetics of ancient catacombs. Thus, walls of rows of skulls and femurs are exposed while concealing the more damaged remains. The funerary monuments—such as the sepulchral lamp, the crematorium sarcophagus, and the Samaritan woman's fountain—somewhat attenuate the morbid character of the mountains of bones.

In this vast necropolis, the world of the dead was, for the first time in Paris, separated from the world of the living. Thury, therefore, considered it a place of recollection. Religious and philosophical quotations are inscribed on plaques and pillars in French, Greek, and Swedish.

From a geological point of view, the Paris catacombs are today the only place in the Île-de-France region that reveals the origins of the Parisian subsoil, which offers a fascinating glimpse of a succession of rock layers representing forty-five million years, lying between the ossuary and the street above it. This is a remarkable site that the city works to preserve to ensure the deceased are provided a dignified final resting place.

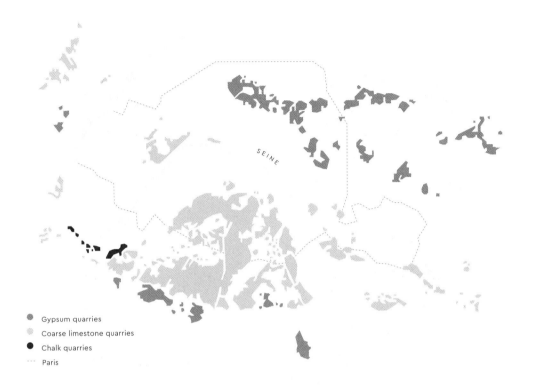

PARIS'S SUBSOILS

- Gypsum quarries
- Coarse limestone quarries
- Chalk quarries
- --- Paris

SEINE

CITY (Street Level)			
BACKFILL (-2000 years)	Sewers and pipes		
SANDS OF BEAUCHAMPS (-3.6 million years)			
	Metro subway system		
MARLS AND SCREE (-40 million years)			
ROCK BANK		Upper floor of underground quarries*	
BANC VERT (Green bank)			
SOLID LIMESTONE		Lower floor of underground quarries**	
SANDY LIMESTONE (-45 million years)			
SAND AND CLAY			

0 ft. (0 m)

68 ft. (21 m)

7 ft. (2 m)

5 ft. (1.6 m)

10 ft. (3 m)

*UPPER FLOOR OF UNDERGROUND QUARRIES (7 ft./2 m)
Rock
Ludian gypsum
Banc franc (bank of medium Lutetian limestones)
Banc blanc (White bank)
Soft stone bank
Grignard (crystallized gypsum)
Pebble bank
Alberese limestone
Gros blanc
Rock
**LOWER FLOOR OF UNDERGROUND QUARRIES (10 ft./3 m)
Banc royal (very soft Lutetian limestones)
Batten floor
Slate bank
Greenish bottom

THE GEOGRAPHY OF PARISIAN QUARRIES

The materials that were used for the construction of the capital's buildings and monuments were extracted from the underground quarries beneath the city and its surrounding areas. These materials include gypsum and chalk, which were transformed, respectively, into plaster and putty, as well as coarse limestone, which was cut into stone blocks.

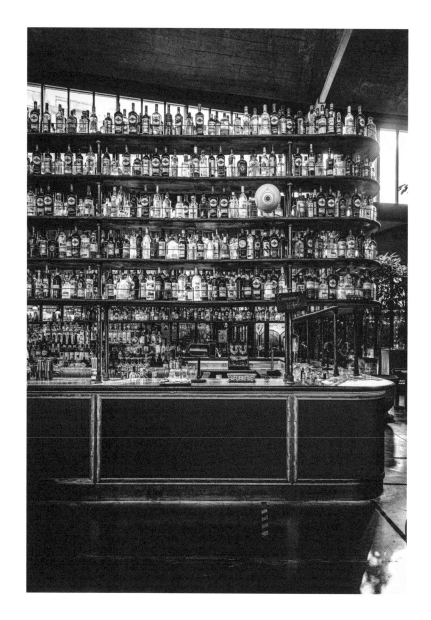

ABOVE

Opened in 2017, Station F, the largest startup campus in the world, is also home to La Felicità, a vast space of Italian-style restaurants and bars.

RIGHT

Managed by the Big Mamma group, La Felicità has five kitchens and three bars, enough to accommodate large tables of guests!

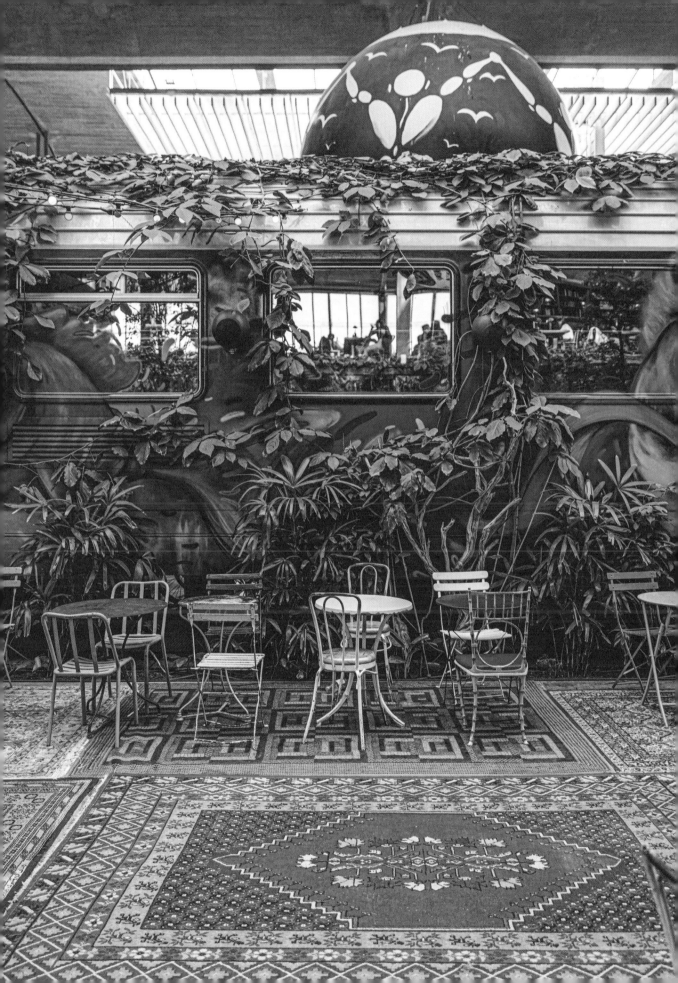

ARCHITECTURE

FRANÇOIS-MITTERRAND LIBRARY

URBAN ARTWORK

The Bibliothèque François-Mitterrand (François-Mitterrand Library), situated facing the Seine in the 13th arrondissement, opened to the public in 1998. A symbol of minimalist contemporary architecture, its four angular towers rise to 259 feet (seventy-nine meters) and are among the most emblematic buildings in Paris.

From its esplanade, the library's silhouette suggests four open books perched atop steps. The last of the major projects spearheaded by president François Mitterrand after the Opéra Bastille and the Arab World Institute, the 430,600-square-foot (forty-thousand-square-meter) building is the result of an international competition. The design selected was by architect and urban planner Dominique Perrault. Both classic and minimalist in style, the library is a response to the desire to expand and modernize the National Library of France. As a large-scale project, it is now part of the history of Parisian architecture.

When he sketched the structure, Dominique Perrault was sure about one thing: he had to address the structure's light as much as its material. To do this, the open book–shaped towers are wrapped in a double facade of glass and sunshades to amplify reflections and shadows. Rising at the four corners of a vast platform made of Brazilian ipe wood, the towers surround a central courtyard filled with pine trees from a forest in Normandy.

The interior leaves nothing to chance. The architect considered the project as a whole and cultivated a taste for detail in the layout and furnishings. Each

wing houses seven floors of offices and eleven floors of storage while the reading rooms are located at the base of the buildings facing the garden. Although the heritage collections are reserved for researchers, the public library is accessible to those aged sixteen and up with a purchased pass. With a collection of tens of millions of books and other documents, this is one of the largest libraries in the world.

For the interior decor, Perrault teamed up with designer Gaëlle Lauriot-Prévost. The floor's red Terre d'Afrique carpet was chosen by President Mitterrand himself. This is the only bold color in the structure, which combines a repertoire of industrial materials, such as wood, metal, concrete, and glass. Beyond the aesthetics, this austerity in design creates an inviting atmosphere. Readers discover a place of serenity conducive to studies and contemplation, as light continually transforms the space.

Today, the François-Mitterrand Library is the nerve center of the Paris Rive Gauche district, which stretches from Gare d'Austerlitz train station to the avenue de France. Its esplanade regularly hosts food trucks and cultural events, including concerts and dance performances.

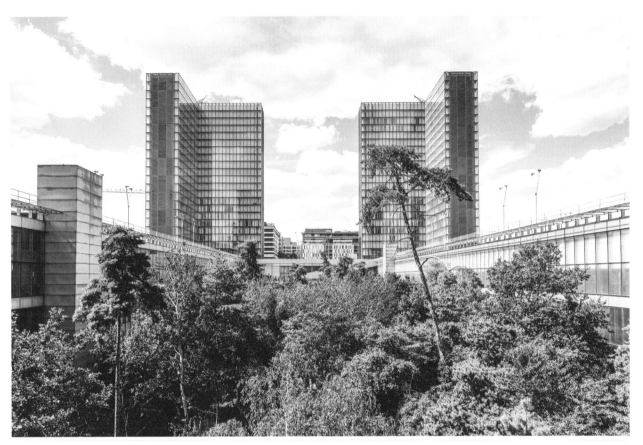

1. FUTURISTIC

Viewed from across the river, the silhouette of the Bibliothèque François-Mitterrand depicts the Paris of tomorrow.

2. COMFORT & DESIGN

Bathed in light, the reading rooms are models of design.

3. FOUR TOWERS

The towers evoking open books are wrapped in a double facade of glass and sunshades to amplify reflections and shadows.

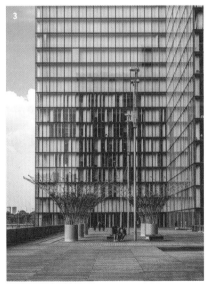

4. VISITING

Accompanied by a guide, visitors can go behind the scenes of the library and even access the top-floor lookout point that offers an incredible panorama of Paris.

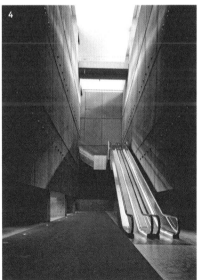

ABOVE

*Created in 1976, Tang Frères's busiest location is in Chinatown
in the 13th arrondissement.*

LEFT

*In the Les Olympiades district, shoppers can find Laotian, Cambodian,
Vietnamese, and Chinese brands displayed together.*

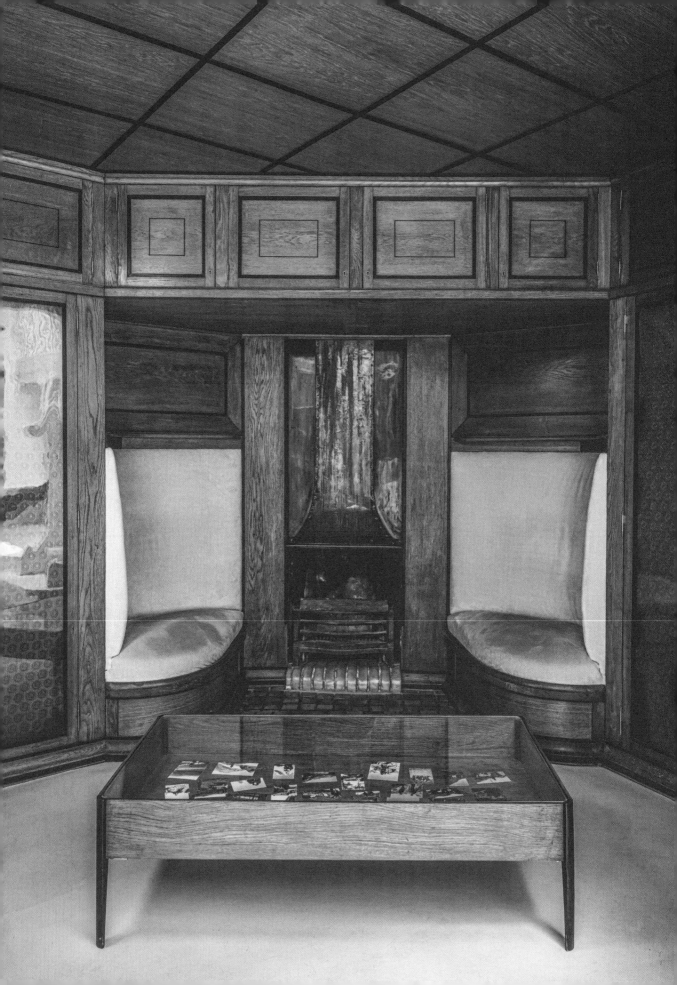

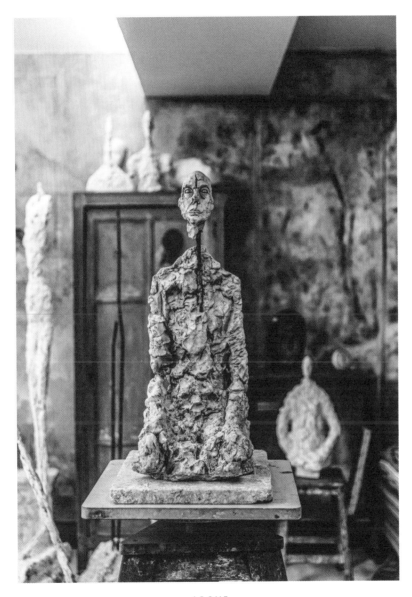

*The former studio of the sculptor (1901–1966) has been replicated
in the Institut Giacometti.*

*This 3,700-square-foot (350-square-meter) museum has remained
approachable in size, but future expansion is anticipated.*

THE ARTISTS' MONTPARNASSE

At the beginning of the twentieth century, Montparnasse experienced an unprecedented cultural movement that is still perceptible today.

STOP 1: RUE CAMPAGNE-PREMIÈRE

Close to Luxembourg Gardens, La Closerie des Lilas has been an important gathering place for intellectuals since 1847. Ernest Hemingway, Pablo Picasso, Paul Verlaine, Oscar Wilde, and Amedeo Modigliani are among the brasserie's most illustrious regulars. And even though the menu is aimed at wealthy travelers, the budget traveler can still, if on a budget, enter just to admire the Art Deco interior, mahogany bar, mosaic floor, and legendary arbor.

On the other side of boulevard du Montparnasse, you will find rue Campagne-Première. This is where many artists chose to settle. The poet Louis Aragon and his partner, writer Elsa Triolet, lived in a studio at number 5. Hidden behind the building at number 9 is a former artists' community with 128 studios where painters such as Joan Miró, Léonard Foujita, and Vassily Kandinsky each established themselves. Unfortunately, the entrance is reserved for residents only. At 29, a hotel once housed penniless artists, including Kiki de Montparnasse, a cabaret performer and muse to photographer Man Ray.

Two doors away at 31, an incredible building impresses with its Art Deco facade. Between its floor-to-ceiling windows and ceramic cladding that changes colors at sunset, it is no wonder that aesthetes become enchanted. Sculptors originally occupied the ground floor while painters lived on the upper floors, but the westward exposure of the building made drawing difficult, and the workshops quickly changed to meeting places.

The access gate to the Passage d'Enfer at the corner with boulevard Raspail is often open. This is an excellent opportunity to venture among private town houses and admire the back of the Art Deco building at 31.

STOP 2: INSTITUT GIACOMETTI

Walk down boulevard Raspail to rue Victor-Schoelcher to this intimate museum, which invites visitors to discover the work of Swiss artist Alberto Giacometti (1901–1966), by appointment only. The museum gives a sense of walking through the artist's house. His studio near rue d'Alésia is completely replicated in a 250-square-foot (twenty-three-square-meter) space. The murals and the original furniture make it possible to lose yourself in Giacometti's universe: a collector, painter, and sculptor who was first a cubist then a surrealist. Next, stroll through the remaining 3,700 square feet (350 square meters), bathed in light, where several hundred slender sculptures are on display, as well as temporary installations dedicated to different facets of the artist's life.

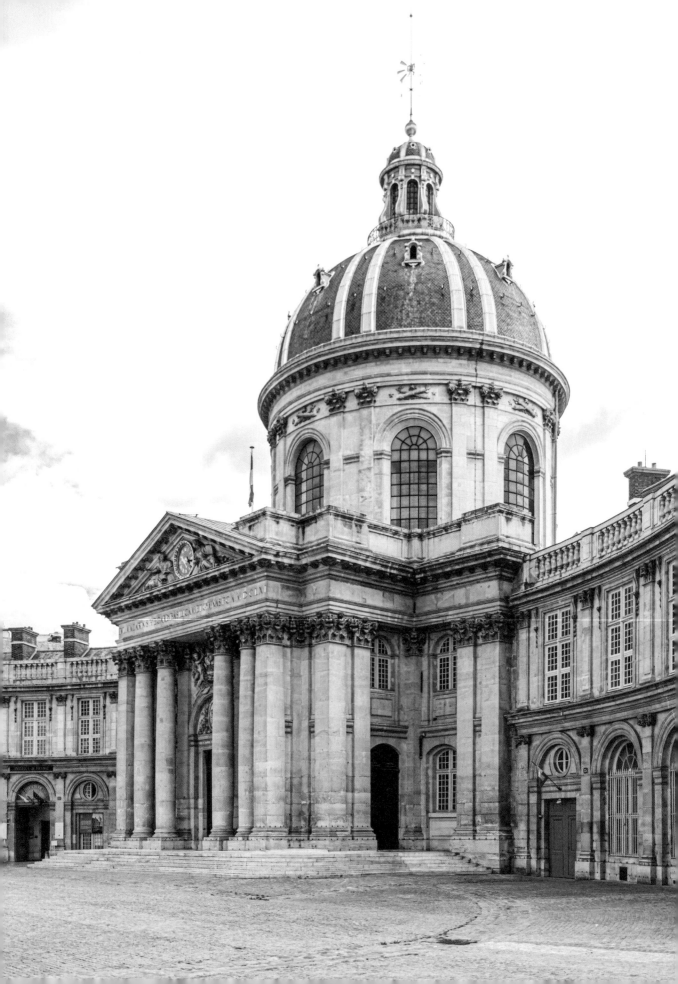

THE WESTERN LEFT BANK

Loved by tourists for its remarkable monuments and museums,
the capital's southwestern sector presents picture-postcard views.
This is where many Parisians choose to live.

P.74

*The Institut de France, the seat of five learned academies,
defines itself as the "Protector of Arts, Literature, and Science." The building
has been facing the Pont des Arts since the seventeenth century.*

RIGHT

Curved lines and ornamentation embellish the Haussmann buildings of the Odéon district.

In the 6th arrondissement, Saint-Germain-des-Prés, once the favored district of the nobility and named after the oldest church in Paris located here, is now the preferred district among intellectuals. After the Second World War, the literary and artistic world flocked to Café de Flore, Les Deux Magots, and Brasserie Lipp to exchange views, listen to jazz, and write and recite poems. Simone de Beauvoir, Jean-Paul Sartre, and Jacques Prévert were among them, as were Boris Vian and Marguerite Duras. Juliette Gréco and Léo Ferré sang in the cellar clubs, where the Parisian youth congregated each night. Today, the art galleries that surround rue de Seine, as well as some publishing houses, continue to attract the intelligentsia.

On the edge of Saint-Germain-des-Prés, Luxembourg Gardens are reminiscent of the Boboli Gardens in Florence. Covering nearly sixty-one acres (twenty-five hectares), the gardens are home to a rose garden, greenhouses, a large central basin where miniature sailboats glide along the water, and even an apiary. There is nothing like relaxing in one of the many green chairs scattered throughout the gardens to enjoy a moment under the sun. Those seeking a little more action can also try their hand at chess, tai chi, and even *longue paume* (an outdoor racket game popular in the past) every Sunday morning with the assistance of on-site instructors. Today, the Senate occupies the garden's palace.

The National Assembly, embassies, and many ministries can be found in the 7th arrondissement. Some of the city's most famous monuments can also be found here, such as the Eiffel Tower, which rises to nearly 1,080 feet (330 meters), but also Les Invalides and the Musée du Quai Branly Jacques Chirac with its collections of African, American, Asian, and Oceanic arts. More upscale than its neighboring district, this arrondissement has a particular taste for exclusivity. Chic avenues, urban mansions, and high-end brands can easily be found here. Le Bon Marché Rive Gauche is the oldest department store in Paris. Since its opening in 1838, trendy products and fashion brands have elegantly filled its shelves. The department store is also home to the Grande Épicerie, which offers the ultimate experience in food products.

Continuing to the 15th arrondissement, you will discover a city in its own right, frequented by families. There is no shortage of places to stroll here: Georges-Brassens and André-Citroën parks, the banks of the Seine near the Port de Javel, La Petite Ceinture public green space, and others. Méconnus, the sculpture gardens of the Musée Bourdelle, is a must-see. The top of Montparnasse tower offers a breathtaking view of the city.

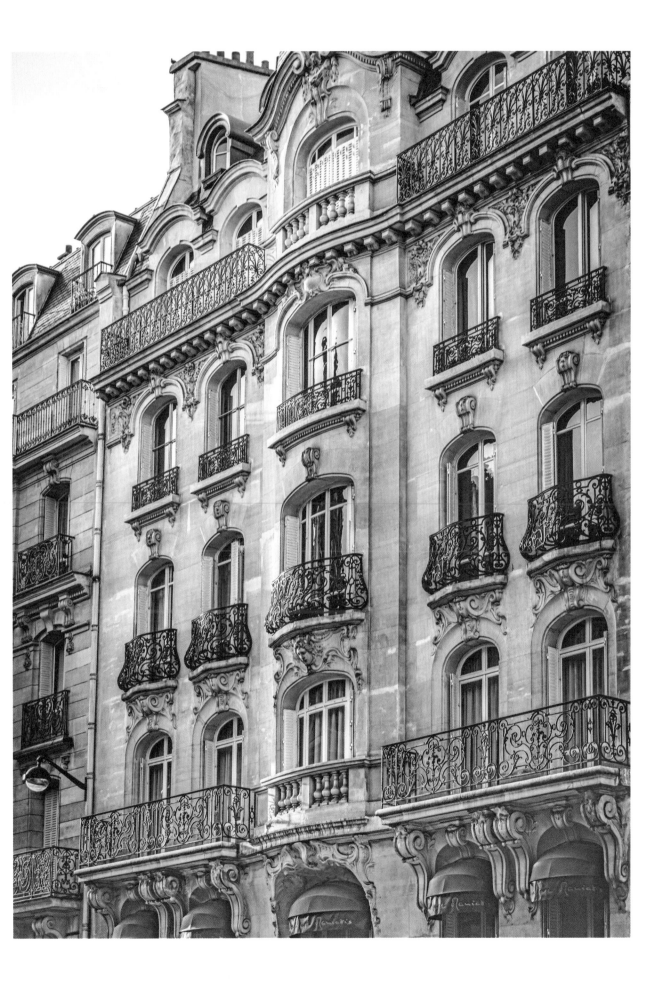

THE ESSENTIALS

20

CAFÉ DE FLORE (6ᵀᴴ)

A haunt of the Parisian intelligentsia from 1910 to the 1950s, this nineteenth-century café has counted Beauvoir, Sartre, Camus, Aragon, and many other intellectuals among its clientele.

21

MUSÉE DU QUAI BRANLY - JACQUES-CHIRAC (7ᵀᴴ)

Housed in a jewel of modern architecture designed by Jean Nouvel, this museum unites the largest French collection of non-Western ethnographic artifacts.

22

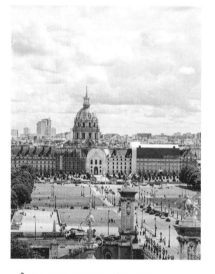

HÔTEL DES INVALIDES (7ᵀᴴ)

This former military hospital houses the Army Museum. Its golden dome protects the red quartzite tomb of Napoleon I.

23

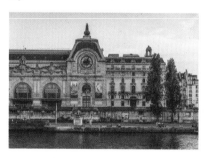

MUSÉE D'ORSAY (7ᵀᴴ)

In addition to the stunning views of Paris that emerge through the face of its clocks, this museum displays the world's most extensive collection of Impressionist paintings.

24

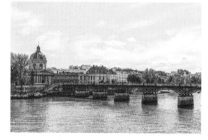

PONT DES ARTS (6ᵀᴴ)

This iron pedestrian bridge is a favorite rendezvous for couples seeking a romantic spot.

25

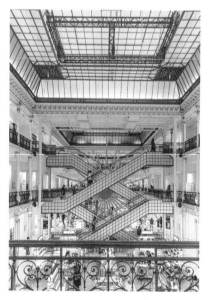

BON MARCHÉ LEFT BANK (7ᵀᴴ)

Bon Marché, founded in 1852 as Paris's first department store, is said to have inspired Émile Zola's novel *Au bonheur des dames*. A wide selection of fashion, furniture, and foods is offered here.

26

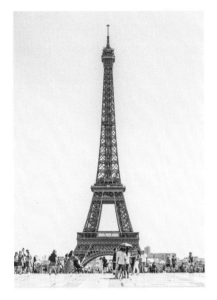

EIFFEL TOWER (7TH)

The tower is the most visited monument in the capital and offers a bird's-eye view of all of Paris from its three platforms.

27

THE BOUQUINISTES (6TH)

This vast stretch of 226 open-air booksellers runs along both banks of the Seine. Displayed inside their famous green boxes are hundreds of thousands of old books.

28

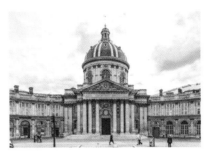

INSTITUT DE FRANCE (6TH)

This building has been facing the Pont des Arts since the seventeenth century and is where the members of five academies, the most famous of which is the Académie Française, meet under the structure's towering dome.

29

MUSÉE RODIN (7TH)

This eighteenth-century mansion and its 5-acre (2-hectare) gardens guard the sculptures and molds of Auguste Rodin.

30

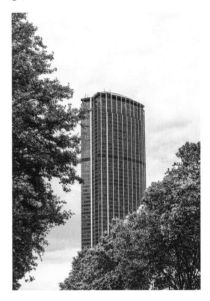

MONTPARNASSE TOWER (14TH)

This 690-foot (210-meter) tower boasts the fastest elevator in Europe, delivering you to the top in only 38 seconds.

31

THÉÂTRE DE L'ODÉON (6TH)

Inaugurated in 1782, this masterpiece of neoclassical architecture is the oldest theater-monument in Europe still in operation.

ABOVE

For decades, children have been sailing miniature sailboats
in the water pool of Luxembourg Gardens.

RIGHT

The 4,500 chairs in the Luxembourg Gardens are among
the most emblematic symbols of the capital.

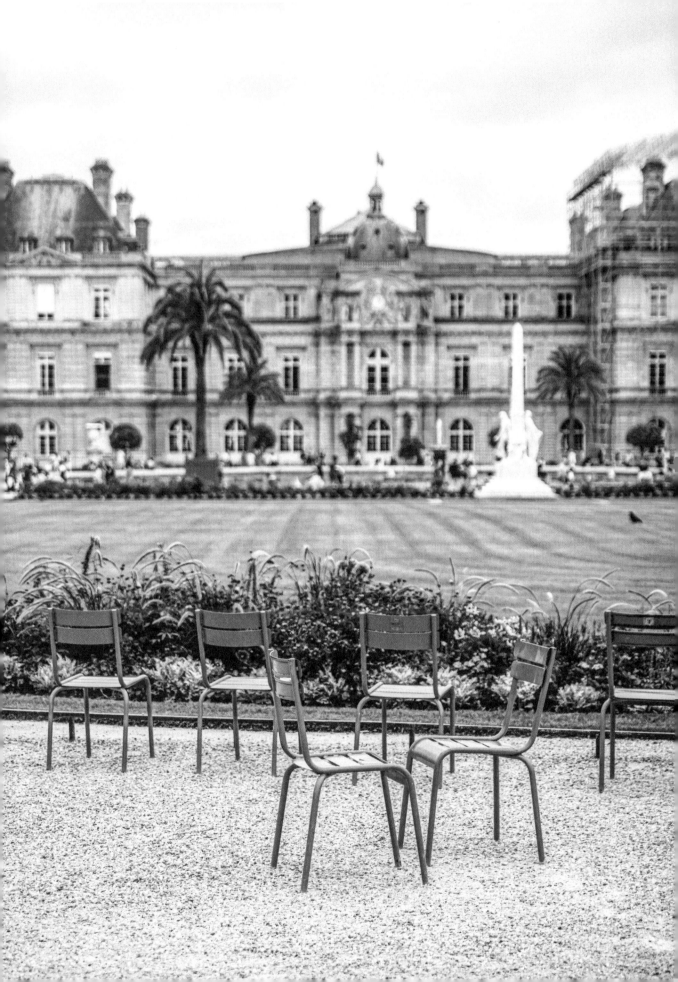

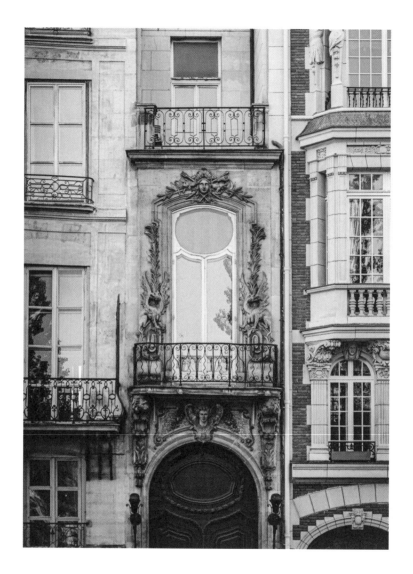

ABOVE

*Taking the time to admire the facades of Parisian buildings
allows you to soak up the city's architectural richness.*

RIGHT

*The 226 bouquinistes store more than 300,000 second-hand books inside their
iconic green boxes, but they also offer prints, magazines, and collector's cards.*

PAGE.84–85

*The Pont des Arts was the capital's first work of art in iron and
connects the Institut de France to the Louvre Museum.*

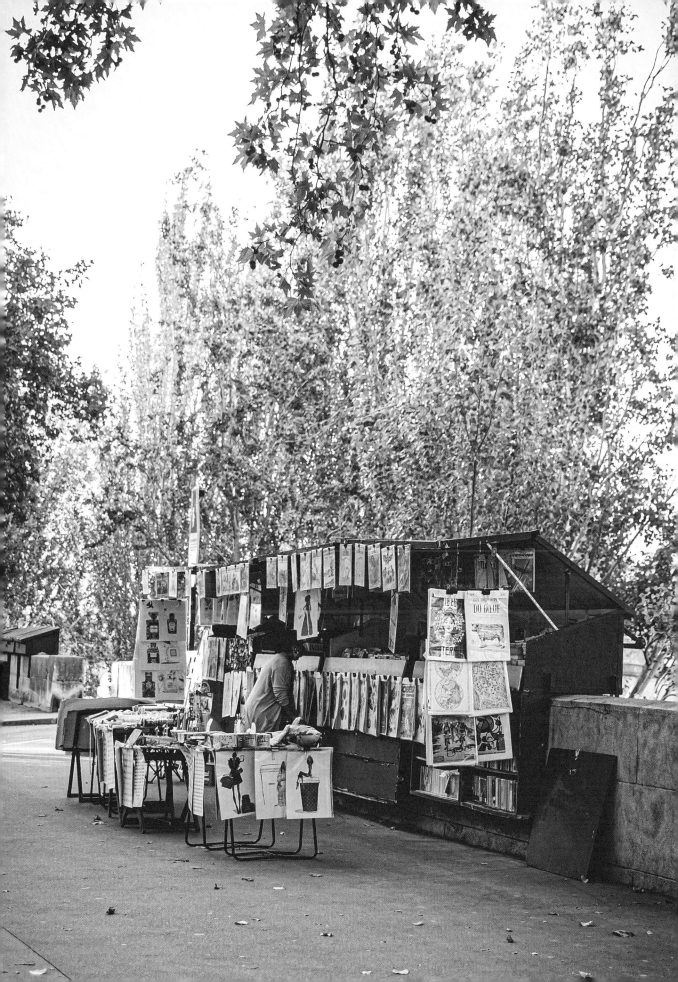

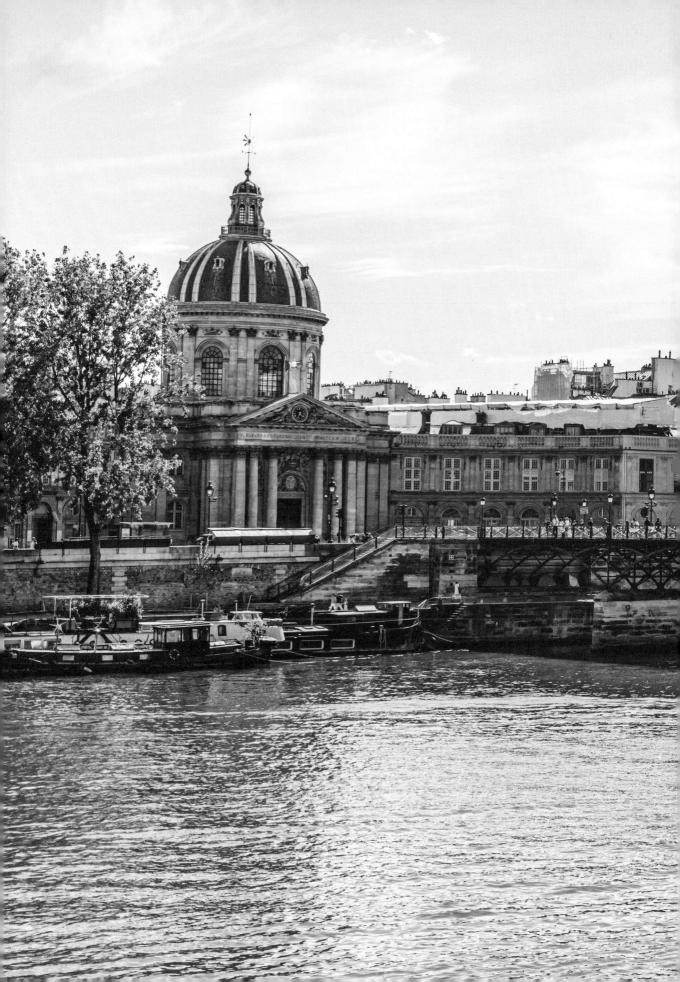

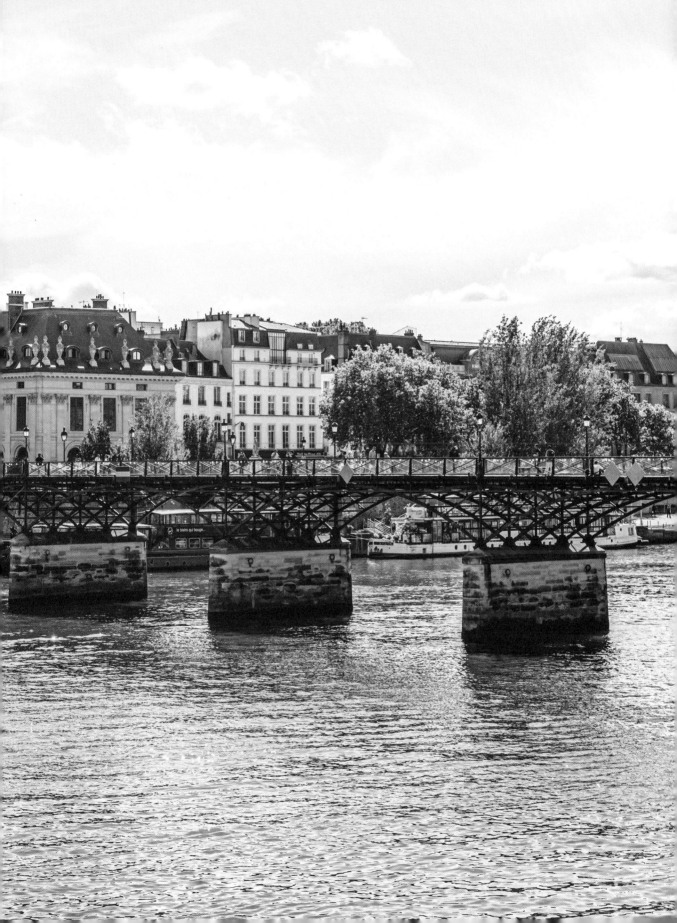

VISITING

DEYROLLE
A NOAH'S ARK OF TAXIDERMY

The last taxidermist in Paris, Deyrolle was founded in 1831 and is an
incredible cabinet of curiosities containing mounted and stuffed mammals
(that died of natural causes), shells, minerals, and display boards.

Born in the late eighteenth century, Jean-Baptiste Deyrolle was passionate about entomology, a branch of zoology that studies insects and arthropods (animals with articulated legs, such as crustaceans and spiders). Under the Deyrolle brand, which he established on the Right Bank, he sold insects and hunting equipment to build up his natural history collections, but he wanted to continue his work as a taxidermist at the same time.

His son Achille, followed by his grandson Émile, eventually took over his work. Naturalists, scientists, and collectors flocked to the store, which quickly became a recognized institution throughout the world. Deyrolle began offering specialized books and materials to schools, as well as display boards of fauna and flora, which adorned classroom walls for more than a century.

In 1888, under the direction of Émile, the establishment moved into a private town house on rue du Bac in the very chic 7th arrondissement, where it has remained. On two floors, the shop is adorned with gold-framed wooden windows and sea-green walls. The ground floor is dedicated to a garden, and visitors take a staircase to enter a new world where a bear, giraffe, zebra, and lion reside—all stuffed, of course. All these animals, bequeathed by zoos or farms after their deaths—and in compliance with the Convention on International Trade in Endangered Species of Wild Fauna and Flora—are displayed in an educational way.

At Deyrolle, you don't have to be a child to marvel at all there is to see! From swans to peacocks to pieces of moon rock and herbariums, this last cabinet of curiosities in Paris is a true place of discovery and wonderment. Several great artists have also walked its corridors, including Hubert de Givenchy, who appreciated its unique aesthetic; Maurizio Cattelan, who purchased a headless ostrich; and Salvador Dalí, who was inspired here to create his work *Ship with Butterfly Sails*.

After competing with national museums and being ravaged by a fire in 2008, Deyrolle has experienced a revival since its acquisition by Louis Albert de Broglie. This magical place hosts both exhibitions and cocktail soirees during fashion weeks. Just like his animal curiosities, Deyrolle's fame is eternal.

THE BOUTIQUE COVERS TWO FLOORS AND IS ADORNED WITH WOOD-FRAMED GOLD-TRIMMED WINDOWS AND SEA GREEN WALLS.

1. A 100-YEAR-OLD INSTITUTION

The address 46, rue du Bac has been home to this cabinet of curiosities for over a hundred years. Its wooden facade beckons visitors to leap back in time.

2. THE WORLD OF INSECTS

Butterflies, beetles, and spiders are presented in boxes after being meticulously spread out for display by the Deyrolle teams.

3. AND 4. WILD ANIMALS

The taxidermy collection is, without a doubt, the most impressive. Wild animals can be studied, without fear, in their natural pose.

5. CABINET OF CURIOSITIES

Deyrolle also offers a cabinet of curiosities that provides the public a chance to purchase some amazing pieces.

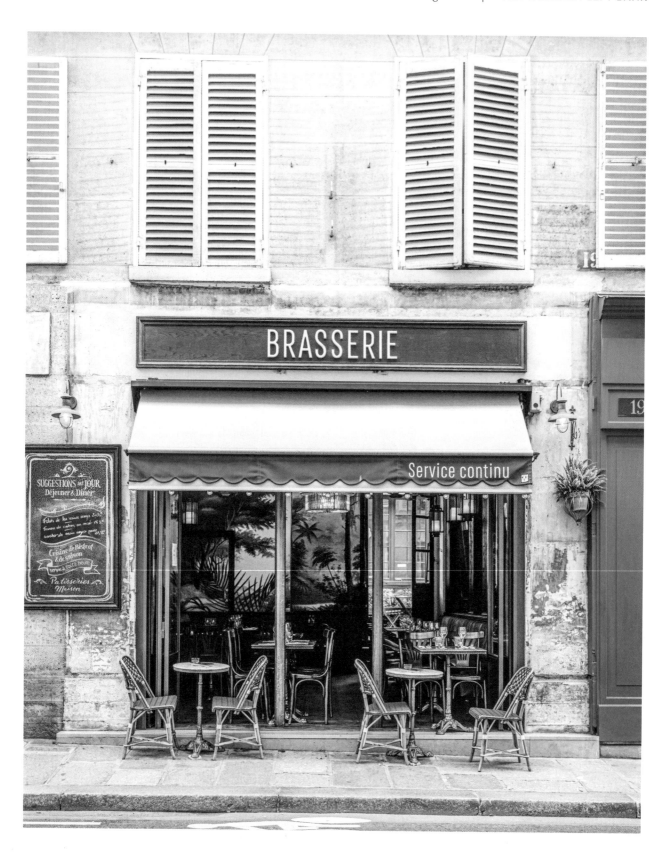

*Despite the city's narrow sidewalks, Parisian restaurants and
cafés spread out onto terraces to the delight of Parisians.*

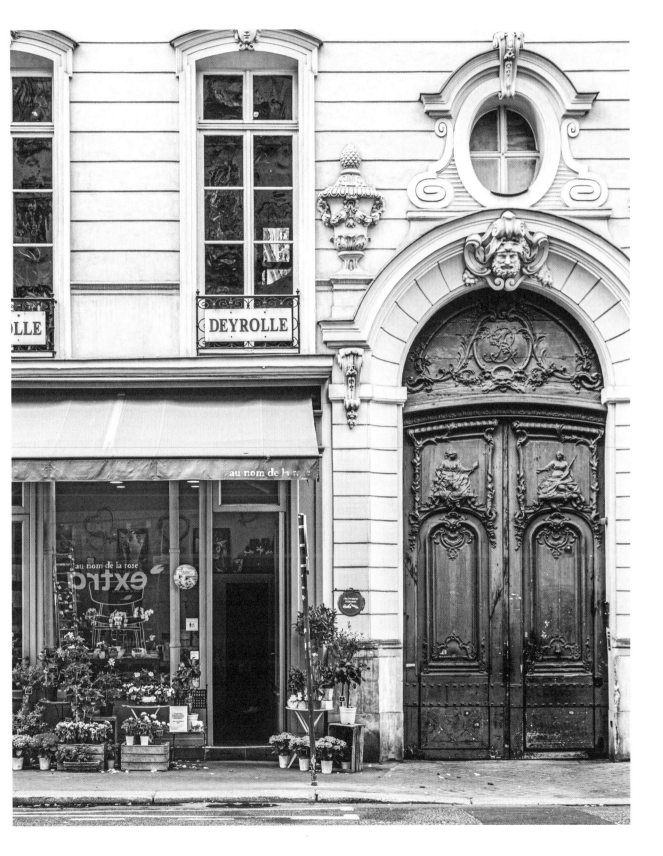

*Paris's carved and colorful carriage doors express
their individuality.*

PROFILE

MORI YOSHIDA

This native of Japan has a passion for French pastry.
In 2013, he opened an elegant boutique near Les Invalides.
Over the years, his shop has become an essential stop
of the 7th arrondissement.

Morihide Yoshida has always known pastry. He grew up in Shizuoka, Japan, in a family of pastry chefs who expected him to continue the tradition. As a young man, he wanted to follow a different path but was convinced to pursue pastry when his father offered to support his studies in the same school he attended in Tokyo. After graduating in 1999, Mori was hired by the Grand Hyatt Hotel, known for its excellence in hospitality. "That's when I really discovered pastry. I remember eating a cream and caramel choux puff, the taste of which was a revelation."

Motivated to succeed, he continued to advance in his work. After four years, his boss asked him to help open his pastry shop. Mori then returned to Shizuoka to take over from his father and opened a new pastry shop. "The first year was difficult. My creations did not meet the tastes of local customers." Next, Mori decided to participate in the Japanese television show *Le Meilleur Pâtissier* (The Best Pastry Chef), which he won two years in a row. His popularity began skyrocketing, and people traveled from afar to savor his French cakes.

It wasn't long before Mori's ambitions focused elsewhere. "Once, while eating poorly prepared sushi in Thailand, I realized the choice of raw materials was crucial. How can you make authentic French pastries without using French butter or French flour?" In 2010, he was offered an internship in Guy Savoy's Michelin-starred restaurant and moved to France. There he immersed himself with Philippe Conticini in a different working style and studied with chocolatier Jacques Genin. "What fascinates me about chocolate is that there is a whole universe of textures and aromas in such a small bite."

In 2013, Mori finally set out on his own and opened Mori Yoshida on avenue de Breteuil. To attract gourmet customers, he continued to improve his pastries until they reached a level of excellence. His two consecutive victories on *Le Meilleur Pâtissier: Les Professionals* in France in 2018 and 2019 helped him gain fame throughout the country. His contemporary creations are refined, are not overly sweet, and follow seasonal flavors. "I am very committed to respecting the French tradition, so I do not aim to reproduce Japanese specialties." Thus, Parisian flan is one of his most popular desserts, as is Mont Blanc. But as a nod to his country, the chef offers a strawberry roulade and a Japanese-style crème caramel. Building on his success, he has written a cookbook, published by Éditions du Chêne, and dreams of opening other shops abroad.

À LA FRANÇAISE

Passionate about French pastry,
Yoshida cultivates excellence
marked by refinement.

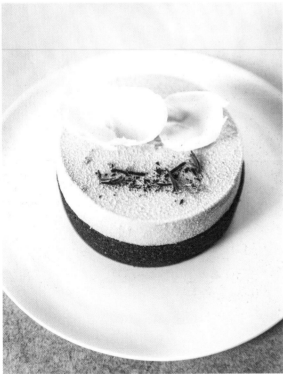

CREATIVITY

In addition to the great French classics,
the chef creates signature desserts, such as Le Beige,
a chocolate tart topped with tea-and-lime cream.

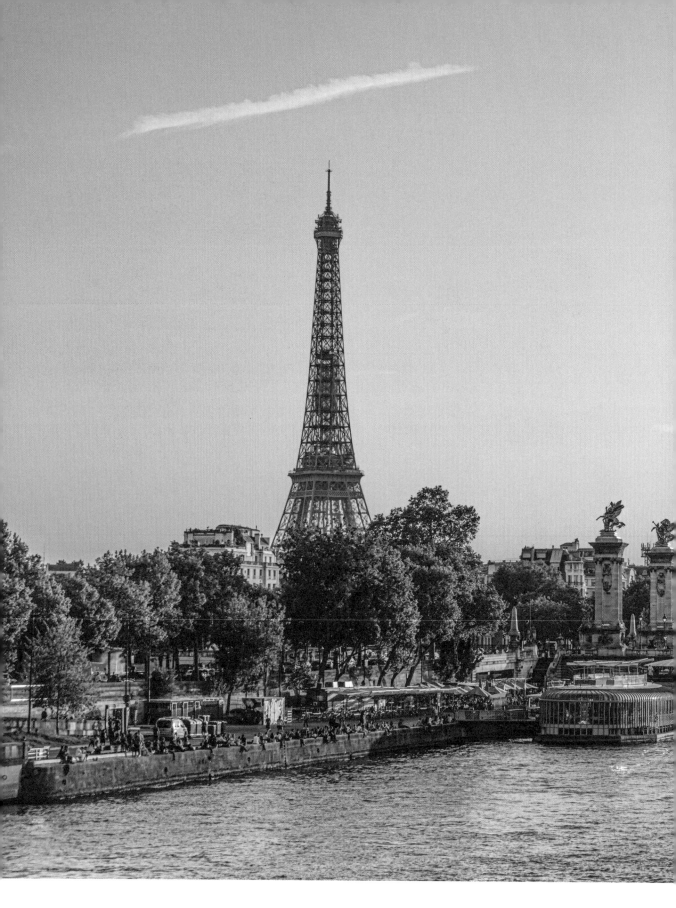

*Savvy travelers meet on the Debilly footbridge at sunset to enjoy
a beautiful view of the Eiffel Tower.*

PASTRY

Emblematic of French culture,
pastries stir up a craze that spans centuries and borders.
Paris is constantly reinventing its refined sweet creations.

Parisians are enthusiastic consumers of pastries, and they have delicious options on nearly every street corner. Whether during the late afternoon or after a good meal, sharing sweet treats together is as much a pleasure as it is a tradition.

Paris's love for sweet things dates back centuries. The recipe for choux pastry was invented in the sixteenth century by the Italian Popelini, the cook of Queen Catherine de' Médicis, but it was perfected by the Parisian Marie-Antoine Carême in the nineteenth century. Since this time, this technique has given rise to many recipes. One such creation is the Saint-Honoré cake, concocted in 1850 in a shop located on the street of the same name. Created by pastry chef Chiboust, this confection consists of puff pastry and choux puffs topped with pastry cream. A few years later, Frascati Café, located on boulevard Montmartre, invented the *religieuse*, made with choux pastry, pastry cream, and buttercream flavored with chocolate or coffee.

In 1867, Adolphe Seugnot created the *mille-feuille*, which became the specialty of his shop on rue du Bac. All of Paris rushed to taste his creation, which consists of 729 layers of puff pastry alternating with layers of cream. At the end of the nineteenth century, pastry chef Lasne invented the *financier*, a small rectangular cake composed of almonds and egg whites. Although its origin remains uncertain, the *moka* was also created in Paris around the same time.

The beginning of the twentieth century was not to be outdone in terms of innovations and witnessed the birth of the *Paris-Brest*, a ring of cream-filled choux pastry inspired by a bicycle race, and the *opéra*, a sponge cake made from almonds, coffee buttercream, and chocolate ganache. In the 1960s, Gaston Lenôtre became the face of new French pastry: lighter but still just as inventive. His student, Pierre Hermé, popularized macarons in the 1980s and created the *Isfahan*, a dessert that combines rose with raspberry and lychee.

Today, Paris pastry seems to be experiencing a true golden age. In recent years, the pastry scene has witnessed an expansive number of young chefs who create pastries as elegant as they are extravagant, whether produced at grand hotels or in their own pastry shops. Among them, Cédric Grolet has become known throughout the world for his trompe l'oeil fruits, Claire Damon is the queen of plant-based creations at Des Gâteaux et du Pain, and Myriam Sabet offers Syrian specialties at Maison Aleph.

One thing is certain, from palaces to tearooms, crowds have never been so present as they are today when it's time for a treat, and the variety of offerings continues to grow.

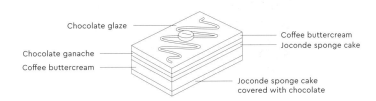

Chocolate glaze

Chocolate ganache

Coffee buttercream

Coffee buttercream

Joconde sponge cake

Joconde sponge cake
covered with chocolate

OPÉRA

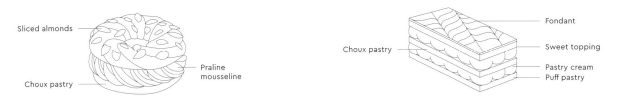

Sliced almonds

Choux pastry

Praline
mousseline

PARIS-BREST

Fondant

Choux pastry

Sweet topping

Pastry cream

Puff pastry

MILLE-FEUILLE

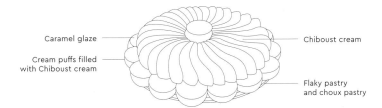

Caramel glaze

Cream puffs filled
with Chiboust cream

Chiboust cream

Flaky pastry
and choux pastry

SAINT-HONORÉ

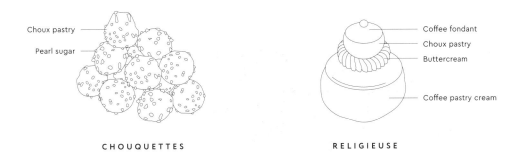

Choux pastry

Pearl sugar

CHOUQUETTES

Coffee fondant

Choux pastry

Buttercream

Coffee pastry cream

RELIGIEUSE

RECOGNIZED EXPERTISE

In Paris, the range of desserts seems endless. Alongside centuries-old
specialties, new pastry chefs invent spectacular creations whose reputations
spread worldwide. Sugar is used less and less in pastries today
as plant-based ingredients grow in popularity.

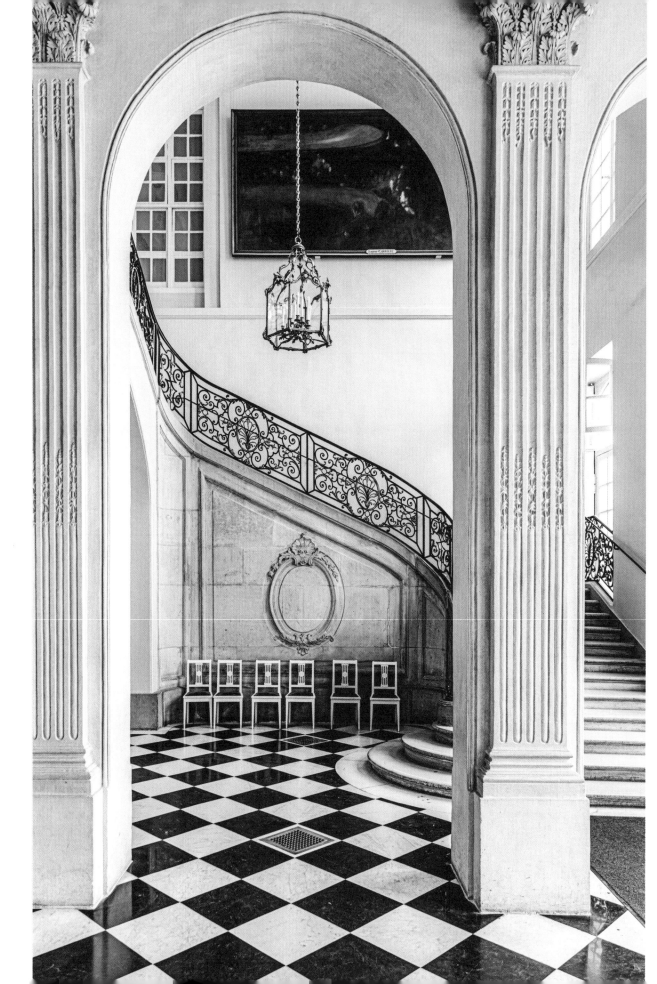

ABOVE

A year before his death, Auguste Rodin donated all his works to the French state, which has exhibited his works in the Hôtel Biron since 1919.

LEFT

In Cantor Hall, the monumental staircase leads visitors to the eighteen display rooms.

NATURE

PARKS AND GARDENS
OF CHIC NEIGHBORHOODS

MUSÉE RODIN (15TH)

In bloom year round, this garden exhibits the famous Thinker,
and many other statues by the sculptor.

PARC GEORGES-BRASSENS (15TH)

This hilly park of more than 19 acres (8 hectares) is the "lungs" of the 15th arrondissement.

MUSÉE ZADKINE (6TH)

The artist's work is concealed behind private, natural gardens.

MUSÉE BOURDELLE (15TH)

Bourdelle's bronze sculptures are exhibited both in the garden along the street and in the museum's inner garden.

PARC ANDRÉ-CITROËN (15TH)

Since 1992, this park has occupied the former Citroën car factory.

MUSÉE DELACROIX (6TH)

The garden of Delacroix's studio reflects the painter's love of abundant green spaces.

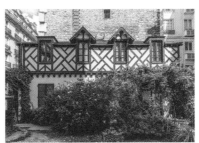

CHURCH OF SAINT-JEAN-DENYS-BULHER (7TH)

This little-known square reveals a quintessentially medieval half-timbered house.

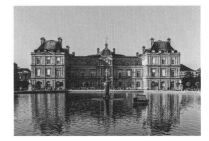

LUXEMBOURG GARDENS (6TH)

This beautiful garden, located in the heart of Paris, comprises both French- and English-style gardens.

ÎLE AUX CYGNES (15TH)

This manmade island is located between the Grenelle and Bir-Hakeim bridges.

MONTPARNASSE CEMETERY (15TH)

Paris's largest cemetery, second only to Père-Lachaise, is heavily wooded and provides a pleasant walking space.

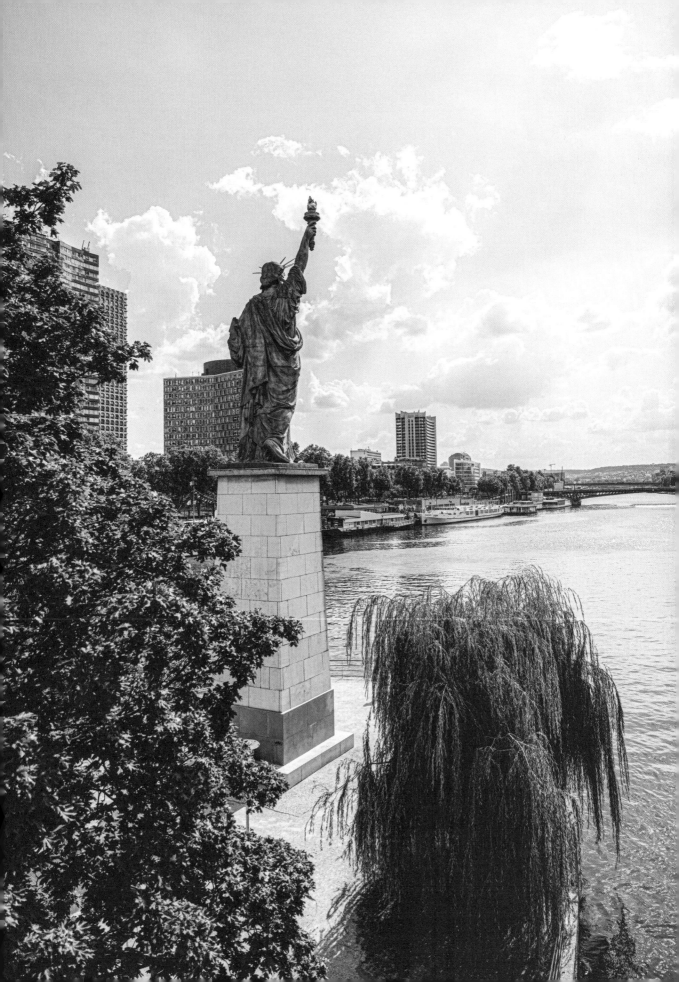

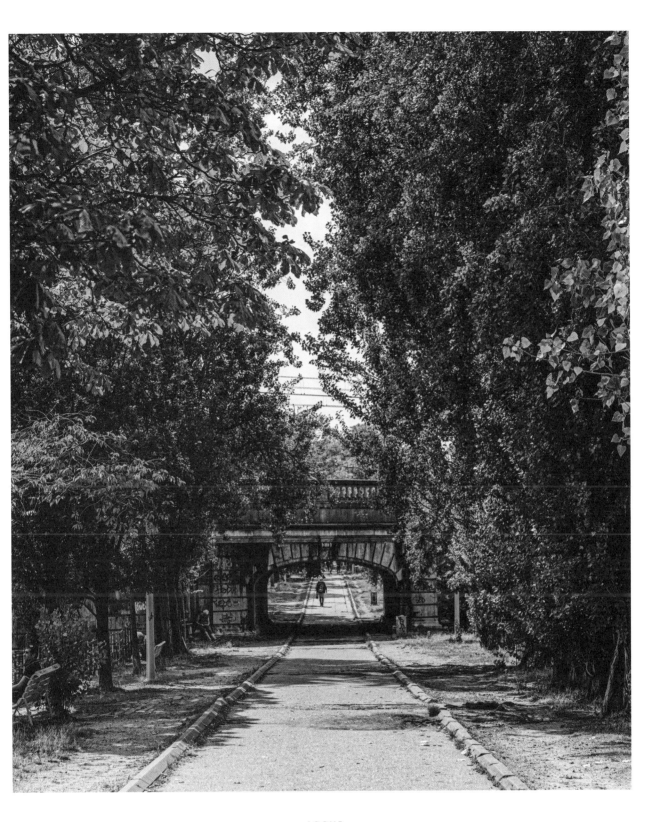

Created in 1825, ile aux Cygnes is an artificial promenade 2,900 feet (890 meters) long and
36 feet (11 meters) wide. It is popular for those who love the outdoors.

LEFT

A 52-foot-high (16-meter) replica of the Statue of Liberty stands at the southern tip of Île aux Cygnes.

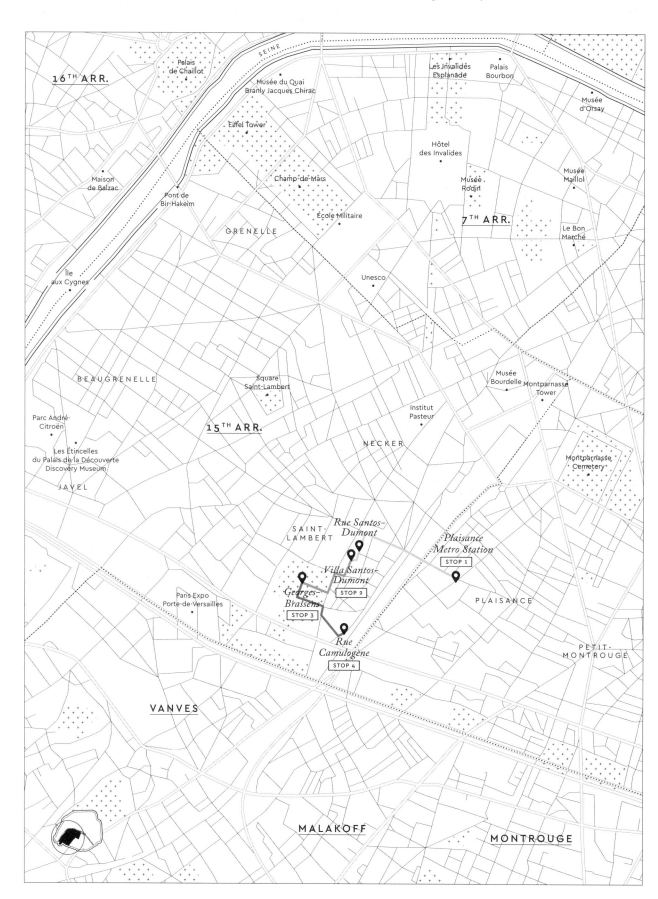

GREEN PATHWAYS

Paris offers many bucolic pathways, including in the 15th arrondissement. The Saint-Lambert district, not far from the Porte de Vanves, is ideal for peaceful walks.

STOP 1: RUE SANTOS-DUMONT

After a ten-minute walk from the Plaisance metro station, you will reach rue Santos-Dumont on your left. Since the 1920s, row houses with gardens, designed by architect Henry Trésal, have occupied numbers 36 to 52. The drip edges on the slate roofs recall the style of houses in England, which was a feature that attracted poet and singer Georges Brassens, who died at number 42.

STOP 2: VILLA SANTOS-DUMONT

Take the cobblestoned path of Villa Santos-Dumont, which branches out from rue Santos-Dumont. On an old plot of vines, architect Raphaël Paynot built a subdivision in 1920 that miraculously resisted urban densification. Walking through this cul-de-sac lined with picturesque homes, it is hard to imagine they were once occupied by the working class. It did not take long for the artists of Montmartre to set their sights on this idyllic location. Sculptor Ossip Zadkine resided here for much of his life at number 3. Houses, lofts, and workshops, covered with greenery, each reveal a different face, and some even hide behind natural gardens that will pique the curiosity of those who decide to wander through.

STOP 3: PARC GEORGES-BRASSENS

To continue the quest for tranquility, walk up rue Santos-Dumont and turn right onto rue des Morillons. One of the entrances to Parc Georges-Brassens is nearby. Formerly occupied by a vineyard, then market gardens and the Vaugirard slaughterhouses, the land is now a green space cherished by locals. Those who love plants will head toward Jardin des Senteurs, which houses dozens of varieties of aromatic plants, rose gardens, and an apiary. Leaving through the book market, take rue Brancion then rue Chauvelot.

STOP 4: IMPASSE DU LABRADOR

This 200-foot-long (60-meter) road, found at the end of rue Camulogène and now covered in greenery, once provided housing for low-income families. Just at the end of the cul-de-sac stands a yellow house, appearing very small compared to the size of its garden.

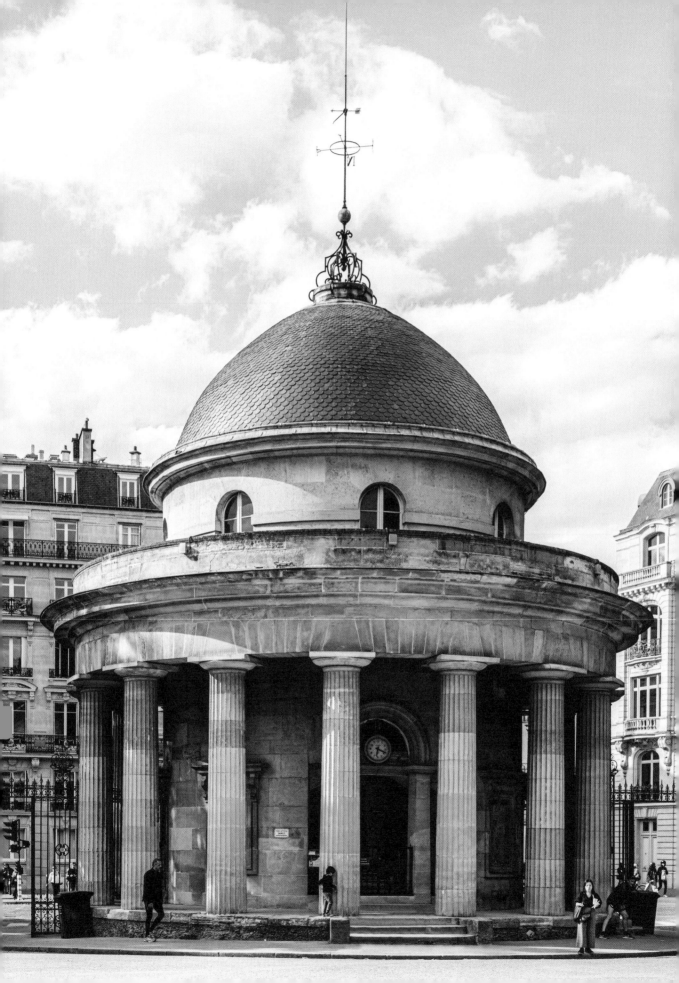

THE HIGH-END DISTRICTS

Located on the Right Bank, the 8th and 16th arrondissements are
undoubtedly the most opulent in Paris. This is where haute couture *maisons*,
large corporations, upscale restaurants, art galleries,
and a host of museums can be found.

P.104

*Parc Monceau is the "green lung" of the 8th arrondissement, with its striking Rotunda
and a water pool bordered by a colonnade.*

RIGHT

*Transformed by Laura Gonzalez, Sir Winston, the oldest British pub and brasserie in Paris,
offers Indian cuisine with a British touch.*

Although primarily catering to the elite, these arrondissements still have quaint charm. With their mix of architecture and cultures, they offer many reasons to take a stroll through the area.

North of the 8th arrondissement, Parc Monceau is an English-style garden that is as chic as it is pleasant. Behind high wrought-iron gates, bourgeois families rub shoulders with joggers seeking relief. The nearby streets are dotted with majestic mansions, two of which house the Musée Jacquemart-André and the Musée Nissim de Camondo. The former houses a collection of paintings, the latter French decorative arts.

To the east, the Élysée Palace, the residence of the president of France, can be found in the business office district of Madeleine. Close to the Élysée, the famous avenue des Champs-Élysées—just over a mile (two kilometers) long and 230 feet (seventy-one meters) wide—stretches from Place de la Concorde to Place Charles de Gaulle where the Arc de Triomphe stands. With avenue Montaigne close by, this area is a temple of luxury and a playground for those who love shopping.

On the banks of the Seine, there are museums to satisfy all tastes: Contemporary art is exhibited at the Palais de Tokyo, fashion at the Palais Galliera, Asian arts at the Musée Guimet, and fine arts at the Petit and Grand Palais. The Cité de l'Architecture et du Patrimoine and the Musée de l'Homme open onto the Trocadéro Gardens.

When exploring the entirety of the 16th arrondissement, the metro can be a great ally. This district consists of ancient villages that once imbued the area with a rural spirit and hosted country manor houses. Walking through its cobblestoned streets, you can happen upon the hidden gardens of Passy. To the south, the village of Auteuil conceals Art Nouveau architectural treasures. Here again, it is not uncommon to come across hidden villas, such as the private mansions on rue Mallet-Stevens, which testify to the richness of modern architecture.

To the east, on weekends, the beau monde meets at the Bois de Boulogne. Between the greenhouses of Auteuil, the Jardin d'Acclimatation, Bagatelle park, and the racetracks, there is no shortage of activities in this green space covering 2,100 acres (850 hectares). Since 2014, the Fondation Louis Vuitton, designed by Frank Gehry, has been located here. Resembling a glass ship, the building alone is worth a visit. After touring its collection of contemporary art, a visit ends with a break on the terraces to observe the silhouettes of the towers of the La Défense business district.

THE ESSENTIALS

32

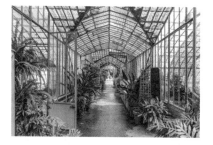

SERRES D'AUTEUIL (16TH)

This garden in the heart of the Bois de Boulogne protects collections of rare plants that attract botany lovers.

34

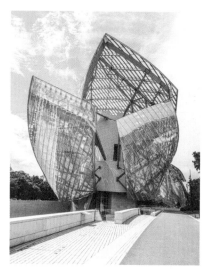

FONDATION LOUIS VUITTON (16TH)

This building by Franck Gehry is an architectural feat with its curved beams and marriage of wood and glass.

36

MAISON DE BALZAC (16TH)

The view of the Eiffel Tower is breathtaking from the garden chairs at the home of this legendary author of La Comédie humaine.

33

PALAIS DE TOKYO (16TH)

Spread over four floors, this 237,000-square-foot (22,000-square-meter) building is the largest contemporary art center in Europe.

35

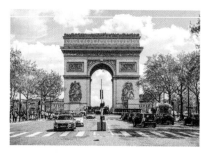

ARC DE TRIOMPHE (8TH)

The body of the Unknown Soldier, a victim of the First World War, is interred under this emblematic monument. The tomb's flame is relit every night.

37

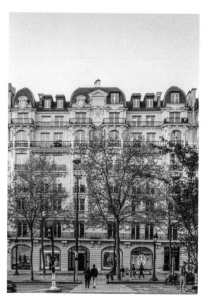

AVENUE DES CHAMPS-ÉLYSÉES (8TH)

Every day, several hundred thousand visitors stroll up and down this iconic avenue, which stretches from Place de la Concorde to the Arc de Triomphe.

38

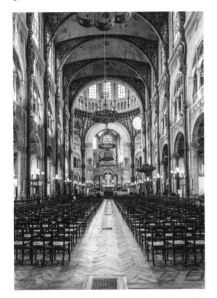

CHURCH OF SAINT-AUGUSTIN (8TH)

The uniqueness of this nineteenth-century church is due to its marriage of Romanesque and Byzantine arts. Its dome rises to more than 262 feet (80 meters).

39

HÔTEL DE LA MARINE (8TH)

Bordering Place de la Concorde, this monument housed the Garde-Meuble de la Couronne and its ceremonial salons dating from the eighteenth century. It is open to the public.

40

PALAIS GALLIERA (16TH)

This fashion museum houses nearly 100,000 garments and accessories that tell the story of clothing and haute couture up to the present day.

41

MUSÉE D'ART MODERNE (16TH)

Located in the east wing of the Palais de Tokyo, this museum, open since 1961, houses more than 15,000 modern and contemporary works.

42

PARC MONCEAU (8TH)

The Corinthian colonnade, the Rotunda, and the large water pool make this park one of the most romantic gardens in the capital, where Parisians come to lounge on sunny days.

43

MUSÉE JACQUEMART-ANDRÉ (8TH)

This private urban mansion, dating to the Second Empire, preserves the private art collection and numerous furniture pieces of Édouard André and Nélie Jacquemart.

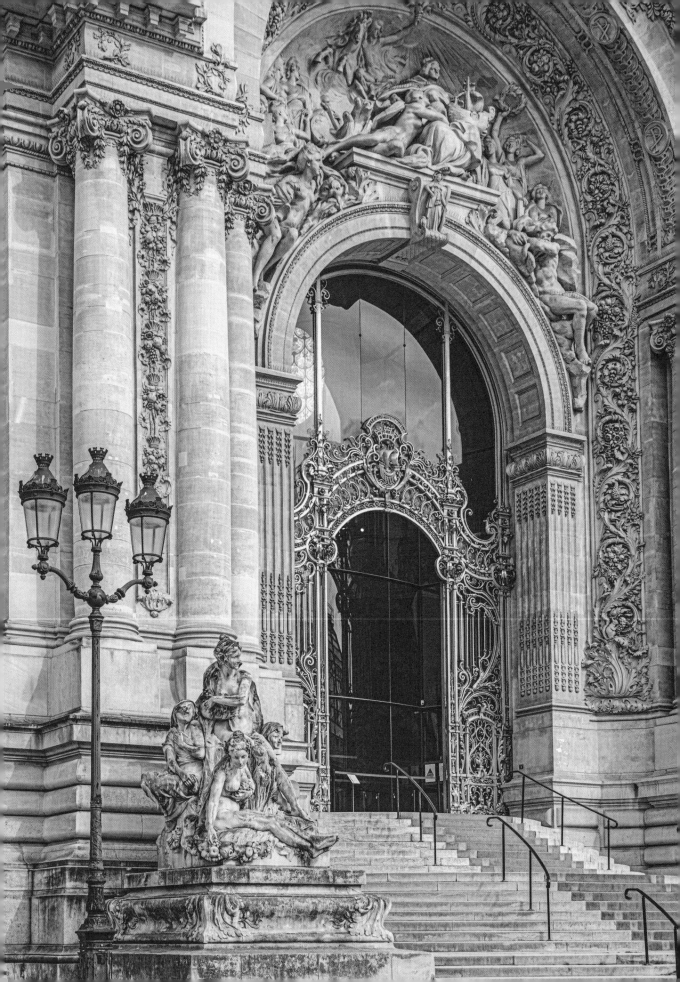

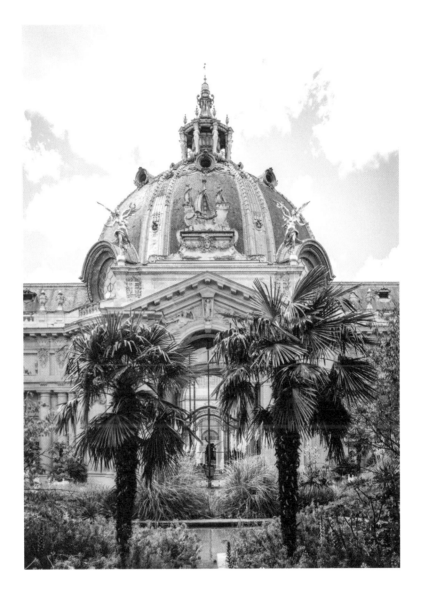

ABOVE

The Petit Palais contains a garden with three water pools decorated
with mosaics, as well as palm and banana trees.

LEFT

The grand door of the Petit Palais, gilded with gold leaf,
is more than 33 feet (10 meters) tall.

PETIT PALAIS

In the 8th arrondissement, the Musée des Beaux-Arts
de la Ville de Paris, housed in an early-twentieth-century building,
offers a fascinating permanent collection accessible free of charge.
Annick Lemoine is the director of the Petit Palais.

Annick Lemoine grew up in Paris, where she cultivated a taste for art by frequenting art exhibits. Intending to pursue a career in engineering, she turned instead to art history and defended her thesis on the Caravaggesque painter Nicolas Régnier. As a researcher, she was driven by her desire to share her knowledge and taught at the École du Louvre and the University of Rennes. During this time, she also became a curator of exhibitions and then advisor to the Ministry of Culture from 2009 to 2010.

Her path from the university to museums was inspired by her experience at the Villa Médici in Rome, where she headed the art history department for six years. "I wanted to be close to the works, and I also like teamwork. Research is very lonely," she says. After becoming a heritage curator, she headed the Musée Cognacq-Jay before being appointed director of the Petit Palais in 2022.

As head of the Petit Palais, Annick supervises the curators who study and restore the collections and enrich them through acquisitions. She also organizes the works of the permanent collection, leads the organization of the four annual exhibitions, is the general curator, and makes decisions with her team about how to make ancient art accessible to all audiences by adopting a fresh perspective.

Erected by Charles Girault, the Petit Palais—together with the Grand Palais and the Pont Alexandre III—form an ensemble designed for the Universal Exposition of 1900. A year later, the city of Paris turned it into an inviting museum supported throughout its history by generous donations. The Dutuit brothers, two great collectors, made the founding bequest, consisting of twenty thousand works spanning antiquity to the Renaissance. The brothers were the ones who insisted admission to the museum be free.

"This tradition continues since artists and many studios wish to make the Petit Palais a place for memories, perhaps because of its bold decor, which is itself the result of skilled artists," adds Annick. Thus, Matisse bequeathed the painting *Trois Baigneuses* (*Three Bathers*) by Cézanne to the museum. At the same time, Gustave Courbet's sister donated several of the painter's works, including *Les Demoiselles des Bords de la Seine (Young Ladies Beside the Seine)*. Today, Annick Lemoine aims to make this institution a museum of everyday life that people visit regularly, whether to admire some of the fifty thousand works of art or simply to have lunch in the peaceful garden planted with exotic trees.

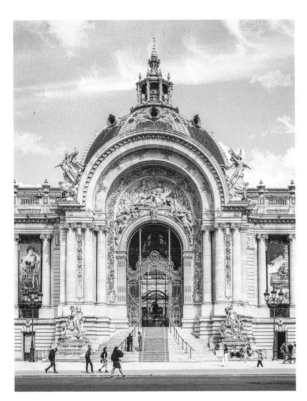

Annick Lemoine, dedicated to
promoting fine arts, works to provide
everyone access to cultural works.

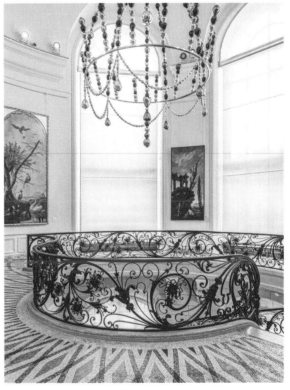

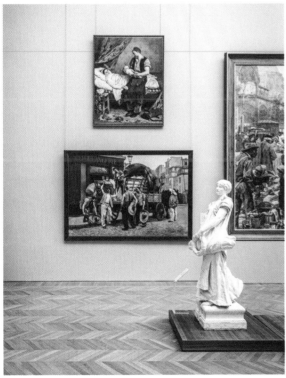

TREASURES

All the works in the museum are from
generous donations by collectors. The collections
are arranged according to themes.

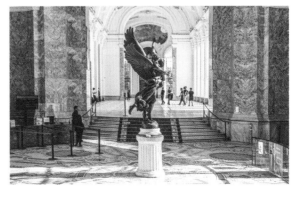

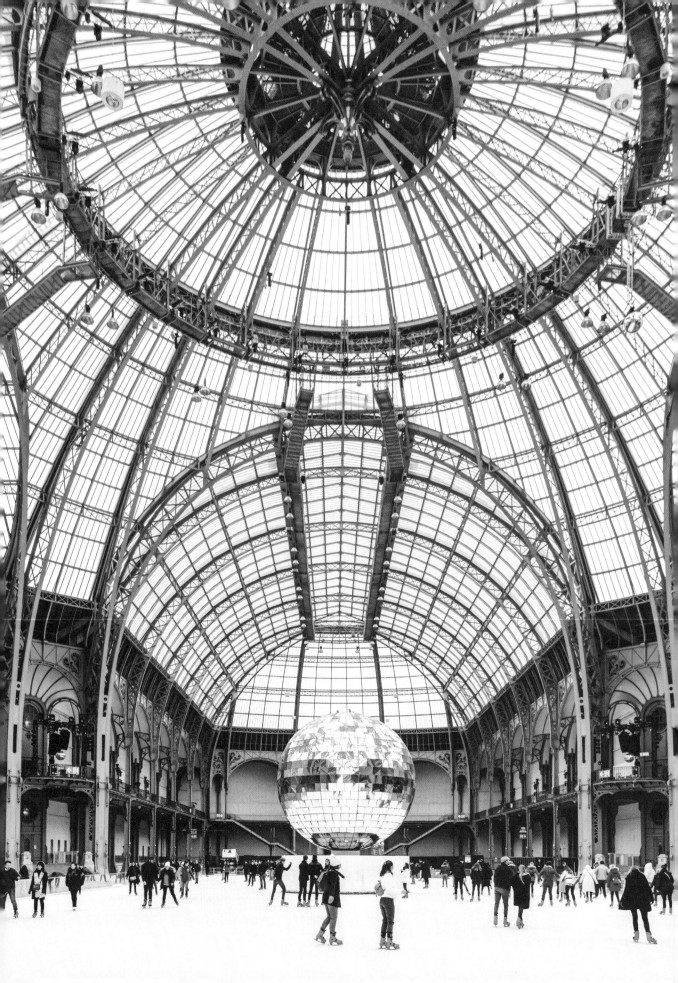

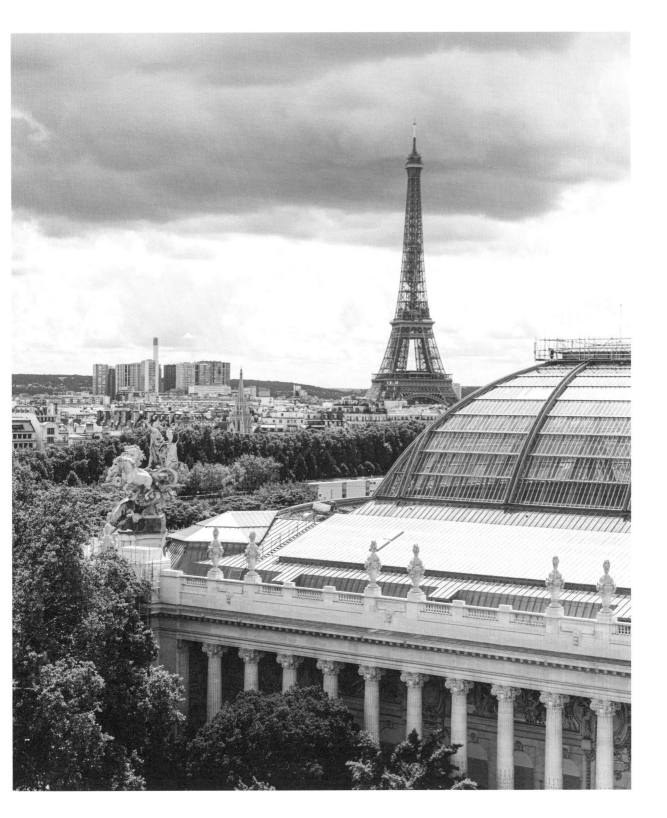

The Alexander III bridge, inaugurated during the Universal Exposition of 1900,
is famous for its gilded bronze Pegasuses, rising 55 feet (17 meters) high.

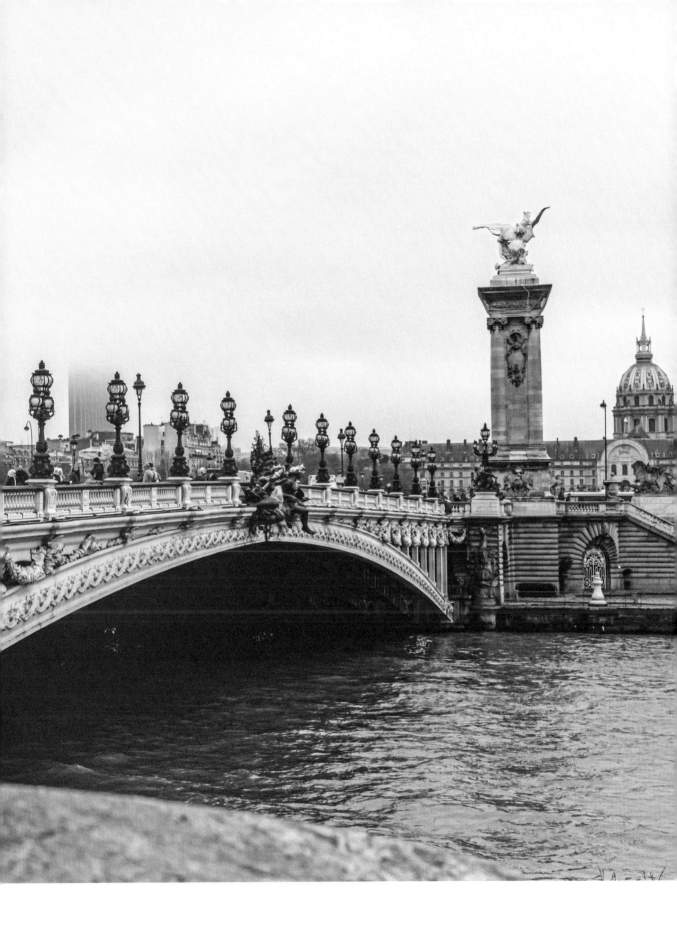

This chic Parisian brasserie specializes in seafood dishes.

*Plaza–Athénée hotel on avenue de Montaigne is adorned
with 1,900 window boxes of red geraniums.*

THÉÂTRE DES CHAMPS-ÉLYSÉES (8ᵀᴴ)

This building, designed by Auguste Perret, was constructed in 1913.
The bas-reliefs on the facade are the work of sculptor Antoine Bourdelle.

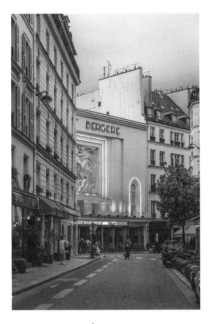

FOLIES-BERGÈRES (9TH)

The Art Deco design of this famous music hall dating to 1926 displays a superb bas-relief gilded with gold leaf.

HÔTEL DU COLLECTIONNEUR (8TH)

This luxurious hotel near Parc Monceau is bathed in Art Deco ambiance, which pays tribute to the art de vivre of transatlantic liners from the 1930s.

POLICE HALL (12TH)

Thirteen sculptures modeled on Michelangelo's *Dying Slave* decorate the top floor of this police precinct.

LE SHANGHAI (9TH)

All that remains of this former erotic cabaret is its Art Deco stained-glass window inspired by Hokusai's *The Great Wave*.

VANEAU METRO STATION (6TH)

This station expresses its Art Deco style through its turquoise mosaic tiles.

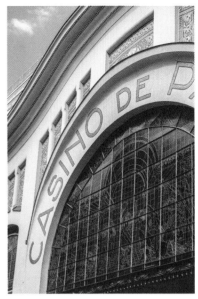

CASINO DE PARIS (9TH)

An Art Deco stained-glass window adorns this famous music hall.

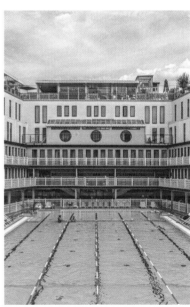

MOLITOR SWIMMING POOL (16TH)

Located near the Bois de Boulogne, this legendary swimming pool by Lucien Pollet dates to 1929. It is now part of a luxury hotel.

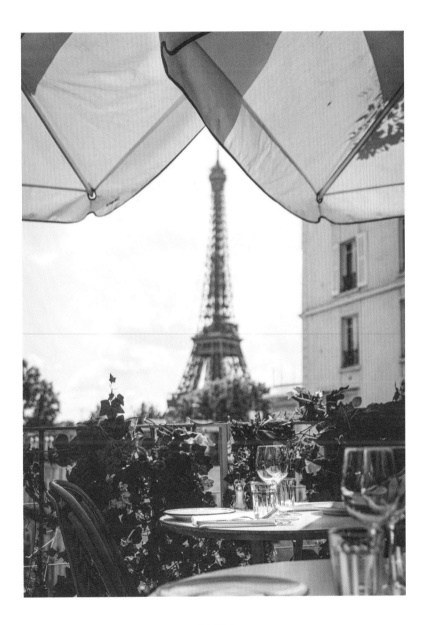

ABOVE

Lunching on terraces is a favorite Parisian activity.

LEFT

*Many Parisians organize working lunches in opulent brasseries
near the Champs-Élysées.*

ARCHITECTURE

MAISON LA ROCHE

Nestled at the end of the Square du Docteur-Blanche in the
16th arrondissement, Maison La Roche is a model of modern architecture.
Designed by Charles Édouard Jeanneret, known as Le Corbusier,
and his collaborator Pierre Jeanneret, this structure is classified
as a UNESCO World Heritage Site.

This white building was designed and built in the 1920s for Swiss banker Raoul Albert La Roche. Neighboring the Fondation Le Corbusier, located in another house designed by the architect for his brother, Maison La Roche is open for tours three days a week. Its design highlights the architect's "five points of modern architecture"—pillars, roof garden, open floor plan, open facade, and horizontal windows—which he presents in a collection of essays. These concepts were epitomized in the famous Villa Savoye, built in Poissy a few years later.

A collector of modern art, La Roche requested a reinforced concrete building to bring together his two-story private apartment with a gallery dedicated to exhibiting his painting collections. The result lived up to his expectations. From the outside, there is a wing with a curved shape supported by pillars where the works of this patron are held. The collection brings together paintings by Picasso and Braque as well as the work *Cathédrale*, a colorful wooden sculpture by Le Corbusier, which sets the tone for this vast polychromatic space.

Access to the library is through a winding ramp that follows the shape of the wall. Visitors take a walkway with huge bay windows to reach the other parts of the building. Eighteen shades of blues, grays, and browns delineate the different spaces throughout this architectural promenade, reinforcing volumes while mitigating others.

The apartment where La Roche lived seems frozen in time. His bedroom, bathroom, kitchen, office, and dining room are located here. For decor, Le Corbusier opted for a simplistic style to accentuate the architecture. Some of his creations, such as juxtaposed tables, mingle with industrial furnishings.

The visit continues on the roof, shared with the Fondation Le Corbusier, where a garden overlooks the city. At the top of the stairs, Le Corbusier also installed a covered terrace. For him, it was essential to enjoy the sun, so he designed houses with flat roofs to avoid confining planters and shrubs to the ground floor. This is a bold, visionary approach given Paris's current craze for rooftop gardens.

1. AND 2. PRIVATE ART GALLERY

The gallery serves as a temporary exhibition space for modern masters.

3. ARCHITECTURE ON STILTS

Maison La Roche was designed as a curved structure supported by stilts, one of the distinct characteristics of Le Corbusier's architectural designs.

4. ALL COMFORTS

Located on the second floor, Raoul La Roche's bedroom adjoins a small bathroom with modern comforts.

5. LE CORBU, THE SCULPTOR

Maison La Roche's collection includes sculptures by the famous Swiss architect.

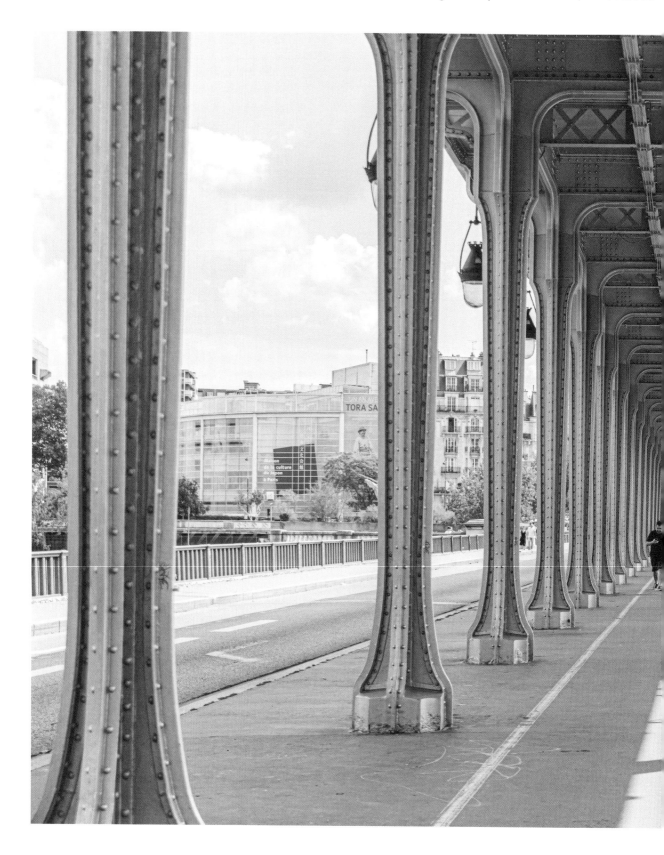

*Pont Bir-Hakeim's double row of metal columns serves as
a favorite spot for photoshoots for newlyweds.*

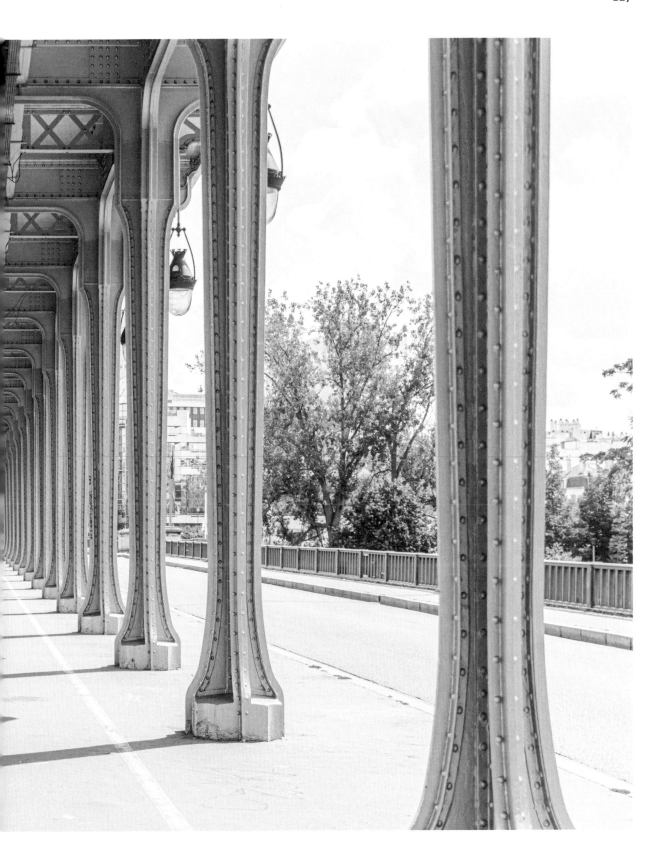

THE PARIS METRO

After London, Chicago, and Budapest, Paris inaugurated its underground train system, the *métropolitain*, during the Universal Exposition on July 19, 1900. Since its opening, the 140-mile (226-kilometer) metro has become a routine mode of transportation for Parisians.

There must have been a certain degree of courage among the passengers of the first metro trips at the beginning of the twentieth century. Rushing underground to board a brand-new train car is quite an adventure. "All aboard, ladies and gentlemen!" could be heard that day on the platforms of metro line 1, which connected Porte-Maillot to Porte-de-Vincennes in twenty-six minutes. This was a significant foray into modernity, of which Paris was proud.

The construction of the metro dates to 1896, when France was selected to host the next Universal Exposition in Paris. During the industrial revolution, the capital had 2.7 million inhabitants. The metro system, therefore, aimed to relieve congestion in its existing transportation networks. The engineer Fulgence Bienvenüe, in charge of developing Parc des Buttes-Chaumont, was tasked with managing its construction.

Work began on October 4, 1898, and had far from unanimous support: where the line passed, gaping openings revealed the bowels of the city. The entity Compagnie du Chemin de Fer Métropolitain was entrusted with operating the network and, twenty months later, this new mode of transport was ready for testing. Although rumors circulated about the risks of landslides and derailment, adventure-seeking Parisians were still tempted by the notion.

Wooden and electric-powered cars were divided into two categories: For first class, tickets were offered at 25 cents and the cars contained about thirty seats. For second class, the price was only 15 cents, and sometimes passengers had to stand. Trains departed every three minutes; Parisians quickly adjusted to this new means of transportation.

Several stations were built above ground thanks to a system of viaducts, which made it possible to cross the Seine and the Canal Saint-Martin, but most were underground. In 1903, a second line connected station Porte-Dauphine to Nation, followed by lines 3 to 7. On January 9, 1910, the first section dug under the Seine made it possible to cross the city from Porte-de-Clignancourt to Porte-d'Orléans.

Under continual expansion, the metro broke beyond the borders of Paris in 1934 to serve the suburbs of Boulogne-Billancourt. Although some features, such as first class, were dropped before the end of the twentieth century, several fully automated lines appeared at the beginning of the new millennium. A new project is now underway: the Grand Paris Express, which will extend to line 18 to make travel throughout the Île-de-France region easier.

1. SPRAGUE-THOMSON

This is the nickname given to the all-metal trains, which were first placed
into service in 1908 and taken out of service in 1983.

2. MF77

The name stands for "Métro Fer Appel d'Offres 1977." Built to replace
the Sprague-Thomson trains and placed into service in 1978.

3. MP73

The name stands for "Métro Pneus Appel d'Offres 1973." Commissioned
in 1974, these trains make up the fourth generation of trains running on
pneumatic tires. This was the first train to sport the royal blue color.

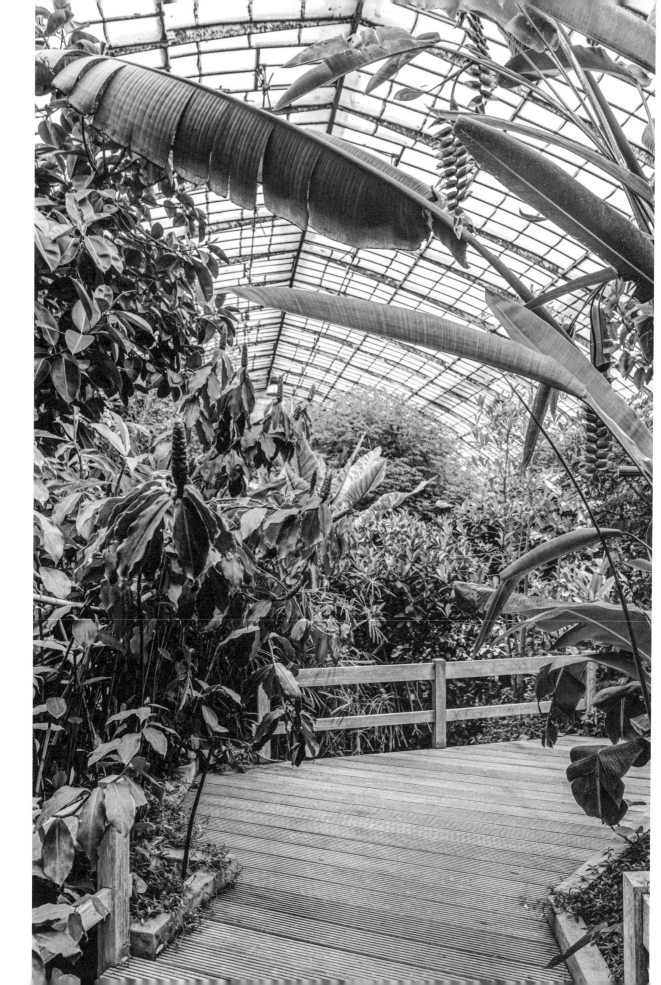

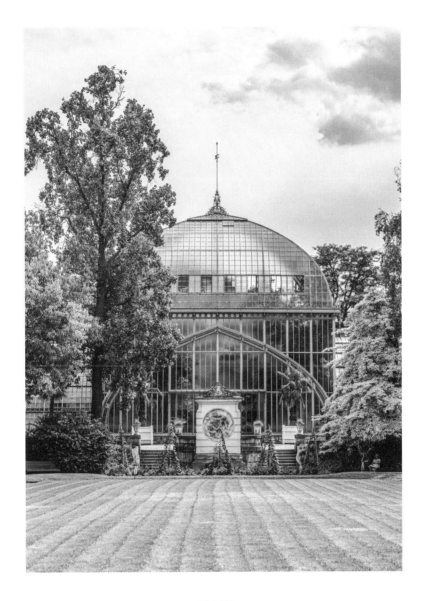

ABOVE

*The palm house of the Auteuil greenhouses is topped by a glass dome
rising to 52 feet (16 meters).*

LEFT

*The Auteuil greenhouses provide heat and humidity to protect
nearly 200 tropical plant species.*

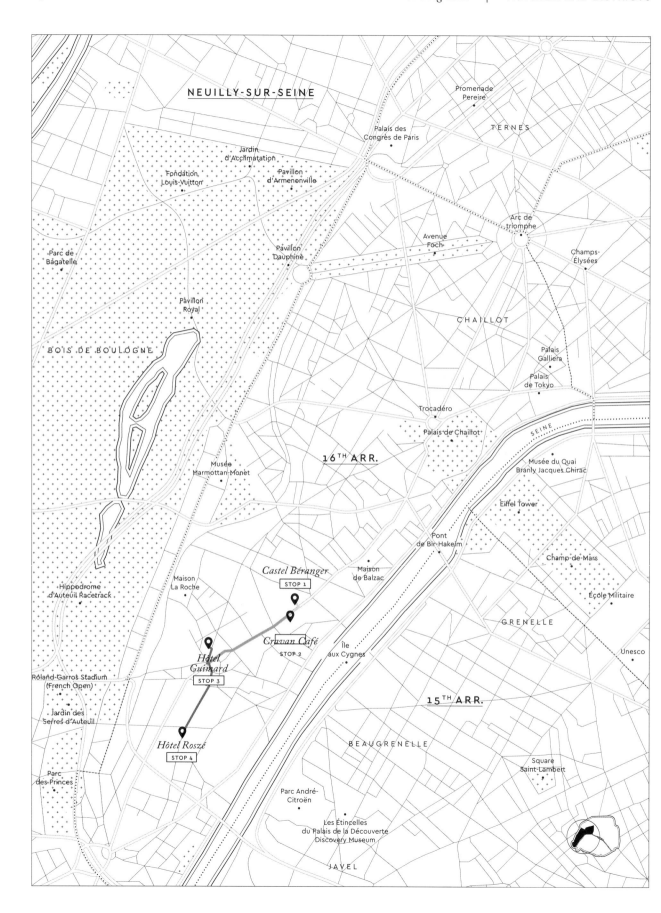

ART NOUVEAU

IN THE 16TH ARRONDISSEMENT: IN THE FOOTSTEPS OF HECTOR GUIMARD

The Art Nouveau style was born at the end of the nineteenth century from a desire for a new modernity. The style was embodied in Paris by the illustrious architect and designer Hector Guimard, to whom the French capital owes its famous metro entrances and many of its buildings in the 16th arrondissement.

STOP 1: CASTEL BÉRANGER

The best way to soak up the Art Nouveau aesthetic is to walk to the residential building Castel Béranger. Guimard had planned this building of thirty-six apartments at 14, rue Jean-de-La-Fontaine in the Romanesque-Gothic style, but he instead decided to make it an example of Art Nouveau. Although this building was not his first undertaking, it secured his fame as an architect when completed in 1898.

From the street, the building's three whimsical facades reveal balconies, bow windows, and recessed top floors. Since the Art Nouveau architectural movement consists of imitating nature by breaking with symmetry, the master architect adorned the building with flames, waves, foliage, and an amazing bestiary including, most interestingly, metal seahorses—the structure is a must-see!

Determined to make it a whole work, which his detractors would nickname the "house of devils," Guimard also planned all the interior decor, even down to the carpets. Unfortunately, to tour Castel Béranger inside today, you must be invited in by one of its residents.

STOP 2: CRAVAN CAFÉ

A few feet further at number 17 stands a vast building complex designed by Guimard. Recognizable by its red storefront, the illustrious Café Antoine, located on the building's ground floor, is now called Cravan Café after a poet who was partial to cocktails. Since cocktails are the specialty here, plan on a Bloody Mary or other cocktail instead of wine (or even an excellent espresso) when pausing here for a rest. Surrounded by classy decor of frescoes, tiling, and a reflective glass ceiling, this is an ideal stop to appreciate the peaceful atmosphere of the village of Auteuil.

STOP 3: HÔTEL GUIMARD

Continue walking down rue Jean-de-La-Fontaine. Then, at the intersection with avenue Mozart, turn right and head toward the private residence at number 122. This is where the architect lived with his wife, the painter Adeline Oppenheim, starting in 1912. His name is carved above the door. The furniture, designed by Guimard, matches the shape of the ovoid rooms.

STOP 4: HÔTEL ROSZÉ

Go south of the district to discover Guimard's very first major achievement. At number 34, rue Boileau, the Hôtel Roszé, a private residence, opened in 1891. At the time, the young Guimard did not pursue extravagance in his designs. Nevertheless, the house, topped with wisteria, combines several materials—iron, brick, and buhrstone—with colors of ocher and sea green.

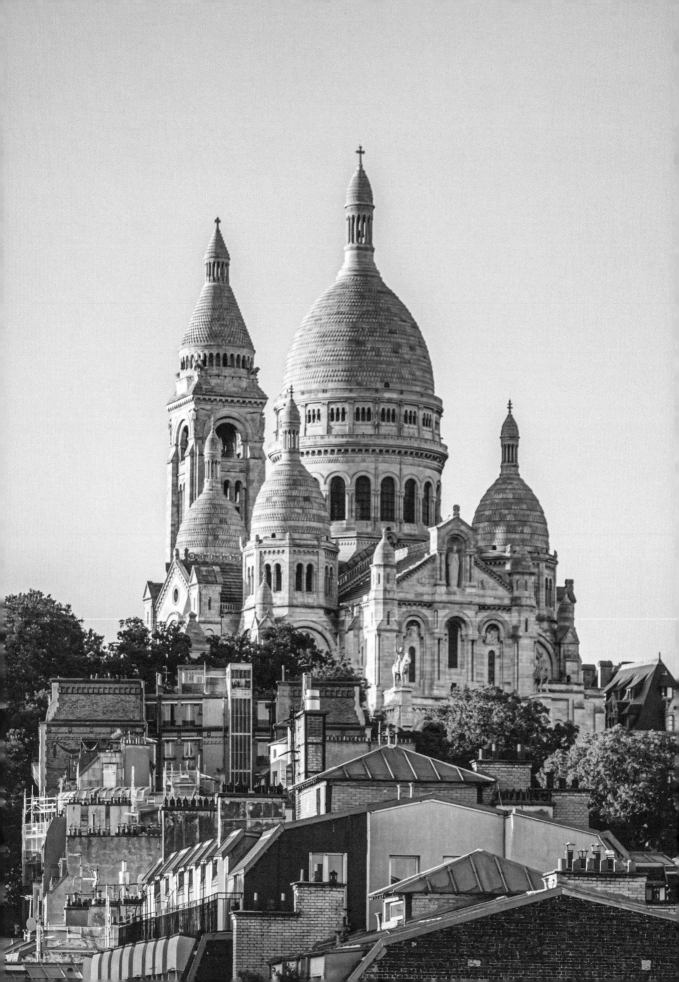

NORTHWEST PARIS

Located at the crossroads of chic and working-class neighborhoods, this pluralist and cosmopolitan section of Paris is lively day and night, from Batignolles to Goutte d'Or to New Athens.

Bounded by avenue de la Grande-Armée, the southern section of the 17th arrondissement is accentuated with affluent residential buildings. To capture the soul of this district, be sure to venture to the Batignolles neighborhood. It was once claimed that the air here was exceptionally healthy, which attracted the bourgeoisie and gave local artisans a sense of pride.

Since 1847, the Cité des Fleurs private pedestrian street has been a veritable oasis within the city. Once the houses were constructed, residents were obliged to plant at least three trees in their gardens. A century and a half later, the result is a path of lush, green charm that is best experienced by walking, but be sure to arrive when the gates to the street are open. The other areas of Batignolles are also pleasant, from the covered market to the square via the Place du Docteur-Félix-Lobligeois. At the end of the day, this is also a popular destination for food shopping or enjoying the terrace of one of the many restaurants. To the north, the modernity of the new Clichy-Batignolles eco-district contrasts with the Haussmann-era architecture.

The same bourgeois-bohemian atmosphere can be found in the New Athens neighborhood in the 9th arrondissement. Also known as SoPi, for South Pigalle, this family-friendly neighborhood enjoys an effervescent culinary scene. In addition to the cheese shops, pastry shops, and other small fine food shops found on rue des Martyrs, good restaurants are constantly emerging. Near the Opéra, the atmosphere is more businesslike with the office complexes around the perimeter, while around the Grands Boulevards, entertainment is king among its theaters, cinemas, and large brasseries.

Straddling the 9th and 18th arrondissements, the neighborhood of Pigalle is the nerve center of Parisian nightlife, where legendary cabarets, nightclubs, and theaters meet (including the Moulin Rouge and Madame Arthur). During the day, tourists venture to the top of the butte of Montmartre, which has maintained its villagelike feel. While it was the refuge for those of modest means during the Haussmann era, Montmartre is now vibrant. With its vineyards, Sacré-Coeur basilica, and steep streets, the district has everything to please. Even its cemetery is suitable for a walk!

In the heart of the 18th arrondissement, the Goutte d'Or neighborhood, which began a transformation a few years ago, exudes effervescent energy. A working-class and multicultural area since the nineteenth century, the district is now inhabited by about forty communities from all over the world. The African market on rue Dejean and the Barbès market on the eponymous boulevard are filled with spices and vegetables from the Mediterranean region. To really know Paris, you must visit here.

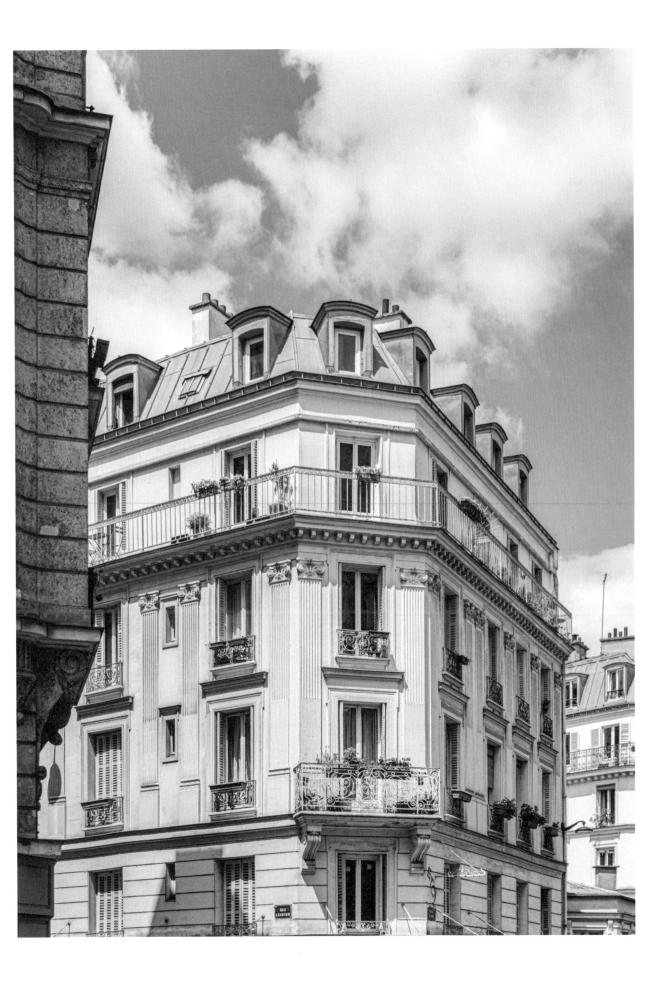

THE ESSENTIALS

PALAIS GARNIER (9TH)

This architectural masterpiece commissioned by Napoleon III
hosts dance and singing performances of the Paris Opera.

45

MUSÉE DE LA VIE ROMANTIQUE (9TH)

In the nineteenth century, the worldly elite crowded into this home of painter Ary Scheffer. Today, people visit to enjoy the tearoom under the glass roof as much as the museum.

46

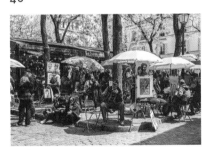

PLACE DU TERTRE (18TH)

After visiting Sacré-Coeur Basilica, tourists like to have their caricatures drawn by artists who populate the square.

47

CITÉ DES FLEURS (17TH)

Opulent villas line this flowery paved lane. The street is open to the public during the day.

48

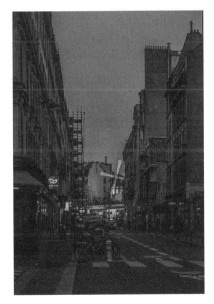

MOULIN ROUGE (18TH)

Created in 1889, this cabaret has become the symbol of Parisian nightlife. Performers La Goulue and Mistinguette elevated its prestige. Today, it enjoys a worldwide reputation.

49

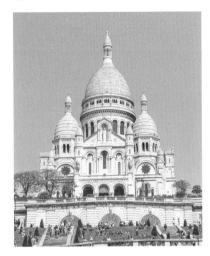

SACRÉ-COEUR BASILICA (18TH)

This Romano-Byzantine basilica dating to the late nineteenth century is a moving experience when observed for the first time. Visitors can arrive by foot or funicular.

50

SQUARE DES BATIGNOLLES (17TH)

Its cave, waterfall, and stream make this green setting ideal for families.

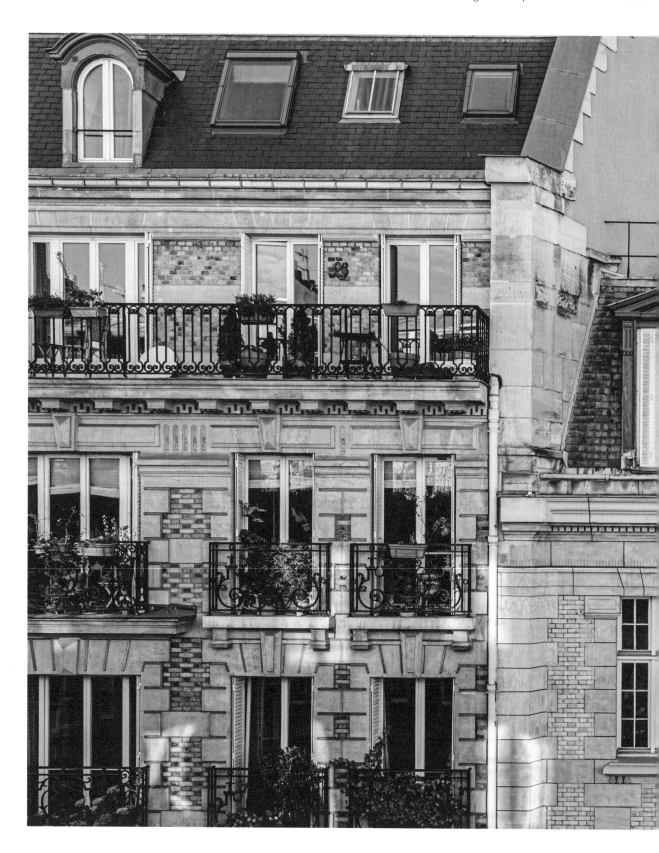

Since the nineteenth century, Parisian rooftops have been dressed in zinc and slate
considered at the time to be a more modern material than tile.

ART

ARTISTS' STUDIOS

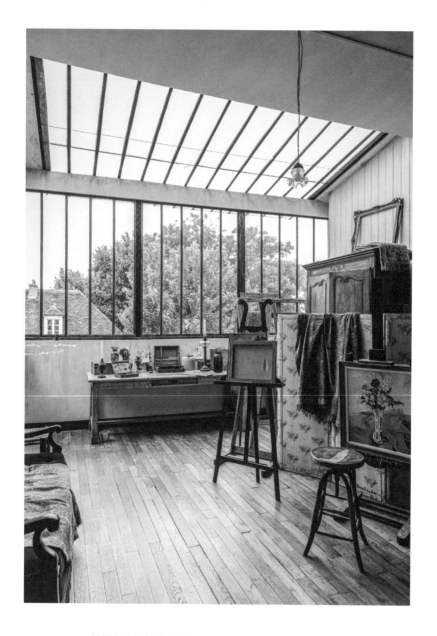

SUZANNE VALADON STUDIO-APARTMENT (18TH)

The Musée de Montmartre houses the studio-apartment of this French
post-Impressionist painter (1865–1938).

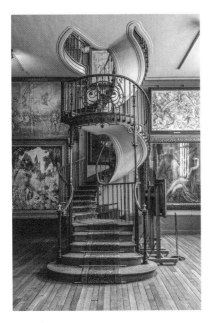

MUSÉE GUSTAVE-MOREAU (9TH)

This house-studio preserves the paintings and family memorabilia of this Symbolist painter (1826–1898).

ATELIER-MUSÉE CHANA ORLOFF (14TH)

The studio of this Ukrainian sculptor (1888–1848), a major figure in twentieth-century abstract art, unites nearly 200 of her original works.

MUSÉE JEAN-JACQUES-HENNER (17TH)

In this nineteenth-century private town-home, the prolific work of this French Symbolist painter (1829–1905) is displayed.

MAISON ARY SCHEFFER (9TH)

The paintings of Ary Scheffer (1795–1858) are exhibited at the Musée de la Vie Romantique, where he hosted the capital's elite.

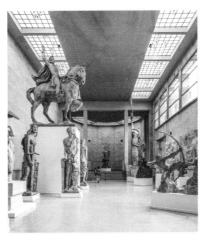

MUSÉE BOURDELLE (15TH)

This museum is a collection of 500 plaster, marble, and bronze sculptures by Antoine Bourdelle (1861–1929).

ATELIER BRANCUSI (4TH)

Rebuilt identically to its original state, the studio of Constantin Brancusi (1876–1957) is opposite Centre Georges-Pompidou.

MUSÉE ZADKINE (6TH)

The house-studio of Osip Zadkine (1890–1967) still retains the spirit of this Russian-born sculptor.

INSTITUT GIACOMETTI (14TH)

This replica of Alberto Giacometti's (1901–1966) studio, along with his personal effects, immerses visitors in the world of this Swiss artist.

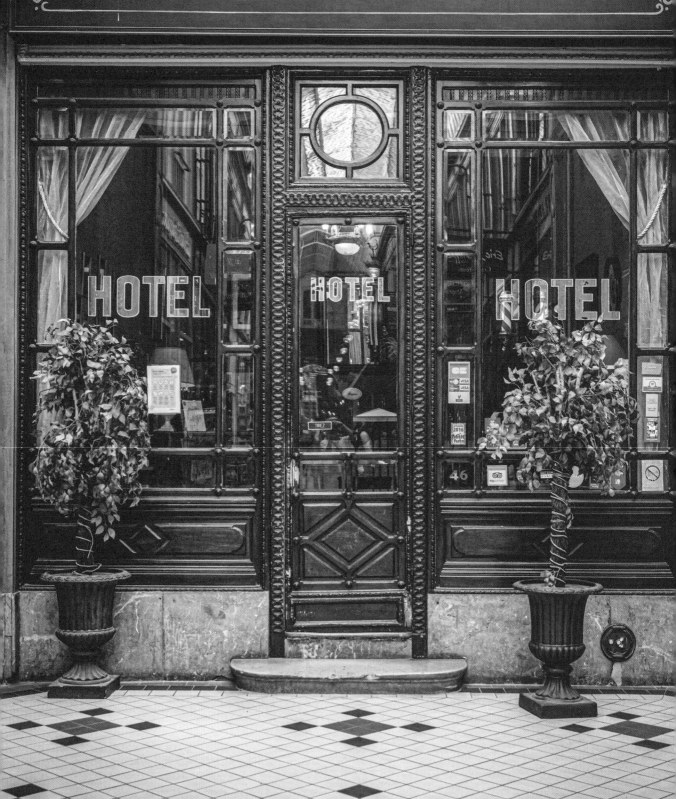

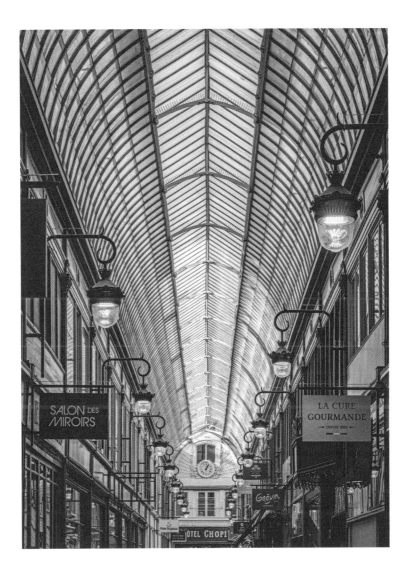

ABOVE

*Created in 1845, the narrow Passage Jouffroy houses the Musée Grévin,
where wax reproductions of celebrities are displayed.*

LEFT

*Opened in the Passage Jouffroy in 1847, Hôtel Chopin is unique for
having a door with no locks to make it accessible at all hours.*

LIFESTYLE

SIMPLE DINING

Before the advent of Parisian brasseries, *bouillons* were
the popular choice for a hearty meal. In recent years, these casual
restaurants for the masses have experienced a resurgence.

In the collective imagination, Paris has always been associated with clichéd images of red-and-white checkered tablecloths, Skaï benches, steak frites, and glasses of red wine enjoyed on a terrace. But the renewed popularity of *bouillons* (working-class restaurants offering classic French food with easy prices and snappy service) proves that the French still love this centuries-old way of life.

The first *bouillon* emerged in 1860 when butcher Pierre Louis Duval opened an establishment on rue de la Monnaie (1st) to prevent wasting less-noble pieces of meat. On the menu were a bowl of broth and a pot-au-feu, called *hochepot*, that fed the workers of the nearby Les Halles markets for a meager charge. In the following decades, these establishments multiplied and, by 1900, reached two hundred fifty. The most famous among them is undoubtedly Bouillon Chartier, whose first location opened in 1896 on rue du Temple (3rd). Building on their success, the owners opened a second location a few years later in the 9th arrondissement. It has now become an institution. Located on rue du Faubourg-Montmartre, this legendary address has preserved its masterful decor, typical of the Belle Époque, and is classified as a historical monument. In the main dining room, lit by a multitude of round lamps, the burst of voices intermingles while waiters zip between the tables. The restaurant's vivacious pace is important as, since

its opening, Bouillon Chartier has served fifty million meals—more than a thousand per day! The reason for such an influx of customers is hardly a mystery. The famous *oeuf mayonnaise* (a halved hard-boiled egg covered with mayonnaise) is served up at just 2 euros, *confit de canard pommes grenailles* (duck confit with new potatoes) costs around 10 euros, and a coupe of *crème chantilly* (a sweetened beaten cream) is offered at 2.50 euros.

With the advent of lavish brasseries, these restaurants almost disappeared completely. But in 2017, two restaurateurs, the Moussié brothers, had the idea of reviving them. Their new location Bouillon Pigalle (18th), which combines the codes of these restaurants of yesteryear with a more contemporary aesthetic, became a great success.

In 2021, the brothers replicated their concept with Bouillon République (3rd). The menu reconnects with an unbeatable quality-to-price ratio and helps make classic homestyle recipes trendy. Invented in Paris, *soupe à l'oignon gratinée au cantal* (onion soup with cantal cheese), for example, has made a comeback alongside *saucisse-purée* (a sausage served with puréed potatoes) and *ile flottante aux pralines roses* (poached meringues floating on a vanilla sauce with pink pralines)—all beautiful, delicious, and at bargain prices. The long lines on the sidewalks of these establishments prove that all of Paris is, once again, under their spell.

Chartier on the Grands
Boulevards is the most famous
of the Parisian *bouillons*.

Created in 1896, Bouillon
Chartier was classified as a
historic monument in 1989.

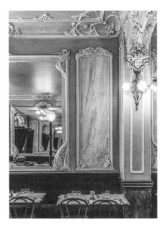

Tréziel and Majorelle are among
the great artists who worked to give
Bouillon Julien its exceptional decor.

Chartier's fame is attributed
to its low-priced plates
and chic decor.

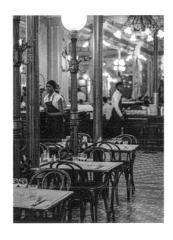

In white shirts and black aprons,
the serving staff at Bouillon Julien
are experts in exceptional service.

Escargots and oeuf mayonnaise
are among the classics of French
cuisine served at Bouillon Julien.

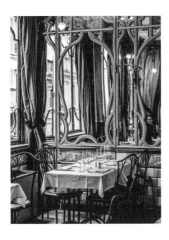

Bouillon Julien has been offering
its clientel great food amid Art
Nouveau decor since the 1900s.

From inside its modern building,
Bouillon Pigalle serves
low-priced dishes.

Le Racine has satisfied
a continual clientele
since 1906.

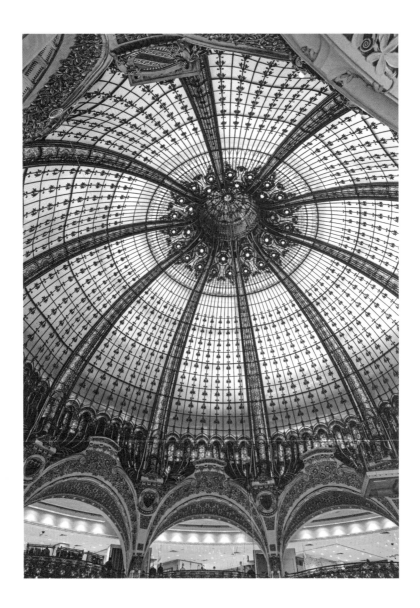

ABOVE

*The magnificent Art Nouveau dome of Galeries Lafayette has been a
dominant feature of the department store since 1912.*

RIGHT

*The terrace of Printemps department store offers a pleasant surprise:
a view of the rooftops of Paris and the Eiffel Tower in the distance.*

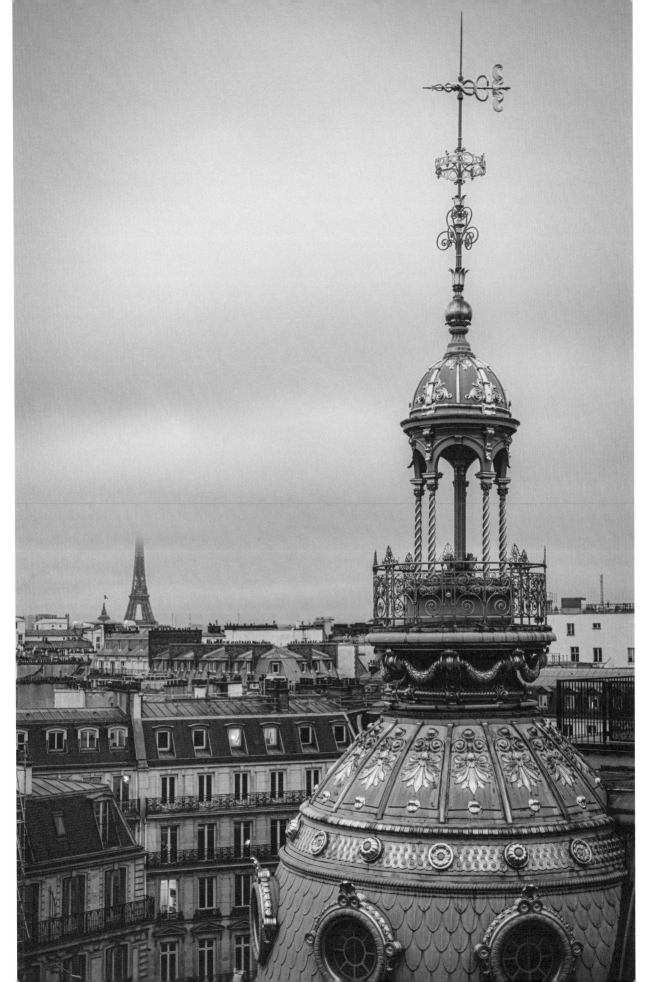

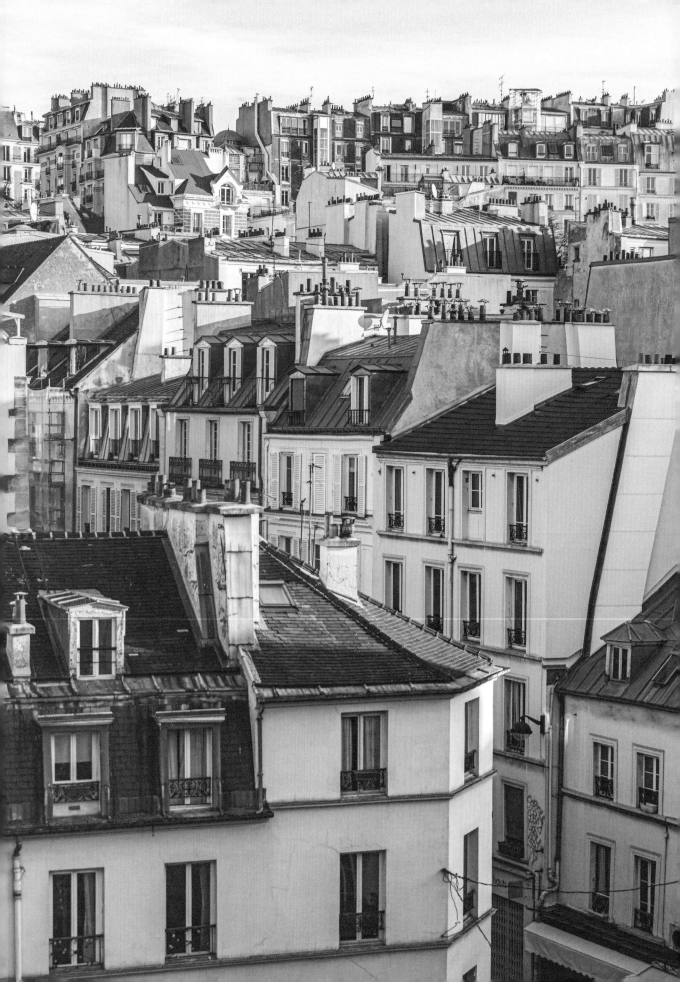

Painted many times by artists, the streets of Butte Montmartre have kept the charm of a village.

Once a very populated district, Montmartre sprawls along narrow streets lined with small,
unembellished buildings.

PARISIAN WINE

Wine is inseparable from French gastronomy. Many people are
unaware that Paris has had a wine culture since Gallo-Roman times,
and several vineyards still operate within the city today.

The slopes of Paris have been dotted with vineyards since ancient times. Until the Middle Ages, the region was even one of the largest wine producers in Europe! Since water during this time was not safe to drink, the French would consume light wines to quench their thirst.

During the sixteenth century, the slopes of Montmartre were covered with vines, and most of the area's inhabitants worked in the wine industry. The site was punctuated by fields and mills, lending it a certain charm. In the eighteenth century, Parisians were subject to a tax on wine, so they could freely drink their glasses in the dance halls and cabarets surrounding Montmartre since, at the time, the village was not considered part of the capital.

Wine production halted, however, at the end of the nineteenth century for two primary reasons: First, the land was highly coveted during a time of increasing urbanization in Paris. Second, Europe was affected by vine diseases, such as phylloxera, from North America. The vineyards thus gradually diminished.

In 1933, the people of Montmartre planted more than three thousand vines on a plot measuring 16,700 square feet (1,556 square meters) at the corner of rue des Saules and rue de Saint-Vincent to help combat urbanization. The following year, they organized a harvest festival even though the vines were not yet producing grapes. Twenty-seven grape varieties, including Pinot Noir, Gamay, and Sauvignon, now flourish on the hill's northern slope.

Owned by the city of Paris, Clos Montmartre now produces eighteen hundred bottles of organic wine per year, divided into two vintages: red and rosé. The sulfite-free winemaking occurs in the cellars on the underground floors of the 18th arrondissement's Hôtel de Ville (the district's administrative building). To taste the wine, you must treat yourself to a guided tour of the vineyard, where a tasting is offered at the end of the visit. In October, the harvest festival is a popular event during which the bottles are auctioned for charities.

Paris has four other vineyards. In Belleville, wine—called *piquette*—was produced starting from the Carolingian period to the mid-nineteenth century. Production was restarted in 1992. In the 15th arrondissement, in Parc Georges-Brassens, vines flourished until the end of the eighteenth century before being replaced by vegetable gardens, but they were revived in 1983. The vines of Parc de Bercy and Butte Bergeyre were established in the mid-1990s.

THE VINEYARDS OF PARIS

VINEYARDS OF CLOS MONTMARTRE
1,800 vines

Production:
75% Gamay and 25% Pinot

VINEYARDS OF BUTTE BERGEYRE
160 vines

Production:
Chardonnay, Muscat, Pinot Noir

VINEYARDS OF BELLEVILLE
140 vines

Production:
80% Pinot Meunier and 20% Chardonnay

VINEYARDS OF PARC GEORGES-BRASSENS
720 vines

Production:
95% Pinot Noir and 5% Pinot

VINEYARDS OF PARC DE BERCY
350 vines

Production:
Sauvignon and Chardonnay

A WINE CULTURE

In recent decades, Paris has been reviving its glorious wine-growing past, which reached its peak in the eighteenth century by producing wines that became as famous as those of Bordeaux or Burgundy. The people of Montmartre were the first to replant vines on the hillsides in 1933.

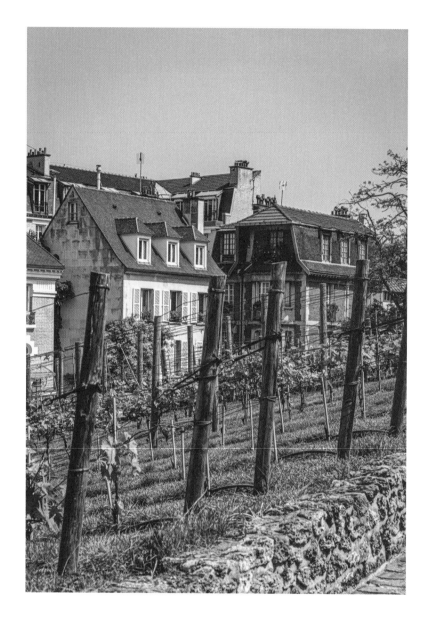

ABOVE

*Clos Montmartre is the oldest vineyard in Paris.
Its existence is attested as early as 944.*

RIGHT

*As the highest point in Paris, Butte Montmartre offers
beautiful panoramas of the capital from every street corner.*

MAISON CHÂTEAU ROUGE

A self-taught stylist, Youssouf Fofana is the founder and artistic director of Maison Château Rouge, a fashion and lifestyle brand that celebrates the eponymous district of the 18th arrondissement.

As a child, Youssouf Fofana had a natural talent for design. He recalls, "I used to do my siblings' plastic arts homework, but I never thought of making it my job." He forged his visual talent through watching television programs and pursued a diploma in banking after high school. Youssouf was born and raised in Villepinte, Seine-Saint-Denis, and landed a job in the Château Rouge district of Paris. "All members of the African diaspora have a connection to this neighborhood. I came with my mother to visit my uncle who had an African wax fabrics boutique on rue Myrha where you could buy Senegalese products." Nourished by multiple influences, the area is full of fabric stores and traditional grocery stores, and this is where Youssouf settled.

After earning a master's degree in project management and digital marketing, he joined Crédit Coopératif, a bank committed to a social and solidarity-based economy, where he worked on an online account management platform for associations. Inspired by his work, he wanted to apply his knowledge to serve an audience to whom he could relate. With his brother Mamadou, Youssouf launched the association Les Oiseaux Migrateurs, which assisted small African businesses by providing them access to an international market. Maison Château Rouge was founded in 2015 to finance this project.

"We wanted to highlight a lifestyle that everyone would want to follow. It was a way to reconcile our two cultures." Following his creative instincts, he bought fabric from merchants in the district and designed a hundred T-shirts with the inscription "Maison Château Rouge," which he had manufactured in Paris. The success was immediate, and the shop opened at 40 bis, rue Myrha in 2016 with a warm reception from the neighborhood. Resulting from its participation at the Who's Next fashion trade show, the brand was noticed by the Parisian concept store Merci, which would soon display Youssouf's creations. As a keen entrepreneur, Youssouf followed his instincts and resigned from the bank to fully devote himself to his label.

As his lines expanded, collaborations with other major establishments followed one after the other, such as Le Bon Marché and Monoprix, for whom he created a wardrobe and decorative accessories made in Africa, followed by Jordan Brand, a brand of the Nike group. Youssouf sketched a first pair of Air Jordans in 2019, followed by a second pair and several outfits in 2022. In his humble way, Youssouf admits to having been surprised by the success of these collaborations, and he has since announced that Maison Château Rouge will have to evolve. "Our collections will be more extensive and presented at each fashion week. Through the universality of dreams, we want to show how all cultures are alike."

1. SHOP

All the streetwear collections designed by Youssouf Fofana
are sold at the parent company, Château Rouge.

2. COLLABORATION

Fofana created the Air Jordan 1
Fearless Mid Maison Château
Rouge for Nike.

3. VISIONARY

The designer opened a pop-up
cultural center in the former
Tati store in 2022.

4. A VARIED OFFERING

In addition to clothing, the shop
offers home accessories, such as
ceramics from Studio Ibkki.

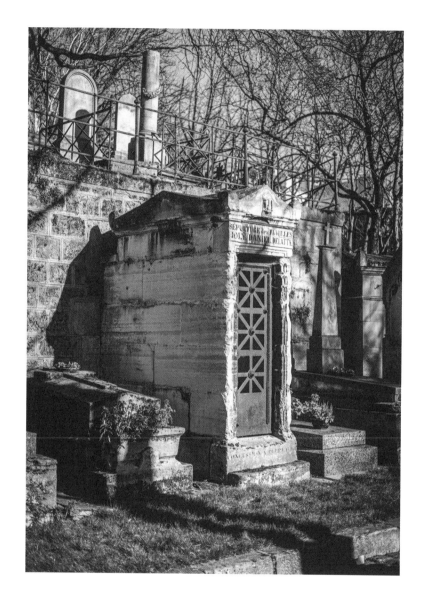

ABOVE

More than 20,000 Parisians are buried in the capital's Montmartre cemetery.

RIGHT

Bordered by 800 trees, the pathways of Montmartre cemetery
provide a shady place to walk during the summer.

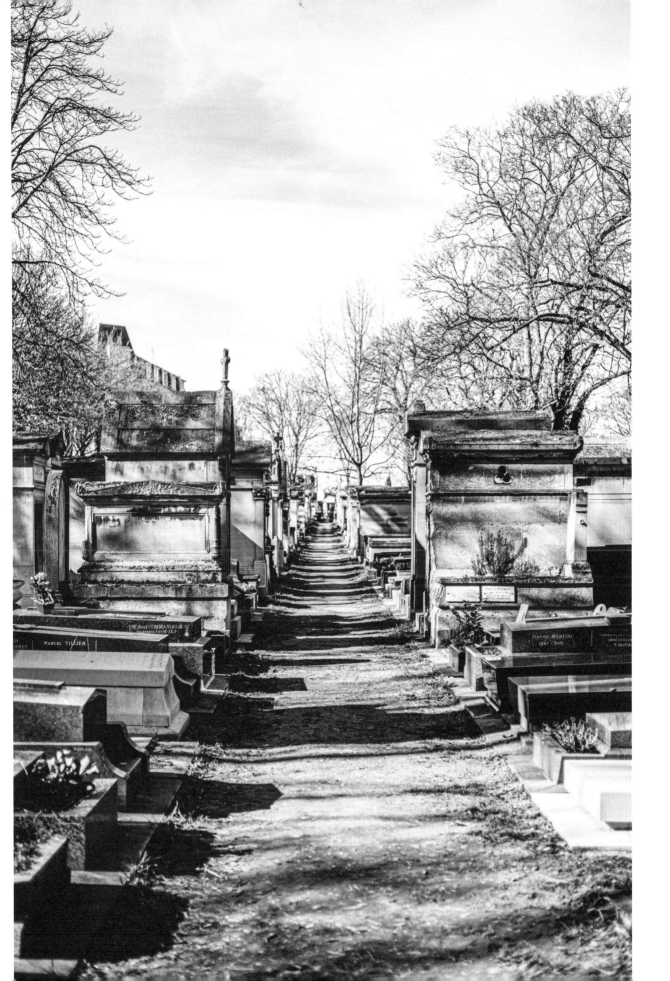

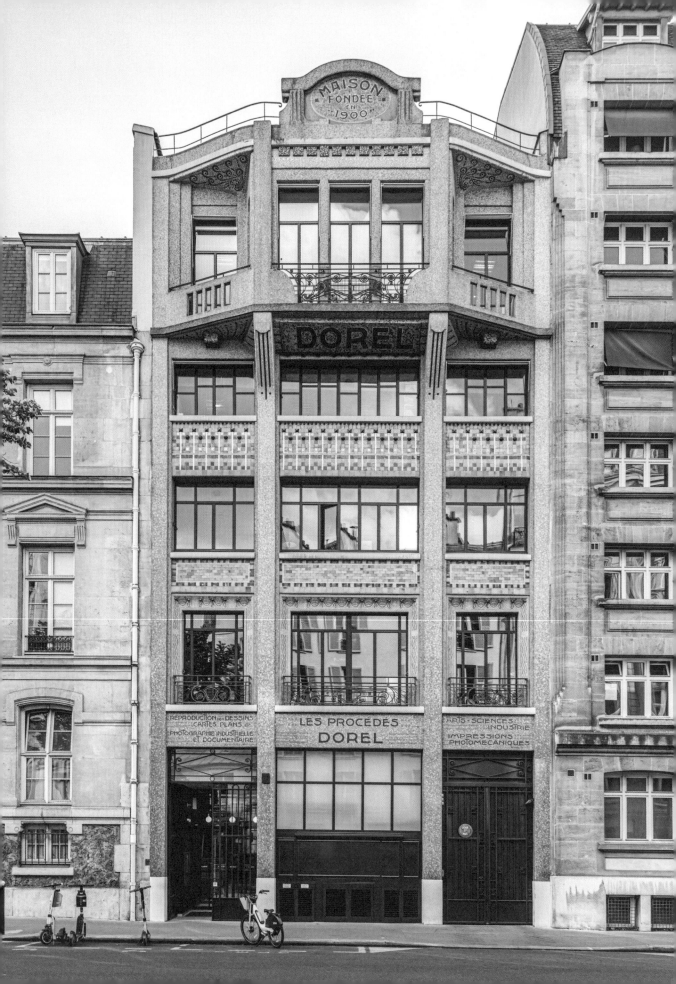

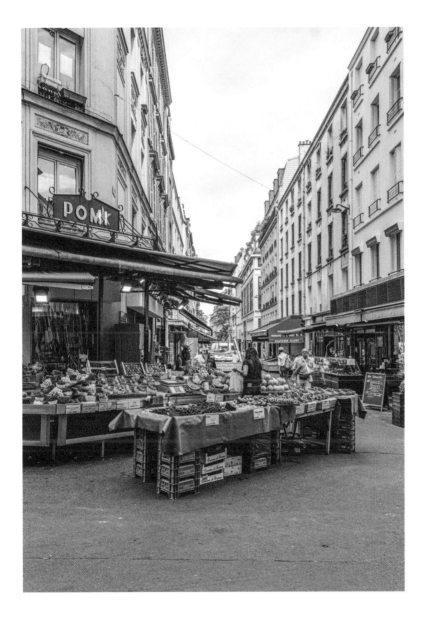

ABOVE

Throughout the city, small markets offer fresh food,
such as this one on rue Poncelet.

LEFT

Les Procédés Dorel has left a lasting mark on the facade
of its headquarters with its Art Deco style.

ABOVE

*The Square des Batignolles is one of the many gardens created in Paris
by order of Napoleon III.*

RIGHT

*The Square des Batignolles was designed as an English-style garden,
with a cave, river, waterfall, and miniature lake.*

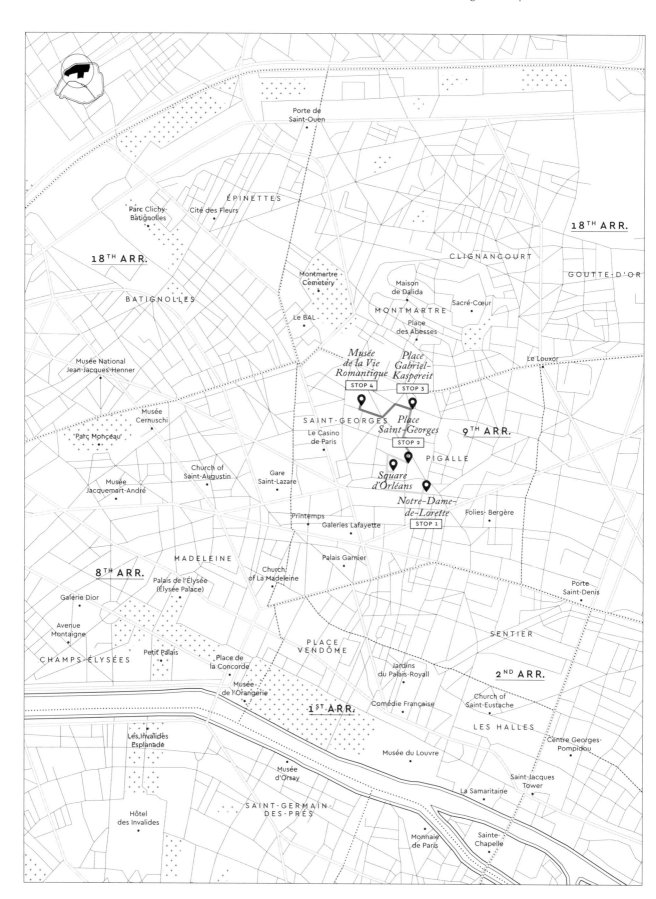

NEW ATHENS

Whether called SoPi, for South Pigalle, or New Athens, as during the nineteenth century,
this district in the 9th arrondissement exudes the bourgeois-bohemian culture.

STOP 1: SQUARE D'ORLÉANS

To reach this private residential square, descend at Notre-Dame-de-Lorette metro station. From the church forecourt, follow rue de Châteaudun toward the right, then take rue Taitbout on the right. At number 80, a high carriage passageway marks the entrance to this little-known area. Built in the early nineteenth century, this affluent square was inspired by English squares and ancient art. With its shaded inner courtyard, the square has attracted figures of the Romanticism movement, such as composer Frédéric Chopin, novelist George Sand, and writer Alexandre Dumas, who settled here at one time where this famous artistic and intellectual movement emerged.

STOP 2: PLACE SAINT-GEORGES

On exiting, walk up rue Taitbout to rue d'Aumale, turn right, then left on rue Saint-Georges. Here you will discover the eponymous square, surrounded by urban mansions. At number 28, the Hôtel de la Païva presents a neo-Renaissance facade that was not to everyone's liking when it was completed in 1840, as its decor was considered a bit overdone with cherubs, griffins, and lions. Esther Lachmann, a courtesan, nicknamed the Païva, and made the building one of the most popular salons in the city. On the other side of the square, Hôtel Dosne-Thiers now houses a museum-library.

STOP 3: PLACE GABRIEL-KASPEREIT

Next, head toward Pigalle via rue Henry-Monnier until you reach Place Gabriel-Kaspereit. A curious eye will be immediately drawn to Le Shanghai, a former erotic cabaret that testifies to the neighborhood's entertainment culture. Since being transformed into a bar and restaurant, only its Art Deco stained-glass window, inspired by a print by the Japanese painter Hokusai in 1920, recalls its lurid past. Before continuing your walk, linger for a few moments in front of the gates of avenue Frochot. Although this private avenue is closed to the public, it offers views of magnificent homes bathed in greenery.

STOP 4: MUSÉE DE LA VIE ROMANTIQUE

Follow rue Victor-Massé on the right, then turn left onto rue Jean-Baptiste-Pigalle. At the first crossroads, take rue Chaptal, which houses, at number 16, the Musée de la Vie Romantique (Museum of Romantic Life). Rising to two stories, this former home of painter Ary Scheffer, built in 1830, welcomed Paris's artistic and intellectual crowds for several decades. With the price of an entrance ticket, you can now enjoy a pastry in the tearoom under the glass roof in the heart of the garden.

AROUND THE CANALS

With their parks and lively cosmopolitan character, the banks of Paris's canals have shed their bad reputation from times past and, since the early 2000s, attract young people and families of a more bohemian lifestyle.

The neighborhoods of Saint-Denis, Saint-Martin, and Temple, located on the edge of the capital since the seventeenth century and marked by still-standing stone arch gateways, make up the 10th arrondissement. Today, this sector of the city, nestled between the bourgeois districts of the city's center and the more working-class districts of the north, is very much in vogue. Although gentrification is taking place here, the historic inhabitants of modest origins have remained. The result is a multicultural district that invites you to explore.

To the south, the vast Place de la République is a starting point for major political events; it is also very popular with skateboarders. The Canal Saint-Martin flows not far from here. Thanks to its picturesque bridges and quays perfect for picnics and shopping on foot, this area is always lively, especially since new restaurants and bars often offer outdoor dining spaces.

When it comes to dining, the 10th arrondissement is an ideal hub. Not far from the Gare de l'Est, the Passage Brady is nicknamed Little India for its numerous Indian restaurants and grocery stores. Turkish, Kurdish, and West African establishments rub shoulders here with bars and eat-in wine shops. For a leap in time, you must have lunch at the Saint-Martin or Saint-Quentin covered markets in one of the stalls that adjoin the food shops.

To the north, the 19th arrondissement follows the border of the former commune of La Villette. The charm of the Bassin de la Villette and the Canal de l'Ourcq, undergoing a complete transformation, attracts Parisians. As in the 10th, cafés and bistros abound along the quays. On sunny days, all generations gather here to play *pétanque* or Mölkky, games compelling enough for the many children who come here to walk with their parents along the water. It is even possible to take a boat, without a permit, for an hour, or a day, to the city of Sevran just northeast of Paris.

The city's residents desiring green spaces can escape to the enormous Parc des Buttes-Chaumont with a waterfall and suspension bridge, or to the Mouzaïa district, populated with villas with flower gardens. In the same arrondissement, the Parc de la Villette is an appealing stop for culture buffs with the Cité des Sciences, La Géode cinema, the Cité de la Musique, the Philharmonie de Paris, and several concert halls located here. Finally, at metro stop Riquet, the Centquatre-Paris public cultural center honors art from all disciplines during expositions and festivals.

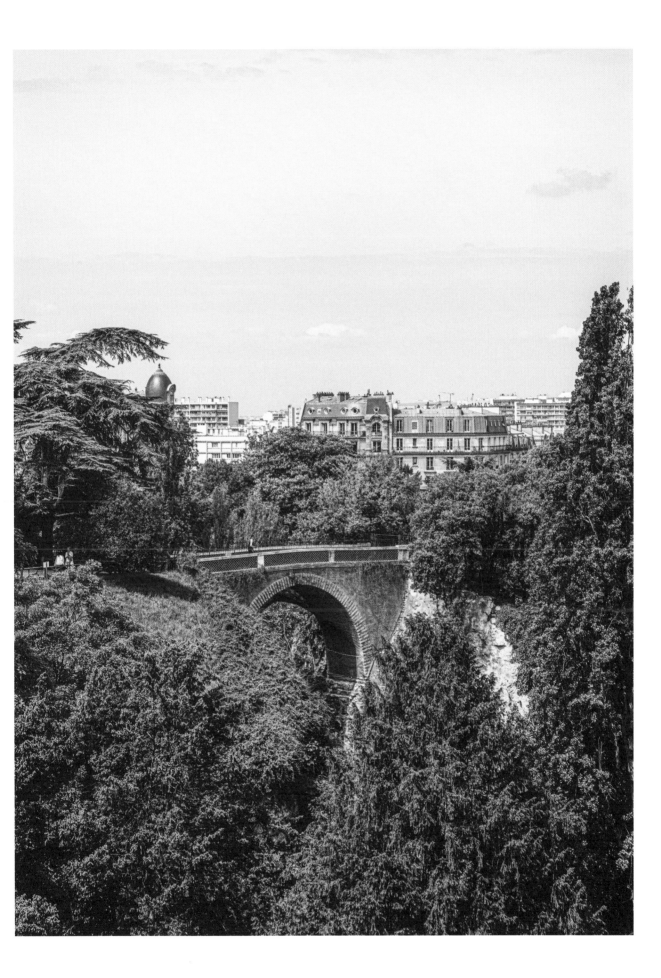

THE ESSENTIALS

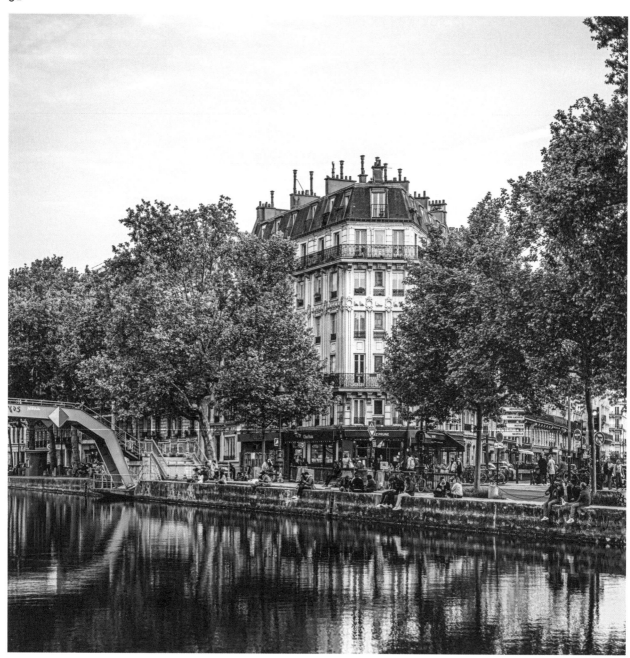

CANAL SAINT-MARTIN (10TH)

Small boats carrying passengers glide continually up and down the canal,
but some visitors prefer to walk along the canal instead.

52

LE GÉODE (19TH)

Serving as both monument and sculpture, this mirror-clad sphere reflects the Cité des Sciences et de l'Industrie located across from it.

53

PHILHARMONIE DE PARIS (19TH)

With its aluminum facade, this incredible structure is home to the Cité de la Musique, which contains four centuries of musical history.

54

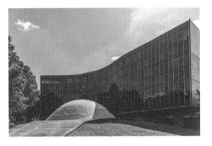

HEADQUARTERS OF THE FRENCH COMMUNIST PARTY (19TH)

The Brazilian architect Oscar Niemeyer designed this modernist building, open to visitors several times during the year.

55

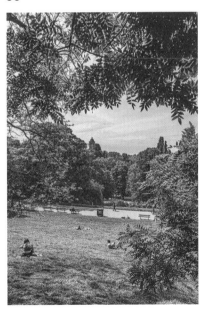

BUTTES-CHAUMONT (19TH)

This hilly 60-acre (25-hectare) park boasts a lake, lookout point, suspension bridge, and waterfall.

56

PLACE DE LA RÉPUBLIQUE (10TH)

Always lively, this square is one of the nerve centers of the capital. This is the starting point for many demonstrations.

47

PORTE SAINT-DENIS (10TH)

Less conspicuous than the Arc de Triomphe on the Champs-Élysées, this triumphal arch was once a gate of Paris's wall.

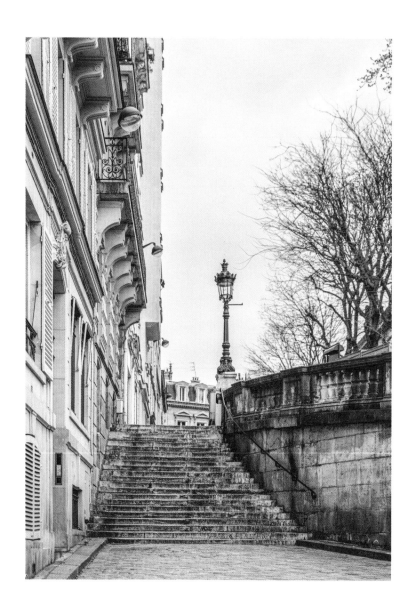

ABOVE

*A staircase leads to the Church of Saint-Vincent-de-Paul,
a listed building since 2017.*

RIGHT

*The Church of Saint-Vincent-de-Paul has stood on the former site
of the house of Saint Vincent de Paul since 1844.*

P.174–175

*In Paris, Art Nouveau, with its exuberant ornamentation,
has left a lasting mark on many facades.*

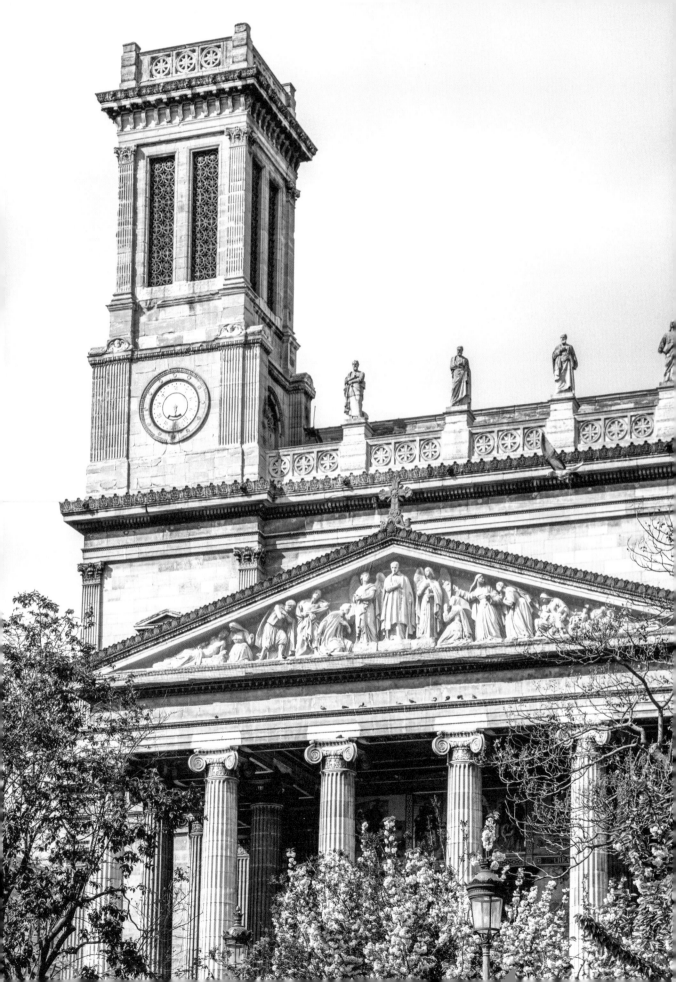

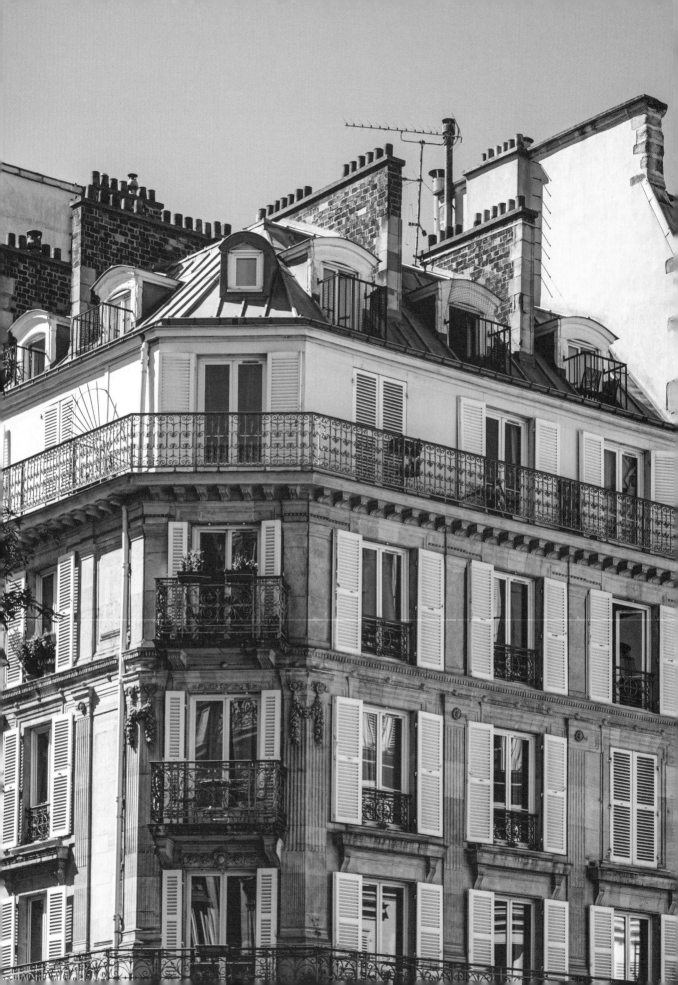

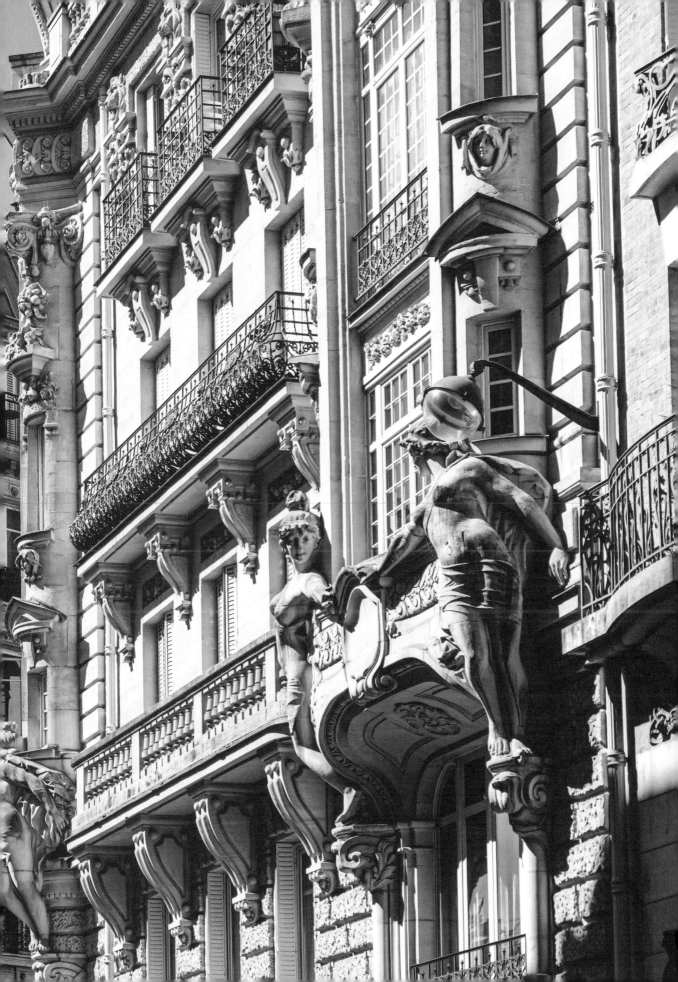

PROFILE

DISTILLERIE DE PARIS

Paris's first legal distillery opened in 2015.
Its founder, Nicolas Julhès, shares his passion for spirits
through recipes inspired by the many influences
of the 10th arrondissement.

Nicolas Julhès moved from Auvergne to Paris with his parents in 1996. His father, who had previously worked in a bakery, opened the Julhès small food shop that same year in the cosmopolitan district of Faubourg-Saint-Denis. The family quickly took over the nearby cheese shop and catering shop. Their high-quality products brought success to their shops, now numbering six. At the time, Nicolas, who was only in his twenties, was fascinated by cheeses, wines, and other products, but he eventually discovered spirits. "It was a revelation to me because the world of spirits associates the culture of clean flavors within gastronomy with the nearly immortal character of aromas."

To pursue his new passion, Nicolas read and traveled to learn the secrets of distillation. His work as a consultant for a major global liquor company allowed him to have inspiring encounters and to immerse himself in the product's history. After learning about the micro-distillery phenomenon in the United States, he dreamed of launching his own distillery with his brother Sébastien. However, Paris had prohibited the distilling of spirits in the city since 1914 because of the dangers of adulterated alcohol and fire risk. After five years of fighting for official approval, however, he opened the Distillerie de Paris in 2015, partly financed through crowdfunding.

Nicolas established the distillery headquarters in the family food store. "I wanted to be challenged, to take advantage of a changing environment, and the energy of rue du Faubourg-Saint-Denis was perfect for that." Today, his 100-gallon (400-liter) copper still, designed by him and made in Germany, shines proudly in a small 300-square-foot (28-square-meter) room at the end of the courtyard served by the shop. Vigilant about the quality of his raw ingredients, Nicolas first created a classic dry gin, using the same process for making a perfume, to which he gave notes of juniper, coriander, and bergamot.

Since then, this creative soul, who follows his intuition, has created rum, vodka, sake, and single-malt whiskey aged in chestnut barrels—and even perfume. Twenty-five thousand bottles are produced each year and distributed worldwide. He soon set his sights on other locations. After going to Cuba to distill gin, he went to Burgundy to distill with winemakers. Just like his adopted neighborhood, Nicolas Julhès has unrestrained energy.

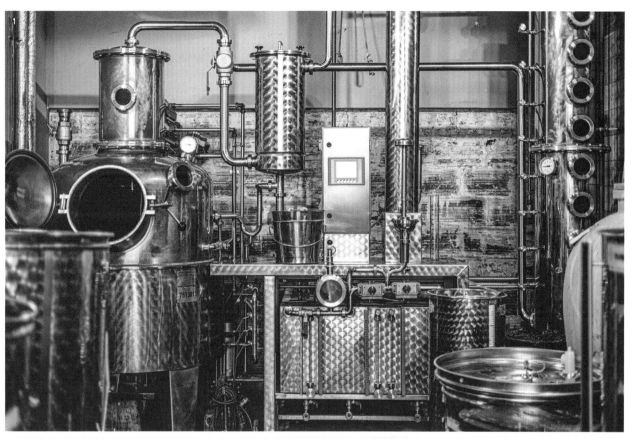

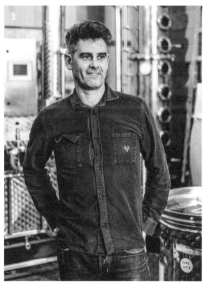

1. AND 2. A SMALL SETTING

Overlooking a Parisian courtyard, the distillery's room of copper stills measures only 300 square feet (28 square meters).

3. PASSION

To launch his distillery, Nicolas Julhès designed his own still.

4. PRODUCTION

The distillery produces 25,000 bottles of gin, rum, and whiskey each year.

ABOVE

At the Saint-Quentin market, all the stalls offer fresh, local products.

RIGHT

*The Saint-Quentin market is the ideal stop to enjoy exotic dishes
served in one of the many stalls.*

PARIS GOES TO THE MOVIES

Among the thirty or so independent cinemas still operating in Paris, some are home to legendary auditoriums worth visiting.

At nightfall, the elegant glow of the neon lights of Paris's cinemas reflects across the pavement. There is no question that Parisians love going to the movies. Whether for romantic dates, family outings, or with friends or alone, the capital's neighborhood cinemas have been welcoming movie lovers for more than a century. As with performance halls, cinemas can present an elegant decor of carmine-colored curtains and spectator balconies. Before the arrival of sound films, cinemas even provided orchestras to lend a new dimension to on-screen images. Starting at the end of the 1920s, talking cinema captivated all social classes, reaching its golden age in the mid-twentieth century. Luckily, some of this cultural heritage has been preserved.

Standing on boulevard Barbès, the Luxor cinema fascinates anyone who sees it for the first time. When it opened in 1921, the building, designed by architect Henri Zipcy, was perfectly in tune with its time: France was fascinated with Egyptology. The theater's three facades, resembling a pharaonic temple, are decorated with Art Deco mosaics. "Luxor, the Palace of Cinema," says a sign on the front. Inside, the majestic 1,140-seat sun-yellow room features scarabs, sun discs, and lotus friezes.

This treasure of cinema, however, almost disappeared. At the end of the 1980s, it was closed and converted into a nightclub. It was not until 2013 that the city of Paris, encouraged by neighborhood associations, returned it to its original purpose.

Another result of the Roaring Twenties is Studio 28, which opened its doors in Montmartre in 1928 and began specializing in rare cinematographic works. Under the direction of brothers Edgar and Georges Roulleau, the cinema's auditorium with the red curtain was funded by eclectic artist Jean Cocteau, who also designed its whimsical lighting, which is still visible today. There is a cozy café tucked away in the garden where you can enjoy a drink before a showing.

On the Left Bank, Le Champo has been the Latin Quarter's must-see arthouse cinema since 1938. Behind its Art Deco facade, regulars come to watch an entire night's worth of movies before enjoying breakfast together.

In summer, many parks host outdoor movies. Parc de la Villette organizes a festival in July and August and has showings free of charge beginning at nightfall.

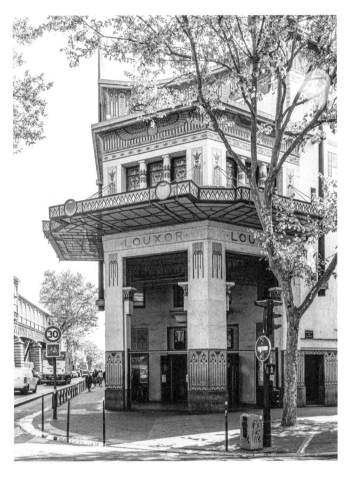

1. LE LOUXOR

The Louxor Cinema, located in the 20th arrondissement, has
Asian-inspired architecture. It is classified as a historical monument.

2. STUDIO 28

This eighteenth-century
cinema was the first avant-garde
cinema in the capital.

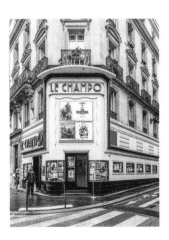

3. LE CHAMPO

François Truffaut established his
headquarters in this cinema lo-
cated in the 5th arrondissement.

4. L'ESCURIAL

Adorned with gold gilding, chandeliers,
and mirrors, this cinema in the 13th
arrondissement has a timeless charm.

ABOVE

*The fashionable boutiques along Quai de Valmy
display colorful storefronts.*

LEFT

*About 3 miles (5 kilometers) long, the Canal Saint-Martin
separates the 10th and 11th arrondissements.*

CANAL SAINT-MARTIN

A relaxing place for walkers, the Canal Saint-Martin stretches
about three miles (four and a half kilometers) from the Bassin de la Villette
to the Port de l'Arsenal. The canal's nine locks and two swing bridges
assist boats with transitioning between two water levels.

Opened in 1825, the Canal Saint-Martin supplies Paris with fresh water and helps relieve traffic congestion on the Seine. Until the middle of the twentieth century, this artificial waterway was bustling with boats transporting goods loaded from the warehouses upstream to the center of the capital. Now, mostly passenger boats use the canal, while goods are transported via Canal Saint-Denis.

In the Port de l'Arsenal, barges float gently on the water. This is where most boat rides begin. At its end, boats enter a one-and-a-quarter-mile-long (two-kilometer) underground tunnel that passes under the Place de la Bastille and boulevards Voltaire, Richard-Lenoir, and Jules-Ferry.

In the darkness of the tunnel, only a few openings in the ceiling bring in light to allow visitors to track their progress. Once back in the open air, boats must cross the Temple lock in the middle of Square Frédérick-Lemaître. The system is scrupulously monitored by lockkeepers using hundreds of cameras. To pass through, boat captains must declare themselves and identify their boats.

The intermediate gates work in pairs: In the center, the water in the lock lowers to the water level in the canal where the barge is located. The barge then crosses the first passage that closes behind it. The lock fills up to reach the water level of the next section. The barge can then pass through the gate and continue its journey. Further on, the swing bridge on rue Dieu, like that of La Grange-aux-Belles, turns aside along the quay to give way to boats.

The Récollets lock (famous for its appearance in the 2001 film *Amélie*) and those of Morts and La Villette operate in the same manner. Pedestrians can cross the graceful iron footbridges to reach the opposite bank.

At the end of the Bassin de la Villette, just before the Canal de l'Ourcq, boats and locals use the lift bridge on rue de Crimée. This bridge has been operating since 1885 to grant passage to boats every thirty minutes. On land, pedestrians must wait until the bridge has finished its maneuver or use the footbridge that adjoins it.

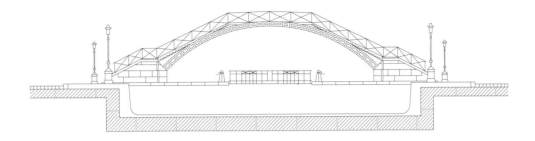

1. PASSERELLE DES DOUANES

Paris's oldest footbridge was inaugurated in 1860.
Made of cast iron, it was designed with a graceful arch.

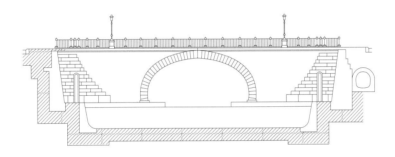

2. VOÛTE DU TEMPLE

The canal flows through a tunnel just over 1 mile (2 kilometers) long,
starting from the Port de l'Arsenal to the Voûte du Temple canal,
where it emerges again into the open air.

3. LOCK GATES

Two intermediate gates permit boats to pass between two water levels.
This diagram represents the stage of elevation of the upstream gate.

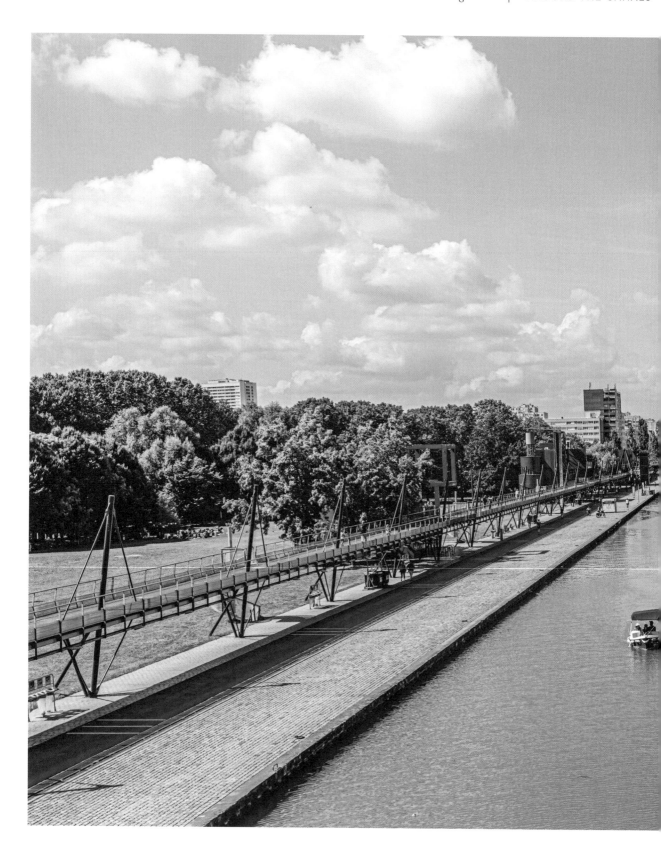

In summer, electric rental boats sail on the Canal de l'Ourcq,
which crosses the Parc de la Villette.

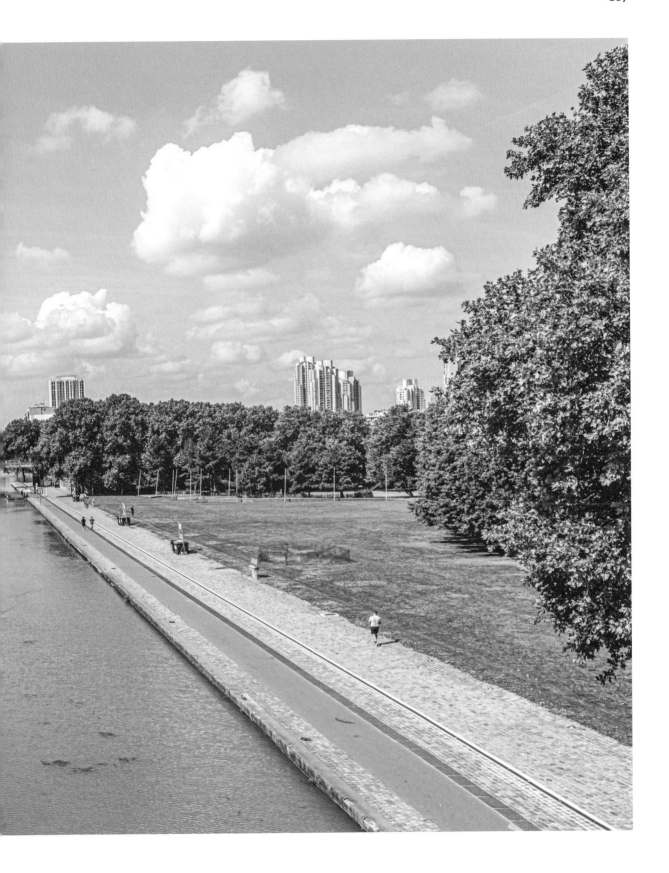

ABOVE

Once a customs gate, the Rotunda at La Villette
is now home to a restaurant.

LEFT

The artisanal microbrewery Paname Brewing Company offers
customers a beautiful floating terrace on the Bassin de la Villette.

ARCHITECTURE

SURPRISING AND UNUSUAL CHURCHES

CHURCH OF NOTRE-DAME-DU-TRAVAIL (14TH)

The Romanesque facade of this church dating to 1897
hides within it an incredible iron frame.

CHURCH OF SAINT-GERMAIN-DE-CHARONNE (20TH)

This Romanesque church was once the heart of Charonne village.

CHURCH OF SAINT IGNACE (6TH)

This neo-gothic Catholic chapel dates from 1855.

CHURCH DU SAINT-ESPRIT (12TH)

This church in the Romano-Byzantine style has a copper dome.

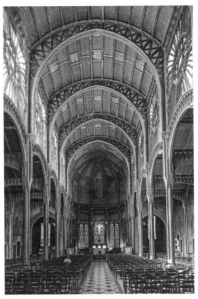

CHURCH OF SAINT-CHRISTOPHE DE JAVEL (15TH)

The walls of this church are adorned with frescoes depicting various means of transport during the 1920s.

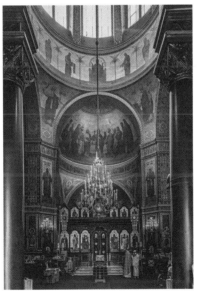

CATHEDRAL OF SAINT-ALEXANDRE-NEVSKY (7TH)

This Russian Orthodox cathedral, built in 1861, has a neo-Byzantine style. In 1918, Picasso married the Russian dancer Olga Khokhlova here.

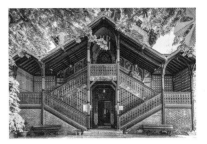

CHURCH OF SAINT-SERGE-DE-RADONÈGE (19TH)

This colorful wooden Protestant parish stands within a courtyard.

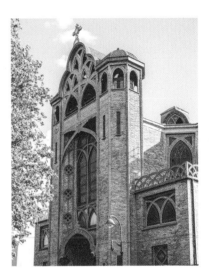

CHURCH OF SAINT-JEAN DE MONTMARTRE (18TH)

This church is made of reinforced concrete and decorated with bricks and ceramics in the Art Nouveau style.

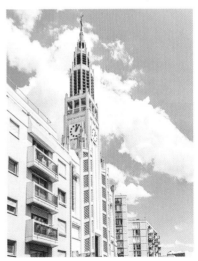

CHURCH OF SAINT-JOHN-BOSCO (20TH)

This church, dating to 1937, has an eclectic style, mixing gothic art with Art Deco.

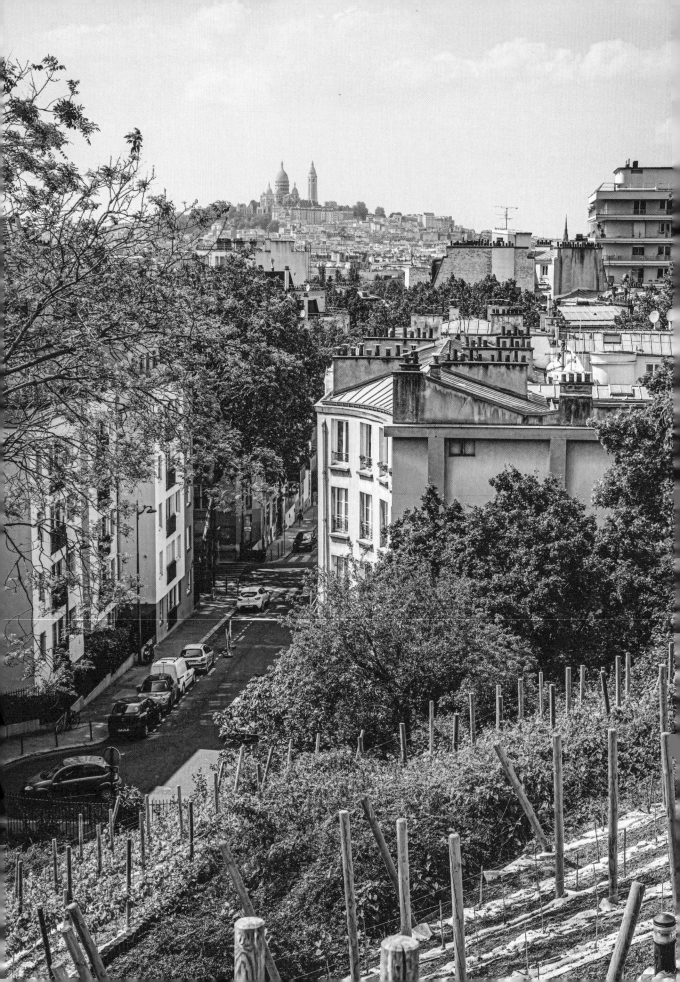

ABOVE

*The inhabitants of Butte Bergeyre can enjoy a communal garden
where they can grow fruit, flowers, and vegetables.
There is also a small, private vineyard.*

LEFT

*Previously known as Jardin des Chaufourniers,
the garden of Butte Bergeyre offers an incomparable and peaceful view of Paris.*

Few Parisians own their own home. In the Mouzaïa district, however,
there are colorful private villas.

The narrow streets of the Mouzaïa district are popular for pleasant walks on a sunny afternoon.

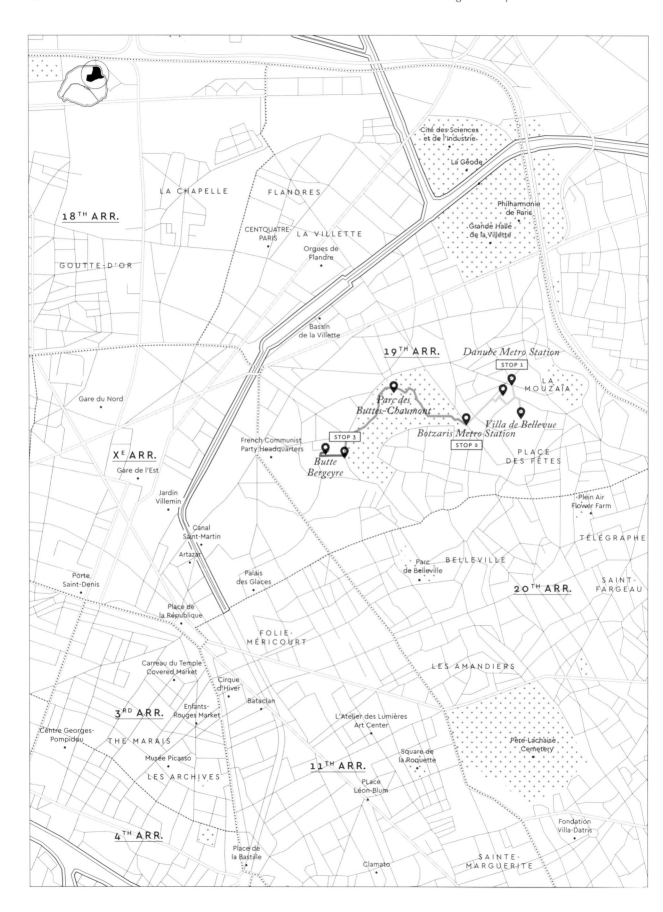

AT THE TOP OF PARIS

After making your way through the frenzy of Parisian streets, a visit among the hills of the 19th arrondissement offers moments of rare tranquility within the city.

STOP 1: MOUZAÏA DISTRICT

To reach this neighborhood, take rue de la Fraternité at the exit of the Danube metro stop on the butte Beauregard. Built at the end of the nineteenth century on former gypsum quarries, this once working-class district owes its name to a place in Algeria. The streets Miguel-Hidalgo, Bellevue, David-d'Angers, and Mouzaïa mark its borders. Strolling through its narrow alleys lined with flowered pavilions, you will realize that sometimes taking time to wander has its rewards.

In spring, the scent of lilacs and honeysuckle drifts down the alleys. In Villa de Bellevue, the thirty similarly fashioned workers' houses composed of a single bedroom and a garden at the front were built in 1898. In the hamlet of Danube, the twenty-eight dwellings constructed in the 1920s are more opulent. All the houses in the neighborhood are prohibited from adding additional levels. Because the landscape here is listed in Paris's inventory of picturesque sites, you can expect it will not change!

STOP 2: PARC DES BUTTES-CHAUMONT

To reach this famous park, stroll a short distance down rue du Général-Brunet. One of the park's many entrances is near the Botzaris metro stop. This green space was developed during the Second Empire. Its reliefs testify to the works of the gypsum quarry once located here. Spread over sixty-one acres (twenty-five hectares), the park contains a suspension bridge, a Roman-style temple perched on a cliff, a waterfall, and even an artificial lake. This masterpiece of landscape architecture is thanks to landscape designers Jean Pierre Barillet-Deschamps and Édouard André, as well as to engineer Adolphe Alphand. Today, the park is a favorite destination among Parisians when the weather lends itself to picnics. It also has several charming cafés where you can escape the chaos of urban life. In the fall, nothing is more poetic than witnessing the changing colors among the park's varied foliage.

STOP 3: BUTTE BERGEYRE

Exit the park on the side of rue Manin. At number 21, take the covered stairway located between the buildings. Eighty steps lead you to the butte Bergeyre, probably the capital's best-kept secret. Culminating at an altitude of three hundred thirty feet (one hundred meters), this unique spot offers an impressive view of Sacré-Coeur basilica and the Eiffel Tower. This is a great place to stroll between town houses and buildings covered with greenery. On rue Georges-Lardennois, you will discover a community garden where wildflowers bloom. A small winery here produces about twenty-six gallons (one hundred liters) of wine yearly.

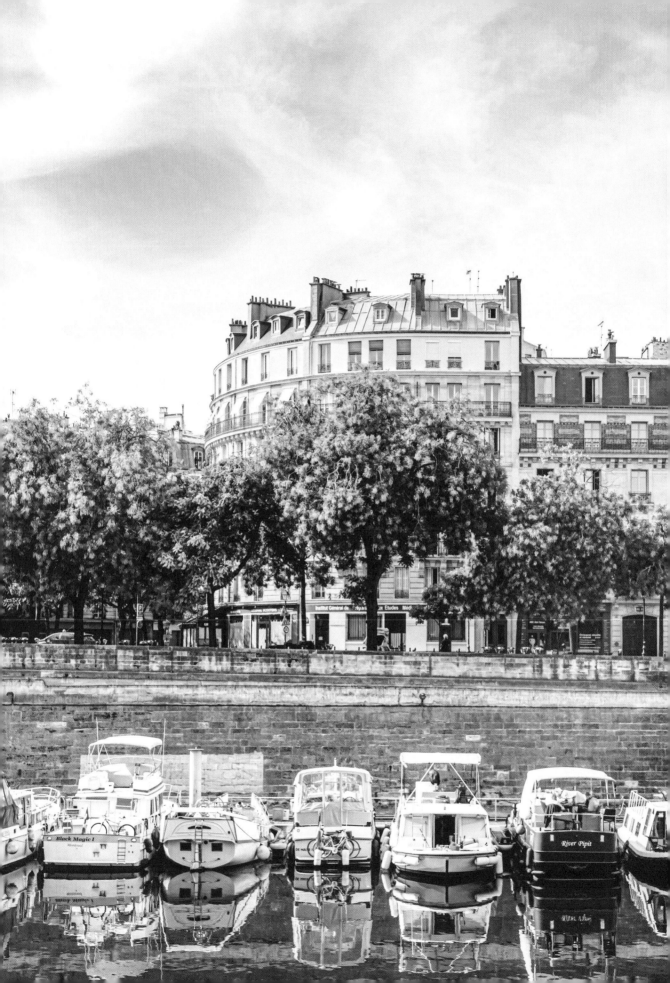

EASTERN PARIS

The eastern arrondissements of Paris were once home to working-class and less appealing areas of the capital. Although this area has few monuments for tourists to visit, it has managed over the last few decades to make more favorable impressions thanks to its relaxed lifestyle and lively nightlife.

P . 1 9 8

*In 1983, this commercial port became
the Bassin de l'Arsenal marina.*

R I G H T

*A slaughterhouse once stood on the site of
Square Maurice-Gardette, inaugurated in 1872.*

Place de la Bastille, spreading partially within the 4th, 11th, and 12th arrondisse-ments, has an insurrectionary past, as this is the legendary location where the French Revolution began and where the Bastille prison once stood. This area maintains a certain taste for controversy, as it often serves as a meeting point for political demon-strations where people gather around the July Column—erected to commemorate the victims of the revolution of 1830—that stands in the center. But others come here for an afternoon of shopping on rue du Faubourg-Saint-Antoine, an evening performance at the Opéra Bastille, or to have a drink with friends in the bars along the streets of La Roquette or Lappe. This same lively energy can be found within all four corners of the 11th arrondissement, and more particularly in the north around rue Oberkampf where gentrification has been occurring since the 2010s.

Although more peaceful in general than the neighboring 11th arrondissement, the 12th arrondissement also enjoys an energetic neighborhood life. Every morning, from Tuesday to Sunday, the Aligre market brings together a diverse collection of city dwellers with vegetable, cheese, and poultry vendors. With a basket in hand, cus-tomers peruse the aisles of the Beauvau covered market before meandering through its outdoor market area. For a century, this market has exuded this same conviviality, which makes an outing here very pleasant.

The 12th arrondissement also offers great opportunities for walking. You can catch a breath of fresh air in the Parc de Bercy after shopping in the Bercy-Village com-mercial center, which occupies former wine warehouses. The Coulée Verte is an obsolete railway line transformed into a pedestrian promenade that runs from Place de la Bastille to the vast Bois de Vincennes, which covers over 2,460 acres (995 hectares) at the edge of Paris. This pathway promises a total disconnection from the city around the banks of its four lakes where you can rent a small boat.

The 20th arrondissement is not to be left out in terms of all there is to discover. Its emblematic and wildly romantic Père-Lachaise cemetery is one of the most visited places in Paris. Its eternal inhabitants cater to all tastes. Found here are the final resting places of Molière, Édith Piaf, Jim Morrison, Marcel Proust, and Oscar Wilde, to name a few. Farther north, the districts of Belleville and Ménilmontant, influenced by successive waves of immigration, are also worth a visit. Casual and bohemian, these districts offer a mix of excellent Asian restaurants and hidden courtyards to be discovered while wandering.

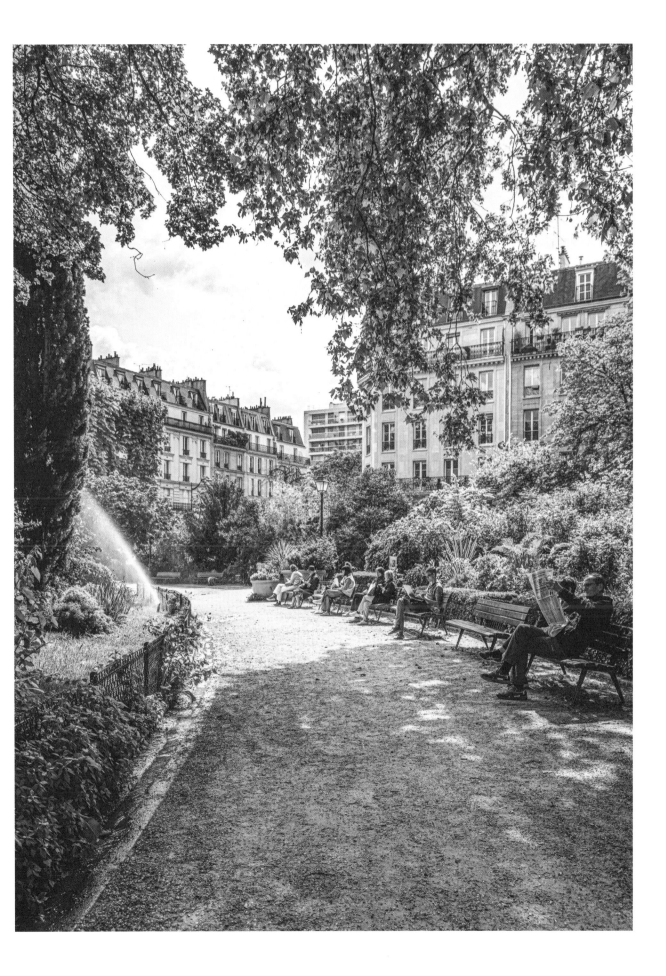

THE ESSENTIALS

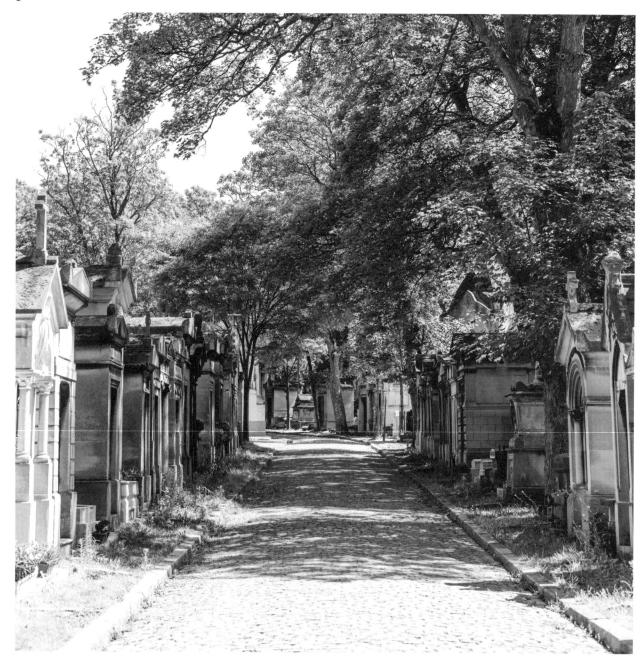

PÈRE-LACHAISE CEMETERY (20TH)

This necropolis, populated with hundred-year-old trees, has more than 70,000 gravesites,
including those of Edith Piaf, Molière, and Oscar Wilde.

59

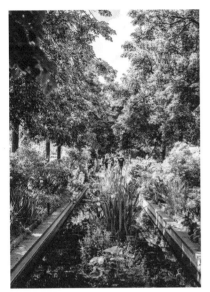

COULÉE VERTE RENÉ-DUMONT (12TH)

This elevated walkway stretches from the Opéra de la Bastille to the Bois de Vincennes and offers several unique panoramas.

60

CIRQUE D'HIVER BOUGLIONE (11TH)

This is one of the oldest circuses in Europe, operating since 1852. Spectators can enjoy trapeze, aerobatics, and juggling performances.

61

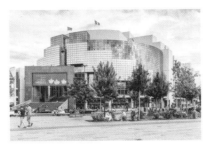

OPÉRA DE LA BASTILLE (12TH)

Opened in 1989, this building was built a century after the Palais Garnier under the direction of François Mitterrand, who wanted to make classical music accessible to all.

62

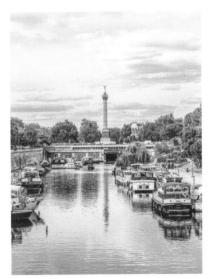

PORT DE L'ARSENAL (12TH)

Nestled between the Seine and the Canal Saint-Martin, this marina is the ideal place for a picnic that offers a change of pace.

63

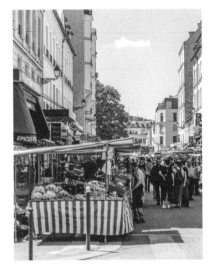

ALIGRE MARKET (12TH)

Six times a week, the neighborhood's gourmets gather under these covered market halls to browse all the top-quality products.

64

RUE CRÉMIEUX (12TH)

This pedestrian walkway is a tourist hotspot thanks to its pavilions and multicolored facades.

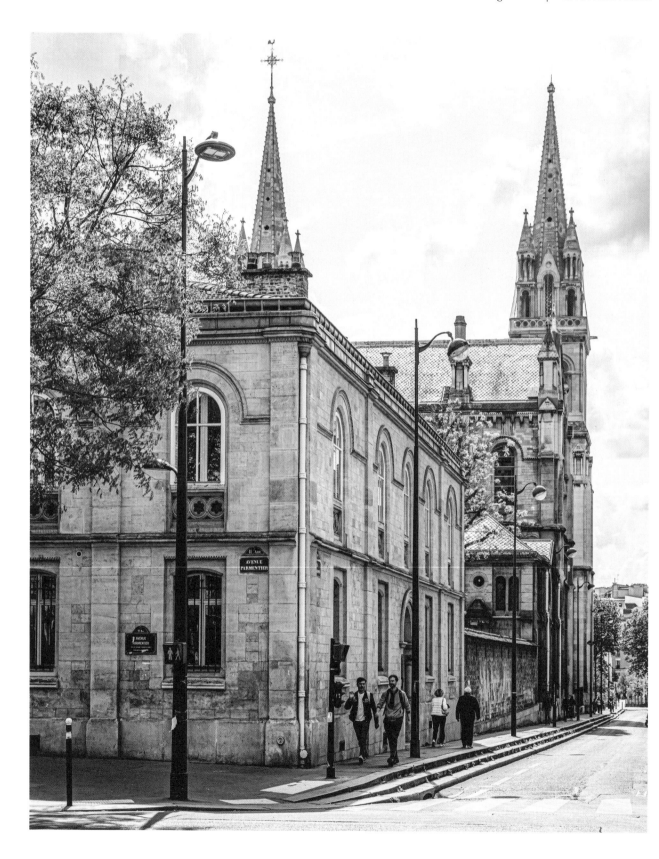

Built during the Second Empire, the Church of Saint-Ambroise
was constructed with a Romanesque-Gothic style

Near Place de la Bastille, Cour Damoye was once lined with artisans' workshops.
It is now home to offices and art galleries.

LIFESTYLE

CHARONNE

A mecca for festivals, Paris's 11th arrondissement also has a constantly evolving culinary scene. The young chefs of the bistronomy movement are setting up shop in the neighborhoods here, attracting food lovers from all around the world.

In the Bastille district, between the streets of Charonne and Faubourg-Saint-Antoine, gastronomy occupies a prominent place. This corner of the capital is lively both day and night and is teeming with good food options. Some restaurateurs have opened several concepts here.

Bertrand Grébaut is the perfect example. In 2011, he opened Septime with his partner Théo Pourriat. The restaurant's name comes from the restaurant of Louis de Funès in the film *Le Grand Restaurant* from 1966. Grébaut's ambition was to become a neighborhood destination that makes great French cuisine accessible to everyone. Among the plastered walls of this cozy bistro, you can enjoy dishes worthy of the most prestigious restaurants, but without white tablecloths or stuffy service.

Only thirty-six places are set among the bare-wood tables to open the space to grant customers more privacy. Served up here are local and seasonal ingredients, and the presentation is simplified, with vegetables refined and placed at the forefront. With a style that hit all the right checkmarks, Septime quickly earned a Michelin star. A year earlier, the duo opened La Cave across the street, followed by the seafood restaurant Clamato and pastry shop Tapisserie where you can treat yourself to a memorable *tartelette au sirop d'érable* (maple syrup tartlet). The Septime group is today a globally recognized institution.

A few doors down, another duo enjoys an international reputation. Pastry chef Moko Hirayama and chef Omar Koreitem head up Mokoloco. Located in a residential building, their establishment welcomes new chefs for several months and thus sees a plethora of promising talent come through its doors.

To savor this duo's cuisine, however, you must continue on to rue Saint-Bernard, just under a quarter mile (half a kilometer) from Mokoloco. From this tiny spot, Mokonuts has the atmosphere of a convivial café but at the tempo of nouvelle French cuisine. In the main establishment, the refined flavors are a fruitful combination from the pair's Japanese and Lebanese origins. To round off the menu of deliciously bold plates, chef Moko's cookies are considered among the best in Paris.

On rues Paul-Bert, Jules-Vallès, and Chanzy, chef Cyril Lignac runs three do-not-miss establishments. After taking over at Chardenoux and turning to seafood, the restaurateur opened a pastry shop and then a chocolate shop where you can enjoy his very popular marshmallow bears with sweet and chocolate coatings. The 11th arrondissement, without a doubt, offers plenty for all appetites.

1. MOKOLOCO

Parisian epicures love Omar Koreitem's labneh, a Middle Eastern specialty made from drained goat's-milk yogurt.

2. SEPTIME

In addition to its Michelin star, Septime has won the Sustainable Restaurant Award for its eco-responsible practices.

3. CLAMATO

This seafood restaurant does not take reservations. To increase your chances for securing a table, arrive outside regular dining hours!

4. LE CHARDENOUX

This seafood restaurant offers a chic ambiance in Art Nouveau decor.

5. CYRIL LIGNAC

Pâtisserie Cyril Lignac offers rum babas, lemon tarts, and classically simple chocolate bars made in-house.

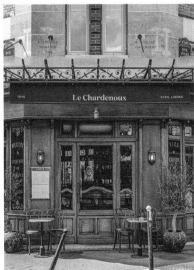

ABOVE

At Tapisserie, pastries vary according to the seasons, but the choux pastry flavored with flouve *(sweet vernal grass) remains a house classic.*

LEFT

At Clamato, the dishes are created according to the availability of fish obtained from sustainable and artisanal fishing methods.

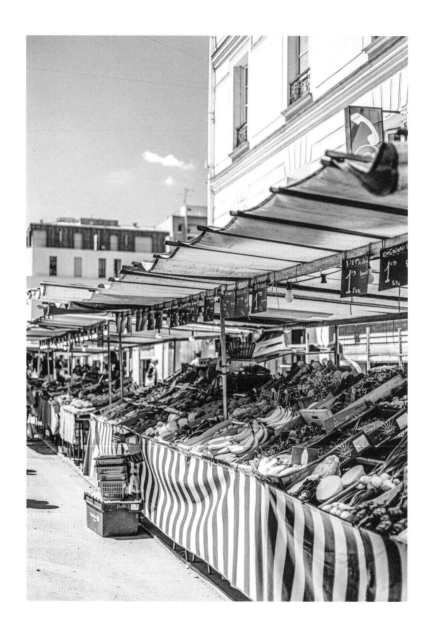

ABOVE

In addition to its central hall, the Aligre market overflows onto the street.
The outdoor stalls are occupied mostly by grocers selling fruits and vegetables.

RIGHT

In the picturesque Aligre market seed shop, established in the 1930s,
you can find everything from pasta to birdseed.

GRAINETERIE DU MARCHÉ

Spécialiste
en
JARDINAGE
et
GRAINES

———

PÂTES · RIZ
LÉGUMES SECS

GRAINETERIE - EPICERIE

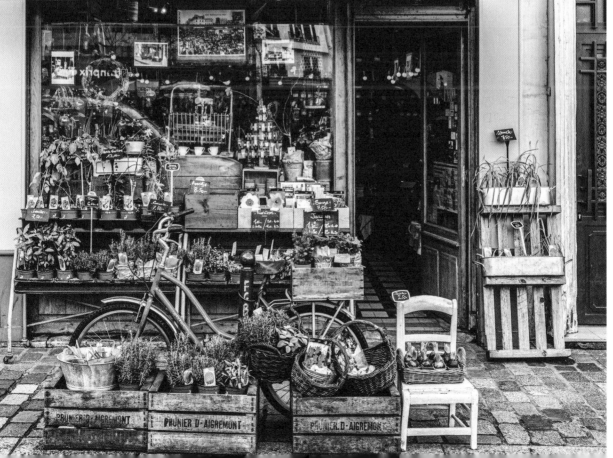

Metro line number 6 crosses the Bercy bridge, inaugurated in 1864.
The bridge has been redesigned several times.

UNDERSTANDING

LA PETITE CEINTURE

Today used for walks amid green surroundings,
this former railway line has encircled Paris
since the mid-nineteenth century.

In 1850, Parisian railway stations were not connected, and the metro did not yet exist. Consequently, a solution was needed to facilitate transporting passengers and goods between stations. La Petite Ceinture (the Little Belt) helped solve this problem.

After work that spanned more than fifteen years, the line opened to freight in 1852 and to passengers in 1854 on the side of the Auteuil section. Passing through tunnels, viaducts, and trenches, the line extended twenty miles (thirty-two kilometers) and connected nearly thirty stations. From Neuilly to Belleville via Parc de Montsouris, La Petite Ceinture discreetly outlined the contours of Paris, as it was not always distinguishable from the street. The train line was a success, and in 1900, the trains, which left every thirty minutes, transported thirty-nine million passengers a year.

The development of the metro system and the increasing use of automobiles nevertheless led to its decline. Until 1934, the number of passengers transported was declining by half every ten years. The service was eventually closed to passengers, except for the Auteuil line, which survived until 1985 before being integrated into the current RER C line. Freight trains continued to use the rail, but there were fewer as time passed, especially following the damage to a bridge during the Second World War when the railway axis was cut off in the 15th arrondissement. The year 1993 marked the end of the commercial use of the railway line, but La Petite Ceinture has not completely vanished!

Over the decades, the line has taken on a new purpose. Now covered in greenery and graffiti, the railway has been converted into shared gardens, nature trails, and even artists' studios. Only certain sections are accessible to the public, such as a nearly mile-long (two-kilometer) path in the 12th arrondissement that extends from Villa du Bel-Air to rue des Meuniers, crossing charming villas. On the Left Bank, in the 15th arrondissement, city residents have tamed a suspended track that runs alongside the beautiful Haussmann-era buildings for just less than a mile (one and a half kilometers) starting from Place Balard. As for the portions left undeveloped, they can still be worth exploring, as some lead to stations transformed into bars or restaurants, such as Poinçon (14th) or Hasard Ludique (18th).

1. ORNANO

Built in 1869, this station in the 18th arrondissement has been home to the REcyclerie since 2014, a hybrid space that brings together a restaurant, farm, market, and workshop.

2. MONTROUGE-CEINTURE

This station, dating to 1867, was closed in 1934 before being reopened as Poinçon seventy-four years later. Now a contemporary space, it is home to a restaurant.

3. AVENUE DE SAINT-OUEN

Opened in 1889, this station, once a cinema and bazaar, is now home to the Hasard cultural and entertainment space, popular among Parisians.

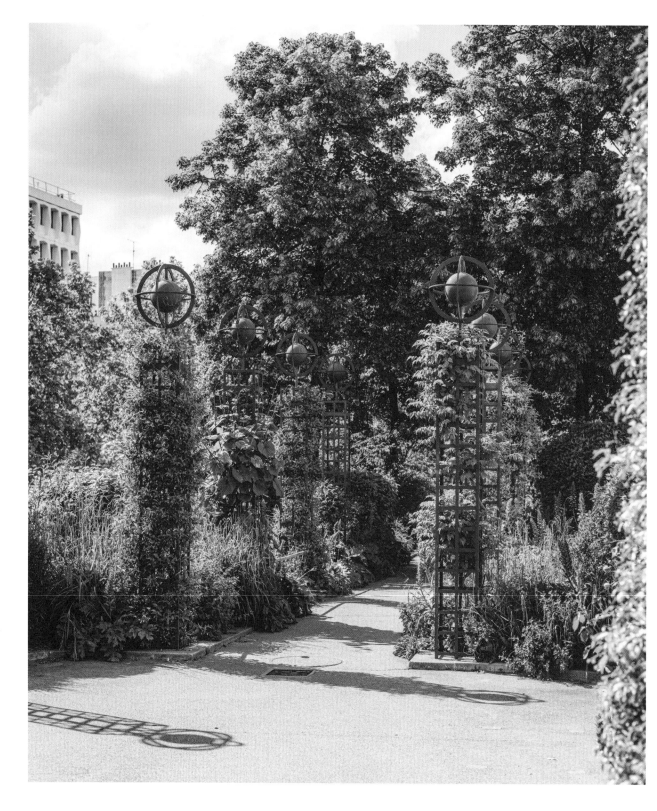

The Coulée Verte René-Dumont gardens extend 3 miles (4½ kilometers).

The Coulée Verte crosses the 12th arrondissement from Place de la Bastille
to the city's périphérique (ring road).

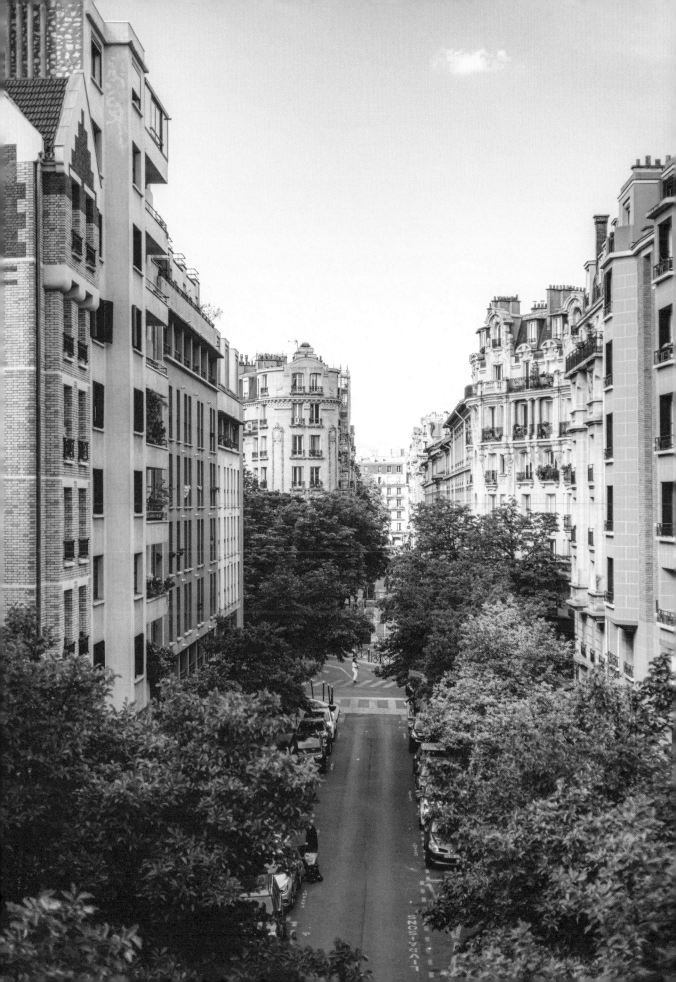

NATURE

PÈRE-LACHAISE CEMETERY

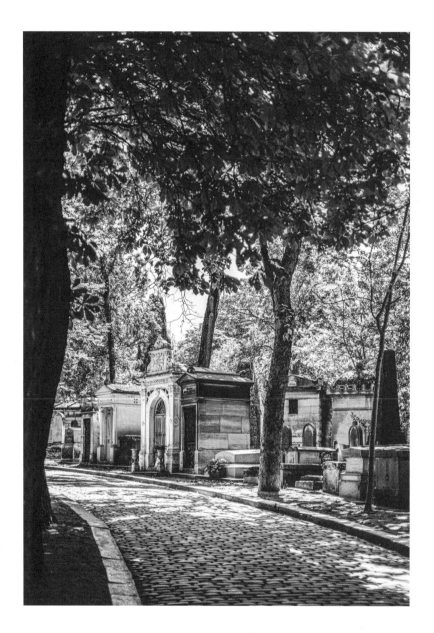

PÈRE-LACHAISE CEMETERY

This is one of the largest inner-city cemeteries and includes famous personalities such as Edith Piaf, Jim Morrison, and Oscar Wild among its 75,393 gravesites.

VIVANT DENON

Dominique Vivant was the first director of the Louvre Museum and played an essential role in developing its collection.

AN INTERFAITH SPACE

The cemetery is open to all religions. The first Jewish square was established in 1810, and a Muslim square in 1853.

AMBIANCE

This cemetery is the largest green space of Paris, with an area of 109 acres.

JIM MORRISON

The lead vocalist of the rock group The Doors died at the age of 27 in 1971. Fans still visit his gravesite today.

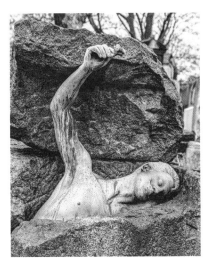

GEORGES RODENBACH

A stone and bronze sculpture depicts this Belgian poet as if springing from his grave.

HONORÉ DE BALZAC

Victor Hugo delivered his eulogy in front of a large crowd.

FRÉDÉRIC CHOPIN

The body of the Polish composer rests here, except for his heart, which is preserved in cognac in Warsaw.

AMBIANCE

This famous cemetery has the feel of a large and peaceful park.

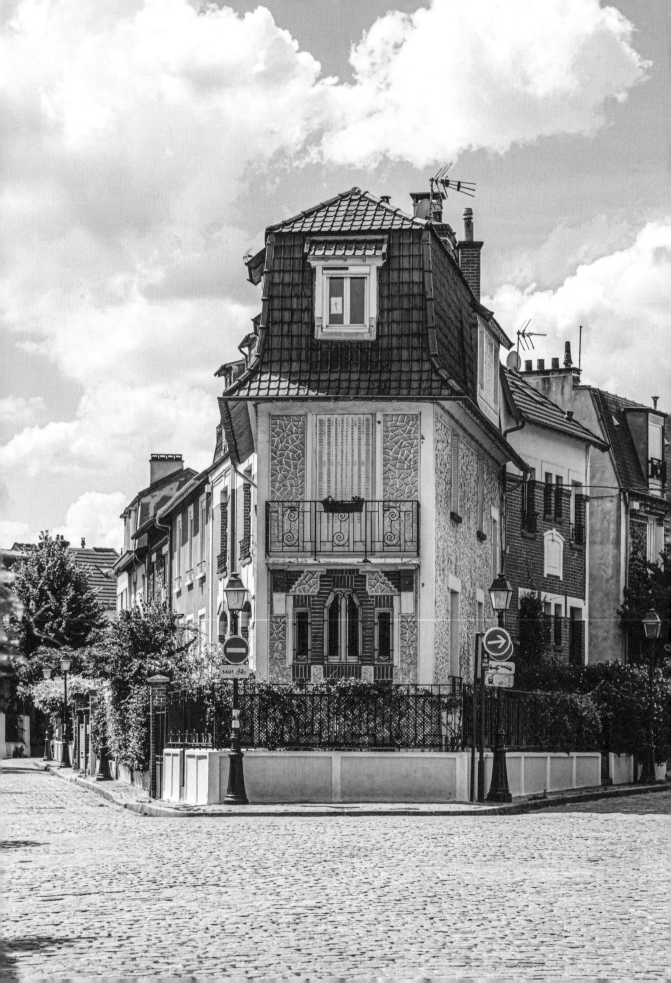

ABOVE

*La Campagne in Paris is a former working-class district near Porte de Bagnolet.
Its cobblestoned and flower-lined streets lend it a timeless charm.*

LEFT

*The hundred or so homes in brick or stone in Anglo-Norman or Alsatian style
are now very popular with Parisians and offer a feel of the countryside
within the city.*

PROFILE

PLEIN AIR

Gardener-farmer Masami Charlotte Lavault founded Plein Air in 2017,
the first flower farm in Paris, located on a 12,900-square-foot (1,200-square-meter)
plot at the end of the Belleville cemetery in the 20th arrondissement.

Born and raised in Paris, Masami Charlotte Lavault studied industrial design in Central Saint Martins in London. "When I became aware of the ecological impact of my job, I stopped everything and decided to work in biodynamic friendly farms in Morocco, Wales, and Japan." At the age of twenty-five, she learned the ins and outs of her new profession and discovered the world of diversified organic market gardening, which aims to produce a wide range of vegetables for a local clientele.

In Lavault's words, she heard the call of flowers while in the UK: "One of the farmers who hired me thought I wasn't strong enough for some tasks, so I was relegated to tending the flower plots." This was her impetus. During the day, the twenty-year-old grew seasonal flowers, and at night she read as many articles as possible about this import industry and realized the extent of its impact on the environment. Returning to Paris to create her own flower farm seemed an obvious path to her.

Due to a lack of available land, however, Lavault would have to wait several years to realize her dream. Eventually, after a call by the city of Paris for projects for an urban agricultural program, she opened Plein Air in the heart of the 20th arrondissement. From the central alley behind the Belleville cemetery, nothing would suggest that a field of flowers extends behind the green door. What was

once a grassy pasture has become, thanks to Levault's sixty to one hundred hours of work each week, an incredible garden. Rue Officinale is heavy with the scent of fig, white bryonia, lily, and pimpernel among the varieties that flourish freely, tucked between a water reservoir and low-rise buildings.

Lavault grows, without any chemicals or mechanical means, two hundred fifty to three hundred species of flowers intended for sale for events. Every year, she plans her crops according to her own tastes, makes her own seedlings, and plants tens of thousands of plants. Although her job is exhausting and involves sacrificing her free time, the young woman appreciates the ephemeral nature of flowers, a thousand miles from the property she designed while in London. Understanding the importance of sharing, she opened her field to guided tours by appointment and leads ikebana workshops, the traditional Japanese art of floral composition.

Soon, Lavault will share her time between Plein Air and the floricultural school she founded near Rambouillet with florists Mathilde Bignon and Audrey Venant, head of the Parisian boutiques Désirée. The entirety of her crops will be sold by the two florists, enough to ensure Lavault a more regular income and a less substantial volume of work. "This will be the assurance I need for my fields!"

Astibles are shade-growing
perennials and reveal tiny,
colorful plumes.

It takes about nine months
between planting and picking
the flowers.

The fragrance of
rue officinale evokes figs
and repels insects.

Visiting this flower farm
reminds visitors that cultivating
flowers is a yearlong task.

Part of Masami's job
is to plan the
next set of crops.

Thanks to greenhouses,
plantings can
last much longer.

Nigella is recognized by
its starry flowers.

This flower grower keeps her
traditional gardening tools in
a wooden shed.

The plants are treated with
Japanese bacteria that protect
them like probiotics.

ABOVE

*Located between Belleville and Ménilmontant, Villa de l'Ermitage
is a private lane lined with townhouses with gardens.*

RIGHT

*The wrought-iron gates and many plants of Villa de l'Ermitage
lend enormous charm to this little-known lane.*

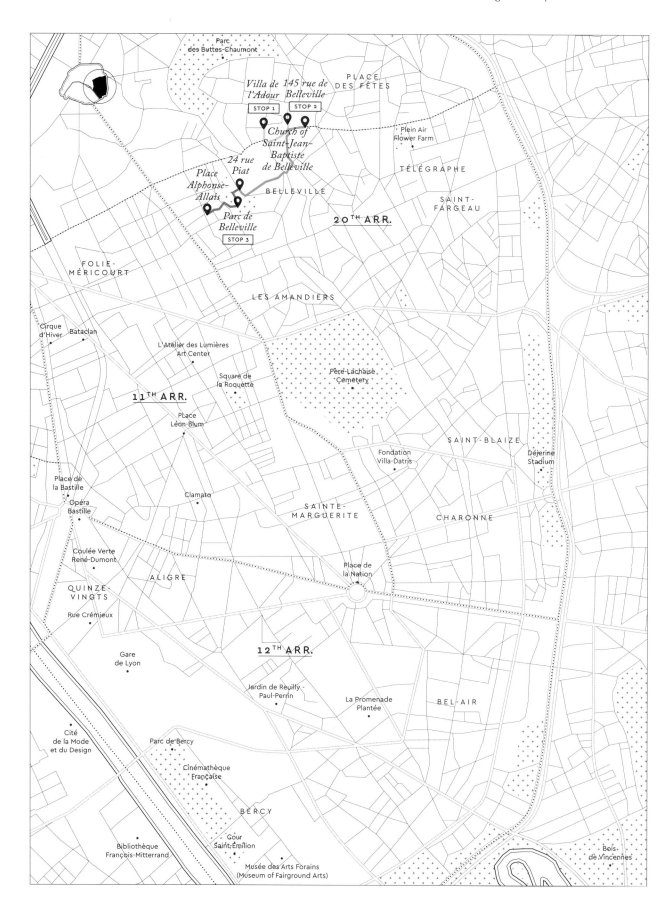

Parc
des Buttes-Chaumont

PLACE
DES FÊTES

*Villa de
l'Adour*
STOP 1

*145 rue de
Belleville*
STOP 2

Plein Air
Flower Farm

*Church of
Saint-Jean-
Baptiste
de Belleville*

TÉLÉGRAPHE

*24 rue
Piat*

*Place
Alphonse-
Allais*

BELLEVILLE

SAINT-
FARGEAU

*Parc de
Belleville*
STOP 3

20TH ARR.

FOLIE-
MÉRICOURT

LES AMANDIERS

Cirque
d'Hiver Bataclan

L'Atelier des Lumières
Art Center

Père-Lachaise
Cemetery

Square de
la Roquette

11TH ARR.

Place
Léon-Blum

SAINT-BLAIZE

Fondation
Villa-Datris

Déjerine
Stadium

Place de
la Bastille

Clamato

Opéra
Bastille

SAINTE-
MARGUERITE

CHARONNE

Coulée Verte
René-Dumont

ALIGRE

Place de
la Nation

QUINZE-
VINGTS

Rue Crémieux

12TH ARR.

BEL-AIR

Gare
de Lyon

Jardin de Reuilly -
Paul-Perrin

La Promenade
Plantée

Cité
de la Mode
et du Design

Parc de Bercy

Cinémathèque
Française

BERCY

Bibliothèque
François-Mitterrand

Cour
Saint-Émilion

Bois-
de Vincennes

Musée des Arts Forains
(Museum of Fairground Arts)

SECRET BELLEVILLE

The soul of this ancient village is still perceptible
if you try your luck through the carriageway entrances.
What is the secret to entering this hidden labyrinth? Extending a
smile to its residents and showing respect for their tranquility.

STOP 1: VILLA DE L'ADOUR

On the edge of the 20th
arrondissement, the gate at 13, rue
de la Villette is often open. Take
the opportunity to step into this
Bellevillois subdivision when you
see it. At 340 feet (104 meters)
long, the cobblestoned alley has
nineteen houses and small buildings
built during different eras. Under
the bamboo and laurel, you can see
hidden gardens. At number 3, the
former wash house was transformed
into a residence by architects who
retained its brick chimney.

Turn back, then turn right to join
rue de Belleville. Here the church of
Saint-Jean-Baptiste de Belleville is
one of the oldest neo-gothic places
of worship in Paris. Its frescoes and
beautiful stained-glass windows are
worth a walk through its nave.

STOP 2: HIDDEN PATHS

Close by to the church, still on rue
de Belleville, three buildings house
bucolic rear courtyard gardens. If
the door is open, cross through the
entrance of number 145, which
overlooks a private cul-de-sac.
Industrial workshops once stood
in this rather narrow alley, now
renovated mostly into art studios.
If you're lucky to gain access, explore
the courtyards of numbers 149 and
140, always with the utmost discre-
tion, then go down to the intersection
with rue Piat where the entrance to
the park is at number 24.

STOP 3: PARC DE BELLEVILLE

This eleven-acre (four-and-a-half-
hectare) green space is relatively new
considering it opened in 1988. (Many
Parisian parks have been open since
the nineteenth century.) The park
offers an ideal view of the west side
of the capital. From the Willy-Ronis
lookout point, it's impossible to miss
the Eiffel Tower, Les Invalides, and
Montparnasse tower!

At the top of the park, a few Pinot
Meunier and Chardonnay vines are
reminders of the district's past, long
a hot spot of Parisian entertainment.
Next, walk its sloping paths between
perennials and rose arbors. In addition
to the foliage from the twelve hundred
trees, the meticulously groomed
flower beds display incredible color.

On sunny days, Parisians particularly
appreciate the long, cascading
fountain, which extends over 330 feet
(100 meters). Less known than the
steps of Sacré-Coeur, this place is
ideal for watching the fireworks on
July 14 (Bastille Day).

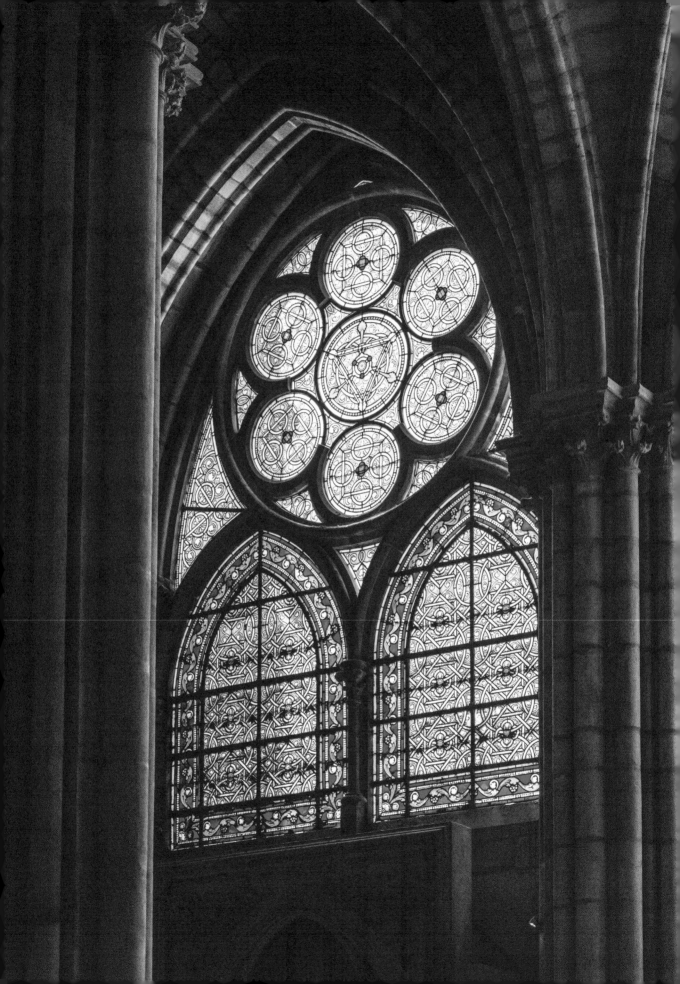

GREATER PARIS

Accessible by train, bike, or on foot, the capital's three bordering departments
form what's known as the Petite Couronne. They reveal a fascinating heritage,
a changing cultural landscape, and many unique corners to find green spaces. Since 2016,
all of their communes make up, along with the city of Paris and several other communes
within the Grande Couronne (the outer four departments not bordering Paris),
the metropolis referred to as Grand Paris (Greater Paris).

P.228

The stained-glass windows of the Saint-Denis Basilica Cathedral
are among the world's oldest gothic stained-glass windows.

RIGHT

The Marne is a tributary of the Seine and crosses
the Val-de-Marne department for 14 miles (24 kilometers).

Paris is a small capital: it is eight and a half times smaller than Berlin and twelve times smaller than Rome! But that's without counting its Petite Couronne (the outer areas that make a ring, or "crown," around the city), which covers a total area of 294 square miles (762.4 square kilometers), seven times greater than the total area of the city. This area includes the departments of Seine-Saint-Denis, Val-de-Marne, and Hauts-de-Seine.

Each of these three departments has a distinct identity. In the northeast, humans have occupied Seine-Saint-Denis since Gallo-Roman times. This territory has a rich agricultural and industrial past and two canals: Saint-Denis and l'Ourcq. In its working-class communities, as in its gentrifying towns, the creative world has taken center stage. More and more unused lands are becoming the homes of associations for artistic creation, such as La Cité Fertile in Pantin and Le 6b in Saint-Denis. As host to the Centre National de la Danse and the Magasins Généraux Pantinois (the Paris Chamber of Commerce and Industry) with its cutting-edge programming, this department now steals some of the spotlight from Paris, which no longer has a monopoly on cultural activities. For time outdoors, the vast parks of Poudrerie in Sevran, Georges-Valbon in La Courneuve, and Jean-Moulin in Montreuil attract many visitors.

In the southeast, the department of Val-de-Marne can boast of its river, the Marne. Walking here is an absolute pleasure! Pedestrians and cyclists have discovered this, as barges and open-air cafés attract Parisians looking for a change of scenery during the weekends. The department also has several major museums, such as the MAC VAL in Vitry-sur-Seine, dedicated to contemporary art, and the Maison de la Photographie Robert-Doisneau in Gentilly. For architecture, you must visit the Château de Vincennes and the postmodernist structures in Noisy-le-Grand.

Finally, to the southwest, the very upscale department of Hauts-de-Seine overflows with châteaux, private mansions, and museums. Among them is the Musée Albert-Kahn, designed by the Japanese architect Kengo Kuma and surrounded by incredible gardens. Another landscape masterpiece, the Parc de Sceaux, spreads over 445 acres (180 hectares). It was designed by André Le Nôtre at the end of the seventeenth century. Within the department, you can stroll through the Meudon forest, fifty times larger than Luxembourg Gardens in Paris, containing dolmens and menhirs (prehistoric monuments). Without a doubt, Greater Paris has many sights to discover.

THE ESSENTIALS

CHÂTEAU DE MALMAISON (92)

This château in Rueil-Malmaison is the former home of
Joséphine de Beauharnais and Napoleon Bonaparte.

66

SAINT-DENIS BASILICA CATHEDRAL (93)

In Saint-Denis, this masterpiece of gothic art is the burial place of kings and queens of France.

67

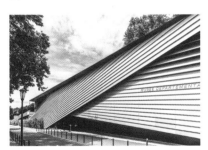

MUSÉE ALBERT-KAHN (92)

The building of this museum, designed by architect Kengo Kuma and located in Boulogne-Billancourt, unveils a garden of a thousand colors.

68

VAL-DE-MARNE MUSEUM OF CONTEMPORARY ART (94)

In Vitry-sur-Seine, the first contemporary art museum in the city's suburbs celebrates French works dating from the 1950s to today.

69

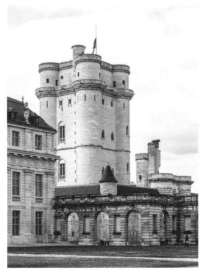

CHÂTEAU DE VINCENNES (94)

Situated on the edge of the Bois de Vincennes, this is the largest royal château in France.

70

PARIS-SAINT-OUEN FLEA MARKET (93)

Some 2,000 merchants share this vast market's 17 acres (7 hectares) dedicated to ancient and antique objects.

71

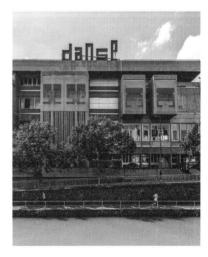

NATIONAL DANCE CENTER (93)

This structure of reinforced concrete, located in Patin, is a place of creation, performance, and exhibition dedicated to contemporary dance.

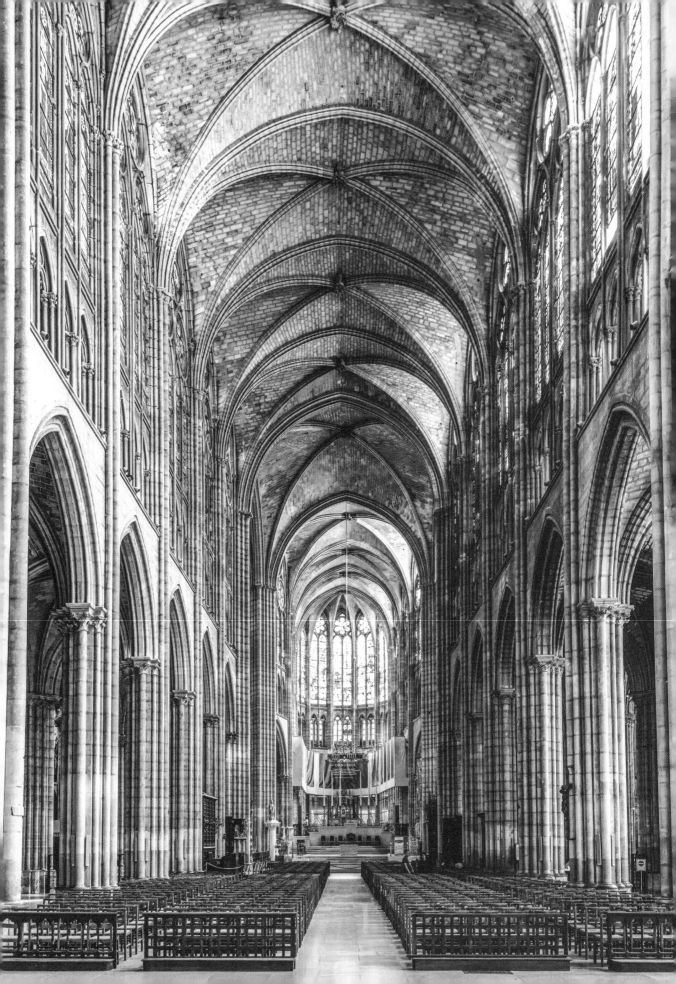

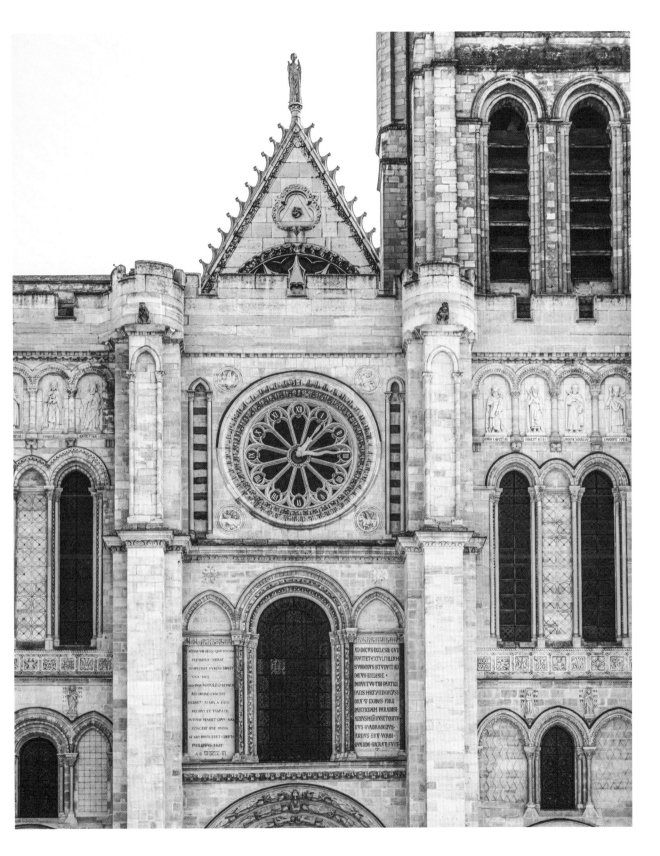

*Saint-Denis Basilica Cathedral has housed the tombs of kings and queens
since the Middle Ages and is a monument of gothic architecture.*

ARCHITECTURE

NOISY-LE-GRAND

BACK TO THE FUTURE

In the Seine-Saint-Denis department, the commune of Noisy-le-Grand
is a showcase of postmodernism. Internationally renowned architects
Ricardo Bofill and Manuel Núñez Yanowsky have built incredible structures here.

The architecture is so unique in Noisy-le-Grand that Hollywood has filmed here twice. The directors of *Brazil* (1985) and *The Hunger Games: Mockingjay Part 2* (2015), which included several scenes in this dystopian film at the housing complex Les Espaces d'Abraxas, were attracted by the city's futuristic silhouette. Designed by Catalonian Ricardo Bofill and opened in 1983, Les Espaces d'Abraxas is a complex of 610 apartments in the Mont-d'Est district. The name Abraxas comes from a rooster-headed pagan deity dating from antiquity, an intriguing name for this fascinating structure composed of three buildings: the Theater, the Arch, and the Palacio.

A result of a growing demand for housing and a quest for social diversity, the project broke ground at the end of the 1970s. The construction site was monumental, and Bofill embraced a neoclassical style. The objective was to adapt the architectural codes of antiquity to particular aspects of the city. To contrast with the other nondescript social housing projects here, Bofill wanted to distinguish his design through its excessiveness, diversity of functions, and beauty of its public spaces.

Once developed, the Palacio, made of ocher-colored concrete, extended over eighteen floors, some of which are reserved for families of modest means. Its U-shaped design encircles the nine-story Arch located in the center of the development. To the west, the Theater evokes an ancient Greek proscenium and contains apartments for a more affluent population. Although the land is narrow, the height of the buildings gives visitors who walk its lawn the feeling of being in another world. Les Espaces d'Abraxas was once threatened with demolition but was defended by its occupants. It is now undergoing renovation, orchestrated by Ricardo Bofill until his death in 2022.

On the other side of the city, in the Pavé-Neuf district, another achievement attracts the attention of fine art lovers. Picasso's Arenas, nicknamed the "Camemberts" by its inhabitants, is the work of Bofill's former collaborator, Manuel Núñez Yanowsky, from Spain. Erected in 1985, this complex of 540 dwellings consists of two large cylinders that frame the Place Pablo-Picasso. Contrary to the more reclusive Les Espaces d'Abraxas, this open public space is a gathering area dear to locals. Noisy-le-Grand station is connected to Paris by the RER A train line, only twenty minutes from Place de la Nation in the 11th arrondissement.

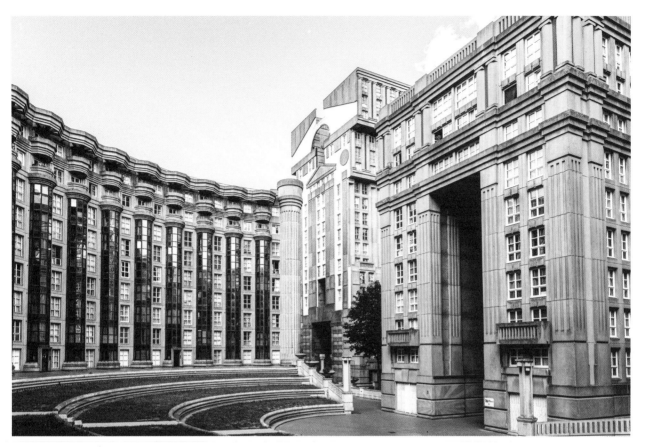

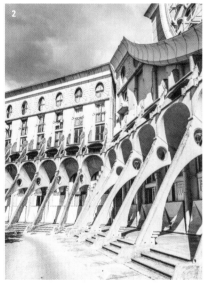

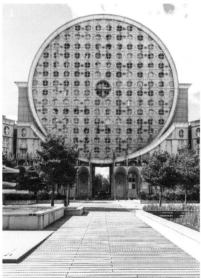

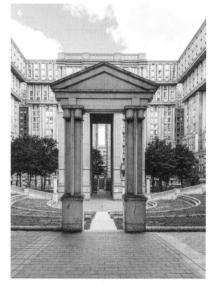

1. A PALACE FOR THE PEOPLE

The neoclassical style of Les Espaces d'Abraxas has reflective glass columns that lend a dynamic character to the structure.

2. ARCHITECTURAL FEAT

The arcade of pedestals of Les Arènes de Picasso (Picasso's Arenas) supports two disk-shaped buildings 164 feet (50 meters) high.

3. THE CAMEMBERTS

Les Arènes de Picasso, nicknamed "The Camemberts," depicts the sunrise and sunset.

4. MODEST DIMENSIONS

In the center of the interior space of the Les Espaces d'Abraxas, the nine-story Arch contains only 20 apartments.

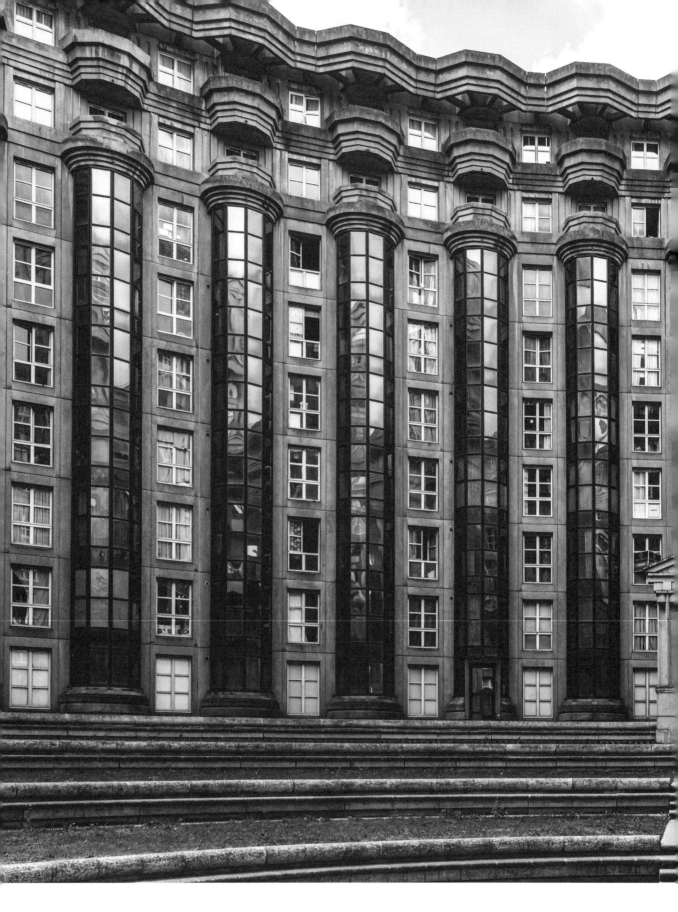

Les Espaces d'Abraxas are large neoclassical complexes from the 1980s, housing about 2,000 inhabitants.
The facades were erected with prefabricated panels composed of stone and a mixture of sand and cement.

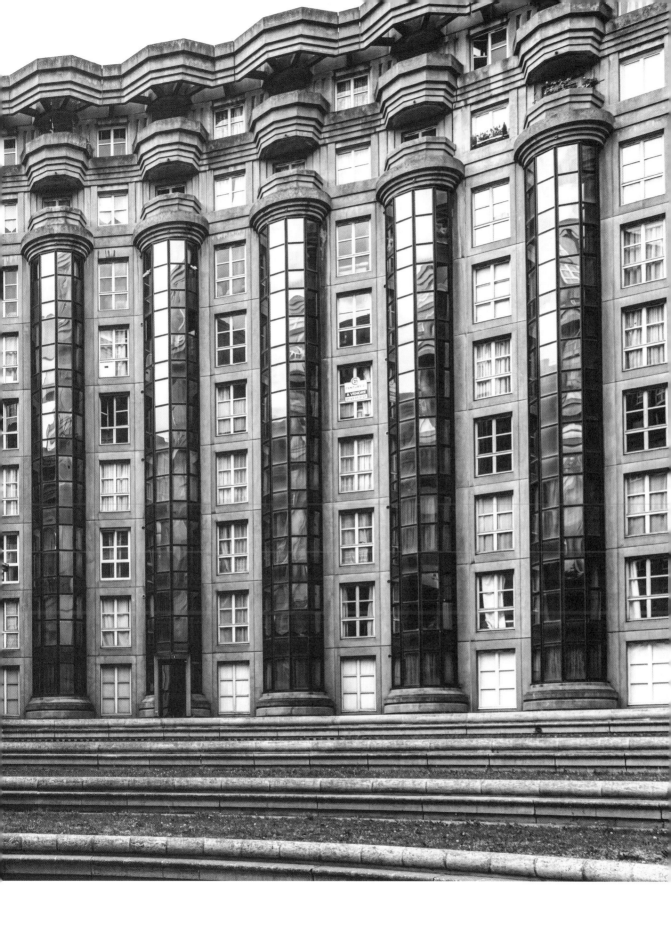

BONNE AVENTURE

At the head of a restaurant next to the Saint-Ouen flea markets (93),
chef Alcidia Vulbeau offers gourmet cuisine influenced by
the city's multiculturalism.

"When I was a teenager, there were very few places to meet friends in Seine-Saint-Denis," recalls Alcidia Vulbeau. At the time, she lived in l'Île-Saint-Denis in a family who always took special care to feed others. This type of unpretentious and generous style of cooking fascinated her. After high school, she studied fine arts for a time, then turned her interests toward culinary publishing. She studied literature, earning a diploma in the book publishing trade, and worked as an editor for four years.

In the early 2010s, a new wave of chefs was shaking up the codes of gastronomy. "At the time, I went to restaurants a lot, and I realized this was the job I wanted to do." She then obtained her CAP (a professional aptitude certificate) in cooking and interned at Frenchie wine bar (2nd). As a commis (a junior staff position in the kitchen), she had a formative experience. "I discovered a very physical reality about the work, but there was a real energy about it. This was the place I needed to be." After working in different kitchens, she met the founders of the Paris Popup, who offered her the chef position at the Nord-Pinus hotel in Arles during the summer of 2017. "They have a relationship with the head company. I learned a lot about the economics of restaurants working alongside them."

When she opened her own location, she naturally chose Saint-Ouen. "Seine-Saint-Denis is my territory, and I feel good there. There is a closeness between people in Saint-Ouen, and there is true multiculturalism." She joined forces with Mathias Tenret, a former literature teacher and wine lover. Laurent Decès, her accountant, found a location near the flea market. Her concept Bonne Aventure opened in 2019. With its terrace, shelves filled with bottles of natural wines, and attentive service, Alcidia's restaurant is a place where you feel comfortable.

"I am in favor of making food accessible to everyone. You can enjoy the experience without being intimidated. I also make sure the prices are affordable." This has been a winning formula for her and now requires a reservation to experience her cooking. The city's foreign origins influence the ingredients in her dishes, including the use of peanut butter, semolina flour, and Asian products. In addition to the fritters, which are always à la carte, you can taste, depending on the seasons, such products as pearl barley risotto with haddock, a rice pudding with herbs from the maquis, and several vegetarian specialties. "I really like the cuisine by chef Manon Fleury emphasizing plants. It reinforces my desire to go in the same direction!" The adventure continues for Alcidia Vulbeau. In 2023, she opened Café Jaune opposite the flea market entrance. It's a place where you can go to bask in the sun from any time between breakfast to an after-dinner drink.

EXCELLENCE

The ingredients and flavors of Alcidia's dishes are considered remarkable for their spontaneity and attain impressive heights without aiming to be haute cuisine.

SPONTANEITY

Alcidia Vulbeau prepares epicurean cuisine in a casual bistro style using seasonal vegetables.

ABOVE

In the English-style garden of Musée Albert-Kahn,
a stream flows from the water basin to a waterfall.

LEFT

In 1895, Albert Kahn created a scenic park, which now bears his name, in
Boulogne-Billancourt. The Japanese garden is one of the park's most visited sites.

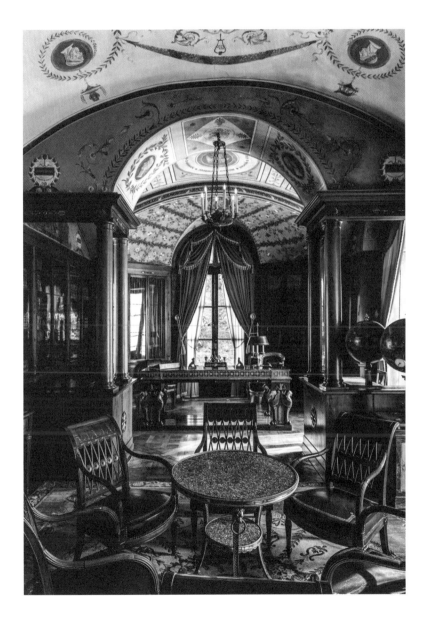

ABOVE

*Château de Malmaison's rich marble, gold gilding, furniture, and porcelain
decor recalls the artistic revival introduced by the Empire Style.*

LEFT

*In 1799, Château de Malmaison became the property of Joséphine de
Beauharnais, wife of Napolean Bonaparte. Today, it belongs to the state.*

UNDERSTANDING

CHÂTEAU LIFE

Whether used as royal residences or vestiges of the glory
of noble families, châteaux and manor houses
abound in the area around Paris and transport
visitors back to other eras.

With their vast gardens, water features, high windows, and large reception rooms behind wrought-iron gates, some of these structures date to the Middle Ages and testify to the social status of their former owners. But these residences, whether occupied by nobles or the bourgeoisie, did not share the same purpose. Their history makes it possible to distinguish a château from a manor house.

In the Middle Ages, a château was a military structure, often with a moat, a keep, and fortification to defend the community. In the Val-de-Marne department, Château de Vincennes was first a hunting lodge before it was transformed. In the fourteenth century, it was enhanced with nine towers and a Sainte-Chapelle. It became one of the dwellings of the kings of France. Louis XIV spent part of his childhood here. Later, Napoleon I used it as a large arsenal. This is the closest fortified château to Paris.

The end of the Renaissance saw the birth of many châteaux of the classical style. During this period, these structures communicated the social influence of their occupants rather than serving a military function. Symmetry reigned supreme in their design. In Boissy-Saint-Léger, in the Val-de-Marne department, Château de Grosbois adopted a "U" shape around a courtyard. Planted at the end of an allée of chestnut trees in the heart of an estate spanning more than 900 acres (400 hectares), the château served as the home of King Louis XVIII.

Decor and exterior ornamentation became increasingly important: sculptures, domes, and other arabesques were now commonplace. In Sucy-en-Brie, the facade of the château features columns, friezes, and wrought-iron balustrades. These were the preferred places of the lords to hold lavish banquets. The extensive French-style gardens are recognizable by their geometric flower beds.

Although renovations sometimes blur the lines of their original purpose, manors and houses of the bourgeoisie differ from châteaux by their smaller size. They are nevertheless worth a visit, such as Vallée-aux-Loups in the Hauts-de-Seine department, where the writer Chateaubriand lived for almost ten years. He completely renovated this former humble cottage, which is now adorned with a sumptuous marble portico, while the English-style garden's design and plantings evoke his travels. Visiting here is an instant step back in time!

1. CHÂTEAU DE VINCENNES (14ᵀᴴ CENTURY)

This château is the largest royal fortified château still in existence in France.

2. CHÂTEAU DE CHAMPS-SUR-MARNE (17ᵀᴴ CENTURY)

This château has a 210-acre (85-hectare) park that combines
English- and French-style gardens.

3. CHÂTEAU DE GROSBOIS (17ᵀᴴ CENTURY)

The high gray slate roofs and red-brick facade identify this château
as Louis XIII style.

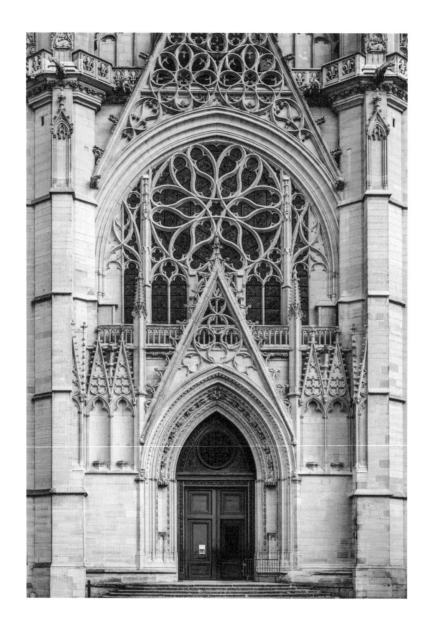

ABOVE

*Located within the walls of the Château de Vincennes, the Sainte-Chapelle
was built in 1379 but not completed until the mid-sixteenth century.*

RIGHT

*In a gothic style, the Sainte-Chapelle of Château de Vincennes houses
a holy relic: a thorn from the crown of Christ.*

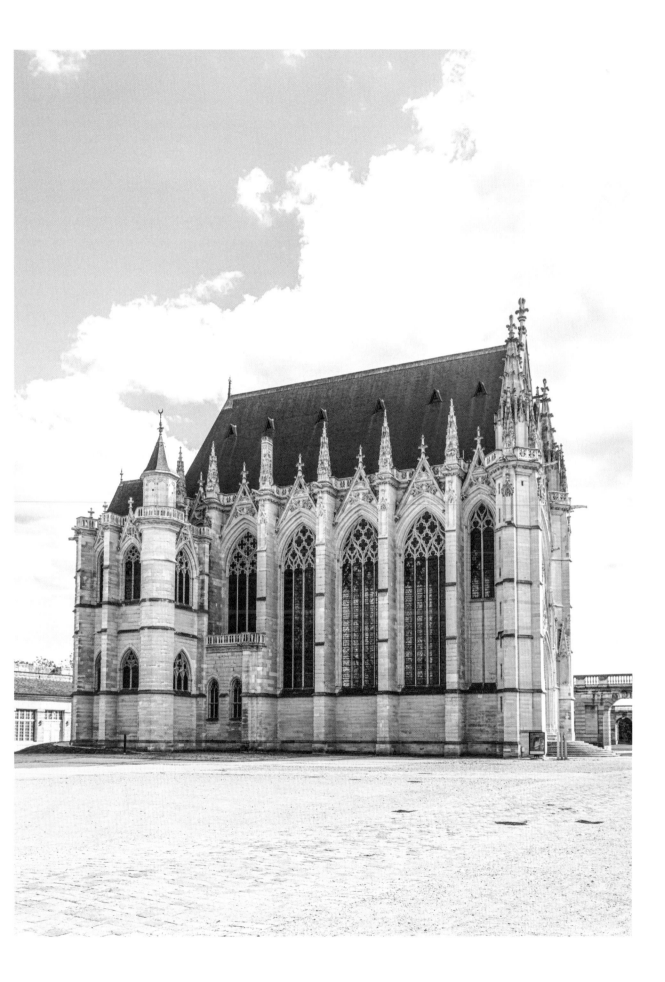

ARCHITECTURE

BRUTALISM AND CO.

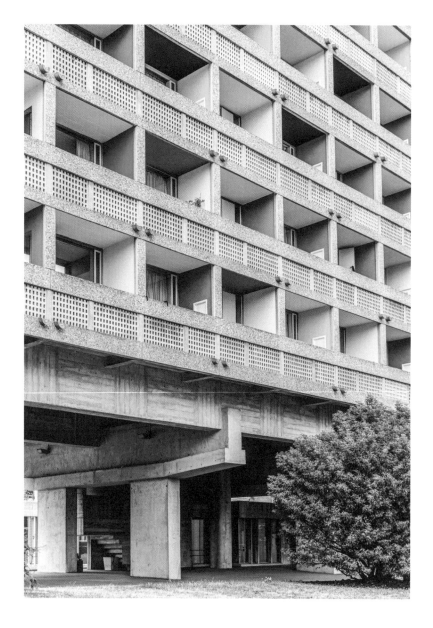

MAISON DU BRÉSIL

Located in the 14th arrondissement, this university residence
was designed by Lucio Costa and Le Corbusier in 1957.

MONTREUIL CONSERVATORY

Dating to 1976, this conservatory is made of metal compartments that provide soundproofing for each classroom.

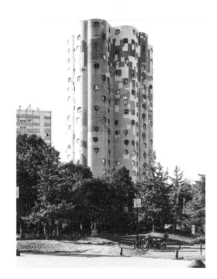

TOURS NUAGES (CLOUD TOWERS) OF NANTERRE

Built between 1973 and 1981 in Nanterre, these eighteen towers are also known as the Aillaud towers, named after their architect. Their cloudlike shape is a clever combination of curves and straight lines.

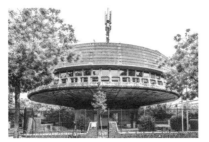

CENTRAL TÉLÉPHONIQUE MURAT

This concrete building constructed in 1976 resembles a flying saucer.

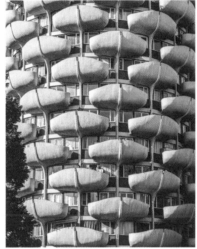

CHOUX DE CRÉTEIL

These round towers built in the 1970s have become the emblems of Créteil.

ÉTOILES D'IVRY-SUR-SEINE

Constructed in the early 1970s, this housing complex forms the center of Ivry-sur-Seine.

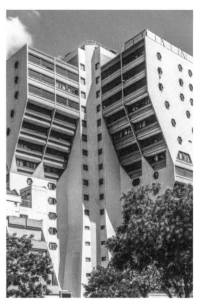

ORGUES DE FLANDRE

Martin Schulz Van Treeck designed this social housing complex in the 1970s.

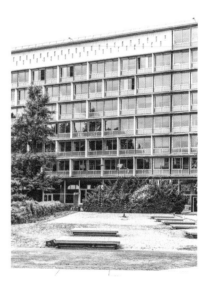

UNESCO HEADQUARTERS

Inaugurated in 1958, the Fontenoy site and its three-pointed star-shaped reinforced concrete structure was a collaboration between Bernard Zehrfuss and Marcel Breuer.

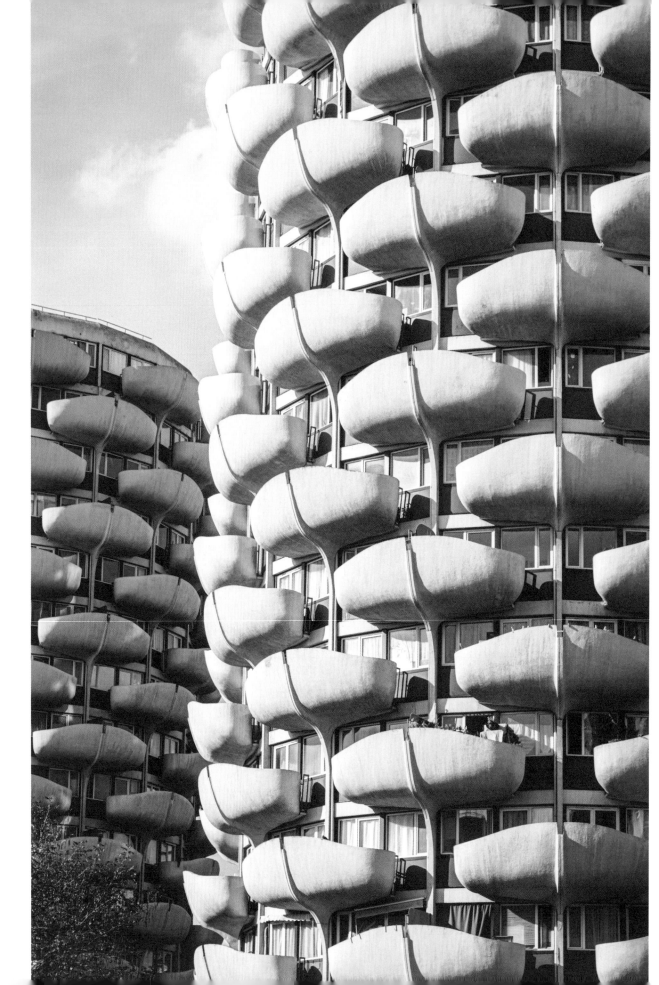

ABOVE

In Créteil, the ten towers designed by architect Gérard Granval were built between 1970 and 1974.

LEFT

The towers of Créteil are nicknamed "the choux" because of their petal-shaped concrete balconies.

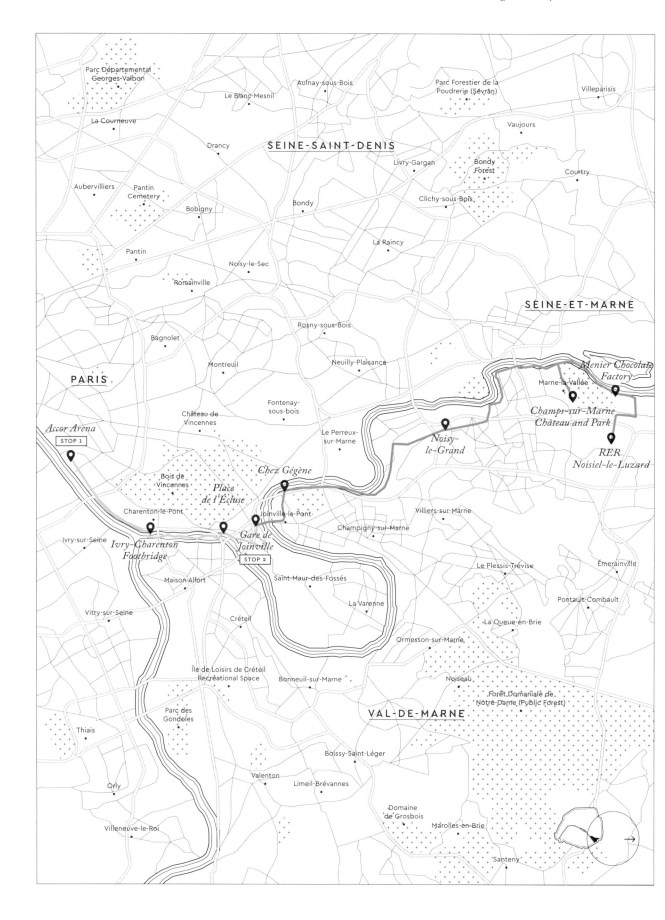

ALONG THE BANKS OF THE MARNE

The Marne is the longest river in France and joins the Seine at Charenton-le-Pont, a few miles east of Paris. The area's open-air cafés and peninsulas make it an ideal setting for a day's outing. Paris Passlib (the official city pass) includes a bike rental offer, and Paris Bike Tour rental service will deliver the bike to you.

STOP 1: FROM BERCY TO SAINT-MAURICE (6 MI/10 KM)

The Accor Arena in Bercy marks the beginning of this easy ride along the water. The bike path is on the bank lanes and runs beyond the périphérique ("ring road"). Once past the Porte de Bercy, you will reach the Ivry-Charenton footbridge overlooking the Seine. Be sure to take the slope on the right to follow the river to the Henri-Guérin stadium. This former towpath is very pleasant and offers a shaded route. You will pass an intriguing Manchu-style pagoda recognizable by its green-tiled roof, where you can find the four-star hotel Huatian Chinagora.

When arriving at Saint-Maurice at Place de l'Écluse, take a slight left and follow the old Saint-Maur canal. The Bois de Vincennes arboretum—a peaceful botanical garden—is near, as is the Joinville-le-Pont RER train station if the ride becomes too much.

Otherwise, continue straight to the Quai de la Marne and cross the river on the Joinville bridge to arrive on the Left Bank.

STOP 2: FROM JOINVILLE-LE-PONT TO NOISIEL (15 MI/24 KM)

From here, follow the path of the water. A few minutes later, the emblematic dance halls of the Marne are found. Chez Gégène tavern is probably the most famous among them. Opened in 1918, it is the last to continue the tradition of tea dances on Sunday afternoons. At lunch, be sure to sit under the arbor to enjoy a serving of seafood and frites ("fries"). Opposite here stands the Baltard pavilion, made of cast iron, iron, and glass, which once stood at Les Halles de Paris before being saved from destruction and moved to Nogent-sur-Marne.

After thirty minutes by bike, you will arrive in Noisy-le-Grand, where the path offers an increasingly wild environment. Pedal another twenty minutes to reach the Champs-sur-Marne park. There, dismount your bike for a stop under the trees or go to the château. This eighteenth-century pleasure-palace, which is open for visits, reveals a French-style garden. The Marquise de Pompadour, as well as men of letters such as Voltaire, Diderot, and Chateaubriand, once stayed here. The route ends not far from there on the other side of the park at the former Menier chocolate factory located in Noisiel in an industrial building classified as a historical monument.

To return to Paris, go to the Noisiel-Le-Luzard RER train station. Bicycles are allowed on board the trains, and the journey takes only about twenty minutes.

ABOUT THE AUTHOR

After finishing her studies in journalism, **Hélène Rocco** moved to Paris in 2015. She became a lifestyles journalist and traveled throughout France and abroad in search of all the top spots. Her love of cooking and her eye for all things beautiful fueled her passion for creating this book.

Acknowledgments: To Jean-Baptiste, my parents, family, and friends for their support and encouragement throughout this project. Thanks to Faris, who turned to me to create this book; to Sophia for her sublime photos; and to Delphine, Elsa, and Fanny for their advice. Finally, thanks to Déborah, Giovanna, and Laurine, who gave me a chance, years ago, and entrusted me with writing several guides in the pages of *Mint*, *Dim Dam Dom*, and *MilK Decoration*.

Dutch photographer **Sophia Van den Hoek** fell in love with Paris after traveling there at age fourteen. In 2022, she realized her dream of settling in the city. Her style is simple and reflects life in all its positive forms. Working with natural light, she captures the pure and true aesthetic of the world around her.

Acknowledgments: To my parents, who accompanied me in France on a tour of Greater Paris, and to my friends Yentl and Fleur, who accompanied me for several days when I needed it most. And lastly, to Hélène Rocco, for organizing all the meetings, and to Faris, who chose me to help create this book.

PHOTOGRAPHY CREDITS

All photographs in this book are by Sophia Van den Hoek, except: Dominique Perrault, architect / Adagp, Paris, 2022: © 67 (bottom left and right); © Unsplash / Sébastien Le Derout: 56. © Adagp, Paris, 2022: 49 (Cité de la Mode et du Design), 99 (Musée Zadkine), 251, 252–253 (Choux de Créteil); © Architects: Jean Nouvel, Gilbert Lézénès, Pierro Soria, and Architecture-Studio / Adagp, Paris, 2022: 49 (Arab World Institute); © Ateliers-Musées Chana Orloff: 143; © National Library of France - Dominique Perrault, architect / Adagp, Paris, 2022: 67 (bottom left and right); © Carlos Ott: 199, 203 (Opéra Bastille); © DB - Adagp, Paris, 2022: 10; © F.L.C. / Adagp, Paris, 2022: 125, 250; © Jean Nouvel / Adagp, Paris, 2022: 171 (Philharmonie de Paris); © Pei (Pyramid); © Jean Nouvel / Musée du Quai Branly Jacques Chirac / Adagp, Paris, 2022: 78 (Musée du Quai Branly Jacques Chirac); © Kengo Kuma: 108 (Fondation Louis-Vuitton); © Manuel Núñez Yanowsky: 238 (The Camemberts); © Niemeyer, Oscar / Adagp, Paris, 2022: 171 (French Communist Party Headquarters); © Renzo Piano: 15 (Centre Georges-Pompidou); © Ricardo Bofill: 237, 238–239; © Richard Rogers: 15 (Centre Georges-Pompidou); © Serge Renaudie: 251 (Étoiles d'Ivry-sur-Seine); © Shutterstock: 219 (Morrison, Rodenbach, Chopin, Balzac); © Seth; © Estate of Alberto Giacometti / Adagp, Paris, 2022: 70–71, 143; © Brancusi Estate - All Rights Reserved (Adagp), 2022: 143.

Published in 2023 by Harper Design
An Imprint of HarperCollins*Publishers*
195 Broadway
New York, NY 10007
Tel: (212) 207-7000
Fax: (855) 746-6023
harperdesign@harpercollins.com
www.hc.com

Distributed throughout the world by
HarperCollins *Publishers*
195 Broadway
New York, NY 10007

ISBN 978-0-06-331398-9
Library of Congress Control Number: 2022950135
Printed in China
First Printing, 2024

Director: Emmanuel Le Vallois
Editorial manager: Faris Issad
Editor: Franck Friès
Artistic director: Sabine Houplain
Artistic creation: Bureau Berger
Layout: Nathalie Kapagiannidi
Proofreading: TBC
Manufacturing: Rémy Chauvière
Photography: Colorway